THE BLACK NIGHTGOWN

The BLACK NIGHTGOWN

The Fusional Complex and the Unlived Life

NATHAN SCHWARTZ-SALANT

Chiron Publications
Wilmette, IL

"The Eighth Elegy," copyright 1982 by Stephen Mitchell, from *The Selected Poetry of Rainer Maria Rilke* by Rainer Maria Rilke, translated by Stephen Mitchell. Used by permission of Random House, Inc.

Printed in the United States of America.

Library of Congress Cataloging-in-Publication Data

Schwartz-Salant, Nathan, 1938-
 The black nightgown : the fusional complex and the unlived life / Nathan Schwartz-Salant.
 p. ; cm.
 Includes bibliographical references and index.
 ISBN-13: 978-1-888602-41-8 (alk. paper)
 ISBN-10: 1-888602-41-4 (alk. paper)
 1. Jungian psychology. 2. Interpersonal relations. 3. Psychotherapy. I. Title.
 [DNLM: 1. Anxiety Disorders—psychology. 2. Anxiety, Separation. 3. Individuation. 4. Jungian Theory. 5. Psychotherapy—methods. WM 172 S3998b 2007]

 RC506.S37 2007
 616.89'17—dc22
 2006103246

DEDICATED TO MY ANALYSANDS, WHOSE COURAGE,
SUFFERING, INSIGHTS, AND GENEROSITY HAVE MADE
THIS BOOK POSSIBLE

Table of Contents

A Note to the Reader

This book is a diary of encounters in psychotherapy—professional sessions and my reflections—that gave rise to a theory I have developed: the Fusional Complex. The salient feature of these encounters is that, professionally and personally speaking, they were exceptionally difficult.

The experiences of the Fusional Complex described in this book are taken from my practice over the last twenty years. But the Fusional Complex itself is not confined to the consulting room. It is ubiquitous in everyday life, creating havoc in relationships and severely limiting people's capacity to leave safe and predictable patterns and engage life in a new, more vital way. Furthermore, this complex exists on a cultural scale in certain historical epochs—for example in Rome in the third century B.C.E., in Renaissance alchemy, and in Elizabethan England (especially evidenced in Shakespeare's *Hamlet*)—where a new form of consciousness began to emerge. Culturally and individually, we are at just such a critical historical juncture today.

Theory, as Einstein said, decides *what* we can observe, and the theory of the Fusional Complex is intended to serve that goal, while allowing us to consider interactions we otherwise don't identify or have construed in unsatisfactory ways. The reader can judge whether the theory succeeds. Does it help you see phenomena you have lived with, perhaps for decades, in a clearer light? Does it help you seek out *what* to observe, beyond what seems manifest at any instant, looking deeper, hearing differently, and,

most significantly, understanding yourself and others better? And does it help you to better understand the times in which you live?

This elusive and intricate complex, which often pervades an analysis but is rarely focused upon, generally goes totally unrecognized in relationships in the wider world. Instead, its symptoms are passively suffered or blindly dismissed. However, there is a purpose to the Fusional Complex, achieved not through a "heroic" attitude of striving to overcome obstacles, but rather through another kind of heroism: the strength required to suffer inwardly the disorganization of painful mental and physical states and, crucially, to feel *limited* by these conditions. Then the Fusional Complex becomes a gateway to the very process it seems to retard, that is, to individuation and connection to that ineffable core of the human personality, the self.

* * *

Many people, in particular colleagues in New York and Princeton, have provided vital assistance spanning the time from my first vague perceptions of the Fusional Complex to its crystallization in the present book. I have also been blessed by an interest in my work in other countries. It was the analyst Luciano Perez who, on translating a paper of mine into Italian, suggested the word "fusion*al*"—for indeed the word "fusion" on its own alludes to a variety of often positive and flexible states of mind that are only marginally found in the fields associated with the Fusional Complex.

Analysts in my supervision groups have had to learn about the Fusional Complex amid the flux of my evolving formulations. This book owes a great deal to their questions, observations, and, above all, willingness to confront, within a group setting, aspects of madness at the center of the Fusional Complex as it impacted them along with their analysands.

How well I am able to communicate the perplexing nature of the Fusional Complex is my responsibility, but for whatever success I have, I am beholden to my editor Sarah Gallogly's affinity for the material and to her editorial skills. I greatly appreciate Erin MacLean's design work on the cover and text. And special gratitude goes to my partner at Chiron Publications, Murray Stein, for his enduring interest in and support of my work.

Without my analysands, and their permission to use their stories, this book could not exist. I am profoundly indebted to them, and to their courage in facing areas of the psyche that threatened them with annihilation and the humiliation of the frozenness of unlived life. An analyst, however, can only embrace such material if he has lived and suffered it himself; nothing short of personal experience could make this book successful. In that regard, my greatest indebtedness is to my wife, Lydia. She has been my guide for many years. Her clinical acumen can be felt throughout this book, and our relationship has been a crucible for the Fusional Complex and for the unfolding of our souls.

1

INTIMATIONS OF CHAOS

T HERE'S A PECULIAR THING THAT SOMETIMES HAPPENS between people in the most innocent of social interactions. It could happen during a chance encounter on a street, at a dinner party, with a colleague at work, or with a friend over coffee—in short, anytime, anywhere, with anybody. It is a situation in which an uncomfortable sensation—which has no ostensible reason to be there—permeates the interaction. It is not an exaggeration to call the experience intolerable. It might be a barely acknowledged sense of weird entanglement that makes your body tighten as if to ward off something you couldn't name if asked. Or sometimes, for no apparent reason, a pause in conversation that ought to be a normal space feels uncomfortable, even threatening, and causes a strange sense of guilt, as though something were present that you were working hard to ignore.

Having noticed these peculiar interactions in a half-conscious way over the years and vaguely wondered about them, I realized, little by little, that this phenomenon also occasionally made its way into my consultation room, in my interactions with my analysands. Perhaps over the years of noticing and wondering about these incidents, I unconsciously built up the capacity to perceive them more fully. Whatever the reason, my conscious attention to the phenomenology I later dubbed the Fusional Complex

began to crystallize for me one morning in a session I had with an analysand whom I will call Naomi.

Naomi, an attractive and intelligent forty-year-old woman, consulted me on the advice of a friend who had read a book I had written on narcissism. She was a physical therapist, and also very well read in psychoanalytic literature. Beyond the marital problems that had first brought her to therapy, it was soon apparent that she was deeply interested in her own psychological growth.

One day, several months after Naomi had entered analysis, I had an emergency in my office building that disrupted my schedule. Generally, I am very careful about boundaries, including being on time, but that day I was five minutes late for our appointment. I felt somewhat unsettled by the words Naomi immediately spoke with just the right measure of exasperation: "I have to tell you, I'm a little disturbed by the fact that you were late for this session."

I became aware of a sudden tension in my body, accompanied by bewildering and chaotic feelings that were casting a shadow upon my capacity to think and reflect. While her demeanor was different from what she had previously shown, my reactions went far beyond what I would have expected. But exploring Naomi's complaint, especially with interest in her feelings, seemed to quickly change the atmosphere. She then went on, telling me about the struggles of the past week, and I felt centered and related to her, as though the deeply disturbing state had come and quickly gone. Yet those chaotic moments felt significant, so later that evening in my notes I tried to re-create my experience with her, to get closer to the condition that I realized I had pushed "off to the side," or, in clinical language, dissociated into a distant co-consciousness.

As I imaginally revisited the experience I realized that, in addition to what I had registered during our discussion, I had also felt a magnetic-like attraction—what I would describe as a compulsive search for a deeper meaning behind Naomi's words—in the

grip of which I felt like a "deer caught in headlights," unable either to move my attention away or to empathically or emotionally connect with her.

Going deeper, I remembered feeling as if we were both in some obscuring atmosphere where I could only grasp at fragments of what she was saying. Though her words were actually clear and straightforward, I couldn't process any of them, as though they were part of a very abstract lecture. I found myself furtively observing her every change in voice tone or facial expression for clues to the meaning I seemed to be missing. Replaying the episode in my mind's eye, I perceived that we had seemed to share a chaotic field that united us through sensation and affect, while the actual spoken communication was not connecting. I felt psychically attached to Naomi, but also unconnected to her.

During this meeting, I had no way to conceptualize or reflect upon the experience.[1] Our work in the ensuing sessions felt more "normal" as, for example, it oriented to her marital struggles, her relationship to her son, her past experiences as an analysand in psychotherapy, her difficulties in accepting that she had needs of her own, and the analysis of her dreams. In fact, it was only seven years later, after a long and arduous process, that Naomi and I could again, without dissociating the experience into a mostly hidden, inner state, experience this strange kind of closeness and simultaneous absence of communication that are aspects of the Fusional Complex.[2]

The Fusional Complex manifests out of an underlying field. Physics explains particles as transient manifestations or concentrations of the energy of the field, which is the primary reality. In the same manner, the Fusional Complex is an activated point of the Fusional Field.[3]

The activation seems connected to a quality of psychic life—for example a creative idea, or a development of the ego, of a capacity to think or feel, or of a self and associated new identity—leaving

the timeless realm of the unconscious and entering life in space and time. This transition always creates disorder,[4] and that disorder in turn enlivens the Fusional Complex. In the absence of a containing relationship—that is, a felt connection with a person who empathically relates to the anxiety of this disorder, typically a parent in early life—the Fusional Complex will become very strong and lead to a stuck condition in which that psychic quality in the field cannot incarnate into embodied life.

For many years of my work with Naomi, before a self and sense of identity could finally incarnate, the suspended condition of disembodied life created a tormented quality in the field—the very material that I glimpsed in this early session. This quality was embodied for Naomi in a fateful dream of a black nightgown (Chapter Seven), which came for us to represent the pain and difficulty of containing the turbulence of the Fusional Complex.

The fusional medium or field is invisible to normal perception, yet it contains a welter of unprocessed information. Reflection upon this condition is exceptionally difficult because, unlike other fields of human interaction, the Fusional Field does not generate an experience of three-dimensional space in which processes such as an exchange of feeling or unconsciously transmitted fantasies can take place between people.[5] Since there is little stable and usable experience of the space of an "inside" or "outside" of the other person, or oneself, no empathy or meaningful communication can take place. No matter how connected one thinks one is, one might as well be in a parallel universe over the communication of even the simplest of matters. The responses between analyst and analysand gradually lose coherence, and if one pauses to explicitly confirm one's impression of the other's meaning, it is often shocking to learn just how disconnected one was.

The two conditions—a fusional pull and a tendency toward distance and non-communication—exist simultaneously. At once there is a fused connection *and* a state of disconnection. Both are

true. In philosophy this is known as the problem of "true contra-
dictories" in which a statement, A = –A, creates a logical impossi-
bility. The picture of the "duck-rabbit" has been used to illustrate
this state.[6]

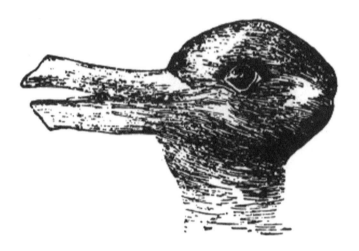

Figure 1. Duck-Rabbit
Is it a duck or is it a rabbit? Are we fused or totally disconnected?

The Fusional Complex is an archetypal pattern,[7] beyond cul-
tural and historical specificity, that organizes life "in between" the
known and the unknown. This inevitable structure is a constant
companion in a creative life, and it attends movement from one
"psychic territory" to another—a change of jobs, transformative
spiritual experience, birth itself. It is found in earliest infancy, and
in later stages of separation from a maternal object, or in times of
fundamental changes in a personality. For some, the Complex
characterizes even the slightest changes of behavior or relationship.
 When the Fusional Complex is activated, separation from an

accustomed "safe territory" of established patterns—or, in an interaction, separation from another person's spoken or unspoken desires or demands—can lead to extreme and destabilizing anxiety, a compensatory rage, and temporarily impaired capacity for reflection and clear thinking.

The subject often defends against the ambiguity and madness in the Complex through a disguised and destructive shadow behavior. One may (usually unconsciously) enact a *desire for disconnection* that is difficult to elevate into consciousness, obscured as it is by a compulsive drive toward connection.

This drive manifests in a strange manner, creating an adhesion to the other person's words or feelings despite the lack of experienced communication. The subject often creates a feigned connection, a quick "I get it" or a compulsive finishing of the other person's sentences, while not actually understanding the communication at all—hoping that a cold absence of feeling and a mad rush to disconnect have gone unnoticed.

For example, another analysand, John, was on the telephone with his wife when she said said, "I love you" to end their conversation. A pause followed, as John was suddenly overcome with anxiety. He believed she wanted him to say, "I love you, too," but he didn't feel any connection with her. "I love you, too," he said, after a moment.

His wife, who like John had been through many years of therapy, replied, "I can't feel that," and John's anxiety level surged.

"I'm sorry," he mumbled. He wanted to get off the phone as quickly as possible.

The following day, when he came to my office for our weekly session, John told me about the phone call and his anxiety. After a few minutes of discussion it became clear to both of us that he had been avoiding a deeply disturbing state—one I had by then come to recognize in my reflections upon my own reactions to the Fusional Complex with my analysands.

In those passing, easily dismissed moments of the felt presence of the Complex, I came to realize that I was at the edge of experiencing something very threatening to my sense of coherence. I began to register its total effect upon my mind and body, disrupting any capacity to clearly distinguish between inner and outer sources of the unbearable distress. For years I avoided this frightening state by adapting a mental-rational level of awareness, as though my perceptions came from "upper" portions of my being. It was only when I allowed my attention to descend more deeply into my body, and attend to the field with another person, that I could sense that extremely disturbing state was between us.

Similarly, John, to escape his anxiety, had "gone up into his head" and tried to figure out what his wife wanted to hear. To explore that anxiety now, I tried to lead him back toward feeling, toward his body and away from his head.[8] It wasn't easy for him to experience being *in* his body and try to access the disorienting state he had fled, and at first he retreated into his head again, adopting an intellectual approach: "I know this is about my mother."

I again urged John to feel into his body, and he started to say, "If I allow myself to just bathe in my wife's love and reception of me—" but then stopped and said, "I just can't do it. It's too scary. I'm going to lose her. I'll feel rejected or abandoned." Again I oriented him to feel more into his body, to stay mentally connected to his breathing and notice whatever he felt.

"There is some combination of rage and fear."

"Fear of what?" I asked, and after a long pause, he said: "Fear of being sucked into her and losing myself. It's like there is a magnetic pull that I felt during the call. It felt too unsafe to be embodied with her. Being in my head was still scary but much safer; I didn't feel so pulled into her and in danger of losing myself. There is always some of this kind of interaction between us. It's like a background presence that I try to avoid feeling, but I know that it makes it difficult for me to fully be with her. In sex, I'm afraid of

losing my erection. I really don't desire to penetrate her, I'm too focused on 'doing it right' to feel my desire."

"What is right?" I asked him.

"It's whatever she thinks is right."

"Does she say?"

"No, I always try to figure it out for myself, like during the phone call."

John further refined his recollection: "There was a watery feeling between us that I could be lost in with none of my own thoughts, only those I think she wants me to have, so that I'll be released. When this goes on I hate her."

While John tried to escape into his mind, he still felt a great deal of chaotic or unprocessed information barraging him through his body, and through the "watery field" in which he was indiscriminately identified with his wife—not in a positive experience of merger and love, but rather feeling somehow imprisoned. At the same time, he felt a sense of a vast psychic distance—a consequence of there being no connection to his wife, any understanding, reflection or empathy. I asked him:

"Are you very close to her, enmeshed together in your search for her feelings and thoughts?"

"Yes."

"Are you totally distant from her, with no communication and no feeling of attachment?"

"Yes."

John was experiencing the same "duck-rabbit" phenomenon I had discovered with Naomi. His conscious mind could not experience the logical impossibility of these "true contradictories" without opening the door to extreme confusion and the fear of "disappearing into her and totally losing himself" that threatened his sense of existing.

* * *

The very nature of the rational mind, with its perspectival forms of awareness, is incapable of perception of these deeply chaotic fields that seem to exist before a capacity for the differentiation of emotional life. The mental level thus becomes an escape from the field. Only when the field is seen and engaged can what was once believed to be a good communication, say an interpretation or a statement about the other's envy, be seen to be a spastic attempt to bridge a huge chasm, across which both people have been talking while failing to experience the gap with real empathy or understanding.

This chasm is a representation of the archetypal core of the Fusional Complex. It is a dreaded, traumatic state, and has been characterized by various analysands as a fear of a "void," an "abyss," a state of "nothingness," a "white nothing," a "bottomless pit," or a "sucking demon." Some find archetypal imagery such as dark aspects of the Indian Goddess Kali or the Anatolian Great Mother, Cybele, to best reflect their experience.

Experiencing this bottomless chasm with another person often leads to an intense feeling of guilt or blame for trying to separate from what feels like "the other's" dangerous insatiability. In opening to experiencing the field, it is not uncommon to feel nausea that seems to say, "This is unacceptable," as though the body were revolting from a dreadful state—and a demand to rescue the other person from it. The field may feel unwholesome, putrid, so that every cell of the body wants to get away from it. And if one insists upon staying with the field, "leaning into it," one may fear becoming contaminated by a "sticky substance" that seems to be emanating from the other's body. It is as though some terrible taboo were being broken.

This allocation of the void to the other is a defense against realizing it as a field quality to which both are subject. The tendency is for both people to pretend that this field between them does not exist, to collude in ways that say, "This is not happening," for seeing

the field and experiencing the agony of the "impossible" opposites is far too disturbing and frightening. The psychologist and philosopher Steven Rosen has explored this condition as the Greek notion of *Apeiron*—variously conceived of as limitless, boundless, indeterminate, the unintelligible, or the inchoate flux of opposites—and avoided by the Western mind for at least two thousand years.[9]

Yet our culture is now in a time of transition, and within it, the Fusional Complex is ubiquitous. For cultures are also subject to the Fusional Field, which activates when a society no longer adapts well to collective needs, causing the Fusional Complex to manifest widely within individuals in the culture.[10] Individuation—that "innate [imperative] for a living being to incarnate itself fully, to become truly itself within the empirical world of time and space"[11]—makes new demands for consciousness and for a new relationship to the self and others. But once the new consciousness and self-structure consolidates, the Fusional Complex gradually re-enters the Fusional Field and becomes far less of an issue for individuals.

It may seem that this complex could only be pathological. However, through cultural and individual examples, we will see that the Fusional Complex is the doorway through which any new form of consciousness and associated self—that structure that bestows a sense of identity and order within human life—must pass if this change is to be stable in space and time, and, most significantly, exist as an embodied experience.

* * *

Generally, the nearer we get to the core of any complex, the unknowable archetype *per se*, the more we experience the *numinosum*. That term, created in 1927 by Rudolph Otto in *The Idea of the Holy* to define the emotional experiences of the sacred, such as Awe, Beauty, Light, Terror, Dread, Fear, etc., describes the nature of deep, archetypal experiences. The experience of the numinosum is

a confrontation with a power not of this world. [It] is a "Wholly Other" outside of normal experience and indescribable in its terms; terrifying, ranging from sheer demonic dread through awe to sublime majesty; and fascinating, with irresistible attraction, demanding unconditional allegiance.[12]

Generally, complexes can cause one to encounter the numinosum in its negative form. With the Fusional Complex the negative numinosum is especially tenacious and difficult to transform, manifesting in the extreme anxiety accompanying separation of any kind. This experience can approach James Grotstein's notion of the black hole of psychosis as an "experience of powerlessness, of defect, of nothingness, of 'zero-ness'—expressed, not just as a static emptiness but as an implosive, centripetal pull into the void."[13] One often tends to find a safe harbor from the deeper anxieties of the negative numinosum by dissociating from awareness of the opposing fusional pull toward objects through an autistic-like flight from communication. This dissociation generally takes the form of extreme mind-body splitting and retreat into passive fantasy. However, meeting the disorganizing energy of the archetype consciously can often turn it into its positive form, i.e., awe, mystery, love, beauty, and compassion.

It is remarkable how attempts at meeting the chaos, rather than dissociating, can effect change. For the numinosum, even when it is negative, is still the sacred energy of the archetype. The analytic process can mediate this change, for, as Jung said, "What you perceive in a person you bring out of him." If one is able to perceive the positive numinosum, e.g., as "light" in a person, one will help its reality to embody, and in this way will nurture the analysand's faith in his or her own archetypal resources. If one does not have this perception—especially if one does not know how the numinosum is coupled with the disorder of its incarnation, or if one has

not experienced how the negative numinosum can change into its positive form—one will provide a very different container or object relation than if one has had such experiences.

Generally, a person does not come to an awareness of his or her Fusional Complex through the usual analytic procedures such as free association, or dream or transference interpretation. The analyst's perception of states of mind or body in the analysand, or in the field between them, must take the lead.[14]

In the course of this book I will use phrases such as "seeing into the field," "seeing through the field," or "seeing the field." These are perceptions that may be achieved with a form of "non-ordinary perception," itself a function of a consciousness that is different from the rational, perspectival form of awareness that has ruled our culture for at least the last three hundred years.[15]

In a sense, one only *sees* the phenomena of the Fusional Complex *after* one has exhausted rational-discursive means of understanding. Then one can be affected enough by the field with the analysand to perceive what is *there*. In my experience, this vision is never conveyed by an interpretation based upon a developmental theory,[16] but rather by a statement of the existence of what we perceive, whether that be through our eyes, feelings, body experiences, smell or hearing.[17]

With the help of a relationship, or a deep belief system, people may manage to stay true to their own process of feeling the "impossible" opposites. Eventually their struggle proves to have been a passage to a new self, for the numinous begins to flicker within. And when the analyst can *see* the numinous energy— through a non-ordinary perception that can evolve through one's eyes, kinesthetic experiences, or feelings—the extreme chaos the person experiences can eventually calm down sufficiently to allow the incarnation process of a new self to become a living reality.

It is difficult not to exhort a person to a "heroic" act to separate from a very destructive behavior or fusional state with another

person, though he or she truly cannot muster the energy for almost anything, let alone changing his or her life. What helps most is a witness who feels his or her own limits of understanding, and who can be compassionate in the face of the person's suffering, but who also has faith in a process through which the self is trying to incarnate.[18]

With adequate containment through such an object relation—that condition in which sufficient communication, harmony, and understanding exist between a subject and an object—this movement from a timeless into a temporal existence forms a creative passage that can yield a new sense of identity and the experience of an inner self. If, however, as is often the case, there is a failure of containment to facilitate the passage, the Fusional Complex takes on the reverse effect: it inhibits the self's incarnation into space-time life.

* * *

The purpose of identifying the presence of the Fusional Complex is:

a) The analyst gains an appreciation of the power of the psychotic anxieties that can be so disorganizing to the analysand's sense of existing. The analyst may then become alert to activities that trigger these anxieties.

b) Many analytic processes are stymied until the Fusional Complex, which can exist along with a variety of less chaotic but still extremely difficult conditions such as borderline, narcissistic, or dissociative states, is perceived in the here and now of the analytic process. This can have a powerfully transformative effect, akin to the miraculous healing the alchemists ascribed to their mysterious *elixir*.

c) Even if a mutual experience—which is optimal—is not

achieved, the analyst's consciousness of the existence of the Fusional Complex can have the effect of unconsciously diminishing the analysand's defenses against the awareness of his or her fusional states and associated absence of relatedness.

d) The Fusional Complex is a theory that helps us see what easily hides from our normal perceptions, issues that rarely, if ever, are revealed through history-taking, or dream interpretation, or interpreting the transference.

The following list—elaborated upon throughout this book—summarizes the main features of the Fusional Complex, with special reference to a therapeutic situation. The following "primary features" are central to the experience of the Fusional Complex. The "auxiliary features" are also essential to the identification and experience of the Fusional Complex, but on their own they do not fully embrace its nature. Yet awareness of any of these auxiliary features is often a first clue to the presence of the Fusional Complex.

SUMMARY OF FEATURES OF THE FUSIONAL COMPLEX

PRIMARY FEATURES

1. **Simultaneity of fusional drives and noncommunication**
 When the Fusional Complex dominates the field between two people, a fusional pull and a tendency toward distance and non-communication exist simultaneously. At once there is a fused connection *and* a state of disconnection. In philosophy this is known as the problem of "true contradictories."

2. **Disorganizing nature of the archetypal core of the Complex**
 The archetypal core of the Complex infuses the field with a chaotic energy that threatens the subject with a loss of coherence and identity.

AUXILIARY FEATURES

3. **Separation, extreme anxiety, and energy loss**

 Attempting to separate oneself from feeling psychically fused with a person, or from a familiar pattern of behavior, leads to the experience of the disorganizing, psychotic energies of the archetypal core of the Fusional Complex. In the subject, this creates a lack of coherence and a radical drop in energy. Considerable shame can follow in the face of the inability to deal with seemingly trivial items, such as paying an easily affordable but overdue bill.

4. **Hidden and extreme passive fantasy life**

 To avoid experiencing the disorganizing effects of the Fusional Complex, a person will engage in a great deal of passive fantasy, often for many hours each day. This extensive fantasy life is usually a deeply guarded secret and is extremely difficult for the analyst to uncover.

5. **Absence of space, precluding productive use of projective identification**

 Three-dimensional space is experienced as unstable or nonexistent within the field of the Fusional Complex; hence there is no container that can help distinguish between "inner" and "outer." Consequently, projective identification, the process whereby the analyst's imagination is partially created or induced by the analysand's split-off, imaginal life, is fragmentary or nonexistent as a useful modality.

6. **Damaged subtle body and use of substitute skins**

 Through non-ordinary forms of vision, feeling, or kinesthetic experience, one can perceive that a person with a strong Fusional Complex has a torn or otherwise damaged subtle body—the container for the inner life, existing "in between" mind and body. "Substitute skins," such as extreme self-hatred,

dissociation, muscular rigidity, and passive fantasy, form as protective containers against inner or outer intrusions.

7. **Powerful and excessive forms of narcissism**
When the Fusional Complex is strong, a powerful form of narcissism (more primitive than that usually found in narcissistic character disorders, and approaching so-called primary narcissism) is present. It can take the form of a "bubble structure" in which the analysand is speaker and listener at the same time. A sense of the other person's strangeness, as often accompanies psychotic process, can be present.

8. **Fear, anger, and blame**
Within the field of the Fusional Complex, one can be gripped by an intense anger, akin to the destructive nature of "road rage," and also by extreme fear. Interaction with others is strongly limited by *blame*, for someone being at *fault* is the currency of the Complex, shutting out the possibility of experiencing conflicting points of view.

9. **Sudden jumps or discontinuity in experience**
When the Fusional Complex is enlivened, one or both people can experience, from one moment to the next, a sudden jump in the scale of the emotions evoked by the encounter. This can be bewildering and frightening.

10. **Abjection**
When the field of the Fusional Complex is strongly constellated, fear of contagion by the other's abject state, such as his or her madness, taking the form of a boundary-less identification with an archetype, is common.

11. **Unlived life and humiliation**
The power of the Fusional Complex creates a wasteland of unlived potential in a person, resulting in strong feelings of humiliation.

12. Typical reactions in the analyst

a) The analyst tends to dissociate from the field of relating because being present is confusing and both mentally and physically painful. The physical pains may be extreme, such as pressures or even sharp pains in the head, chest, or abdomen. The mental confusion defies one's ability to create an inner sense of order. Often, the mental and physical levels of pain intertwine and it is impossible to differentiate them from one another.

b) The analyst tends to feel blank, dumb, and deadened to perceiving any mental or physical state. In his or her near-muteness, the analyst can feel suddenly controlled or imprisoned by an impersonal force to which there is no possible response.

c) Psychotic processes in the field lead to a sense of strangeness; for example, what the analyst says, even if seemingly heard and registered, is often taken in ways very different from what he or she meant. This is a nagging and bewildering quality of the interaction, and can lead to strong negative reactions in the analyst.

d) The analyst tends to diagnose his or her analysand as a narcissistic, schizoid, obsessive-compulsive, dissociative, schizoaffective, or borderline character. However, while such conditions may be present, and require treatment, many obstacles exist until one consciously engages the field of the Fusional Complex. In addition, many of an analysand's so-called "anti-therapeutic reactions" in an analytic process, and other severe forms of resistance, are artifacts of the Fusional Complex, and may diminish or resolve when the Complex is identified.

13. Non-pathological nature of the Fusional Complex

As an analyst is able to more consciously suffer the Fusional

Complex, and learns to "lean into" its field, the opposites of fusion and distance may become conscious as a sequence of states. This engenders a beginning awareness that something beyond pathology is involved in the effects of these "impossible opposites." When a sense of containment within a higher-dimensional field is further established, the opposites can be glimpsed together. This especially opens to a deeper awareness that the Fusional Complex is far more than pathology: it is a potential gateway to a new form of both ego-consciousness and the self.

2

PERCEPTION: THE INVISIBLE WORLD
OF THE FUSIONAL COMPLEX

T HE FUSIONAL COMPLEX EXISTS *IN BETWEEN* A STATE IN which the opposites of fusion and distance have not yet separated, and another state, in which the opposites have become separate and well defined. In this "in between" world, mental and physical pain can be dominant, and there is no stable experience of space. This fusional state with an analysand deprives the analyst of a cherished tool: he or she cannot distinguish his or her own feelings or "innerness" sufficiently to be able to discover what aspect of them may be derived from the analysand's psyche. This process, known as projective identification, is often a valuable source of information in psychotherapy,[1] but other forms of perception must be employed when the Fusional Complex organizes the field between analyst and analysand.

Furthermore, standard therapeutic practices such as dream or transference interpretation can often cause the analysand extreme anxiety, for such approaches can be experienced as forcing a premature subject-object separation. If the analyst intends to engage the energies and dynamics of the Fusional Complex, he or she should not force such rational levels of dialogue.

A consequence of the chaotic nature of the "in between" world that the Fusional Complex inhabits is that the analysand will rarely be able to describe experiences until the analyst first per-

ceives them. On his or her own, the analysand will rarely become conscious of dynamics of the Fusional Complex. Furthermore, asking the analysand questions, or looking for associations to dream images or life experiences, will not result in discovery of the existence of the "impossible" fusion state.

Generally, the step-by-step reasoning and consciousness that dominates our modern world—the rational-perspectival form of awareness, which is central to science and all inquiry that attempts objectivity and understanding of life as separate parts that interact through causality—fails to facilitate perception of the opposites of the Fusional Complex. Whether employing a theory, such as one that describes infant development, or inner, imaginal experiences, this rational form of awareness fails to uncover and *see* the Fusional Complex.[2]

Another kind of awareness is required, a non-ordinary form of perception that can perceive the spiritual or psychic background in a person, or in the field he or she occupies. The perception is not an intuition in the usual sense of a nonrational connection to unconscious processes; rather, it requires an act of *creation* similar to those described in numerous creation myths. Out of this process an essentially new form of awareness develops through which the analysand's inner reality becomes perceptible, as does the reality of the field.

The belief that the earth and sky were originally one, or were commingled in a watery Chaos, which required separation into opposites and the creation of space, is found in many cultures. "The earth was without form and void, and darkness was upon the face of the deep; and the Spirit of God was moving over the face of the waters" (Genesis 1:2). With "Let there be light" (Genesis 1:3), the Creator separates light from darkness, calling the light day, and the darkness night. This completes the Old Testament's account of the first day of creation. Before this point, space does not yet exist. Then, on the second day, the Creator says: "Let there

be a firmament in the midst of the waters, and let it separate the waters from the waters" (Genesis 1:6). Heaven is thereby created, and hence space comes to exist.

In ancient Egyptian texts the god Shu curbs the demons of darkness and separates Nut and Geb, sky and earth.[3] Again, a great deal of creative action occurs within the formless void that *precedes* the creation of space—Shu curbs demons, Yahweh subdues a watery chaos and creates heaven, earth, and light. Likewise, the analyst subdues his or her tendencies to dissociate, to withdraw into a stance of mental reflection and avoid an embodied presence. Most significantly, the analyst works to create an "inner space" by sensing and feeling and caring for his or her own, younger parts that are so frightened by the fields generated by the Fusional Complex.

Pre-scientific cultures considered the chaos that exists "before the Second Day" as both dangerous and the font of the creation of something essentially new. Some symbolized it as a mythical dragon with a jewel in its forehead that had to be extracted. The analyst, buffeted by painful feelings in this absence of a sense of space,[4] is called upon to seek out the mystery of this state. He or she must have the intention to lean into the field and experience the field's chaos, without imposing a premature order. In a sense, one allows the field, itself extending endlessly but also sensed as "in between" analyst and analysand, to be one's focus. Out of this suspended condition, both seeing and not seeing with one's ego, allowing perceptions to emerge, the analyst can begin to sort out opposites from their merged and undifferentiated state.

* * *

What is the nature of the non-ordinary perception that can open the analysand's field of perception to what is *there*? The rational-discursive form of consciousness, that great and hard-

won achievement of the last three hundred years, resulting in the capacity to see a human being growing through a developmental process, from intrauterine life and birth onward through well-defined stages, fails, alone, in creating such perception. I hasten to underscore the word *alone*, for such "developmental perspectives"—for example, a theory of early development[5]—must be combined with a non-ordinary form of perception,[6] so that together they form a perception that accords with the analysand's actual history.

The painter Marchand's words, quoted by Maurice Merleau-Ponty, tell us something of the nature of the required perception:

> In a forest, I have felt many times over that it was not I who looked at the forest. Some days I felt that the trees were looking at me, were speaking to me. . . . I was there, listening. . . . I think that the painter must be penetrated by the universe and not want to penetrate it.[7]

The analyst attempting to perceive the presence of the Fusional Complex must, analogous to the painter, allow him- or herself to be penetrated by the field that is enlivened with the analysand. The field is a "third area," like Marchand's forest, and a consciousness that is penetrated by the field while not primarily desiring to penetrate it (in order to extract information or create order) can find that essences are revealed, images that are worthy of recognition. In this way qualities of the field, such as the fusion-distance opposites, or images representing a "top-bottom" split in the analysand, can become known.[8] Such images are not gained in a continuous fashion as are perceptions gained through projective identification. Those "three-dimensional" frameworks, characteristic of the continuity of rational-perspectival forms of awareness, fail to "open the space of perception."

Many of the greatest poets, psychologists, and philosophers of

the last century have insisted upon the openness of a different kind of perception. One may recall Herman Melville's characterization of the sight of the whale, which, with its eyes on the side of its head, could see opposites simultaneously,[9] while humans are constrained to see one and then the other. Rainier Maria Rilke's lament for the lost openness of childhood vision is stated so beautifully in the Eighth of the *Duino Elegies*:

> With all its eyes the natural world looks out
> into the Open. Only *our* eyes are turned
> backward, and surround plant, animal, child
> like traps, and they emerge into their freedom.
> We know what is really out there only from
> the animal's gaze; for we take the very young
> child and force it around, so that it sees
> objects—not the Open, which is so
> deep in animals' faces. . . .[10]

We find the same longings in D. H. Lawrence and his critique of rationality. Artists throughout the last century have continued to tackle the same basic issue: the consciousness that largely developed during the Renaissance, while of great importance, has severe limits.

The new form of awareness is concrete, happening *now*, felt, seen, and known in the present. It does not derive from a step-by-step procedure, cutting the world up into parts, but rather lives within a sense of totality. What Jean Gebser called "*a*perspectival awareness" is an experience achieved through the ego contracting, loosening its hold, and joining the felt processes of the unconscious field between people. The transformed ego then can see through the vision of the unconscious (and this "vision" can actually be visual, auditory, kinesthetic, or emotional) that "light of nature" that was so much the focus of previous eras.[11] Through

this "light" one perceives the pure present; time is no longer divided into three phases of past, present, and future.[12] Gebser writes about an unnamed drawing of Picasso, from 1928:

> It is precisely integrality or wholeness [that is] expressed in Picasso's drawing, because for the first time, time itself has been incorporated into the representation. When we look at this drawing, we take in at one glance the whole man, perceiving not just one possible aspect, but simultaneously the front, the side, and the back. In sum, all of the various aspects are present at once. To state it in very general terms, we are spared both the need to walk around the human figure in time, in order to obtain a sequential view of the various aspects, and the need to synthesize or sum up these partial aspects, which can only be realized through our conceptualization. Previously, the "sheafing" of such various sectors of vision into a whole was possible only by the synthesizing recollection of successively viewed aspects, and consequently such "wholeness" had only an abstract quality.[13]

The awareness thus achieved is like an epiphany or revelation of what is *there*,[14] much like "the experience of the painter who lives in fascination. The actions most proper to him (seem) to emanate from the things themselves, like the patterns and the constellations."[15]

Merleau-Ponty says:

> Four centuries after the "solutions" of the Renaissance and three centuries after Descartes, depth is still new, and it insists on being sought, not "once in a lifetime" but all through life. . . . Depth [is] the experience [of] a global "locality"—everything in the same place at the same time,

a locality from which height, width, and depth are abstracted, of a voluminosity we express in a word when we say that a thing is *there*.[16]

In the *The Visible and the Invisible,* he writes of opening a new dimension that is not a

de facto invisible, like an object hidden behind another, and not an absolute invisible, which would have nothing to do with the visible. Rather it is the invisible *of* this world, that which inhabits this world, sustains it, and renders it visible, its own and interior possibility, the Being of this being.[17]

He further notes that "Paul Klee said the line no longer imitates the visible; it 'renders visible'; it is the blueprint of a genesis of things to come."[18] The "line" may correspond to observable patterns of behavior that, through aperspectival perception, render visible what is normally unseen. Thus levels of trauma and abuse that are hidden in an analysand's manifest recollections and behaviors may be "rendered visible" in the analytic process.

Through the field one sees in an idiosyncratic way, and if one has been penetrated by the field's energies, one's "vision" is very often meaningful to the analysand. There is a circulation between penetrating (the field) and being penetrated (by the field). This reversibility is, for Merleau-Ponty, "the ultimate truth [that] enables and calls for the circulation of Being."[19]

* * *

The aperspectival approach appears to be emerging in the collective consciousness, rendering it more generally available than it was, say, a hundred years ago. The new form of awareness is found

in the work of a number of creative psychotherapists.[20] It is also a remarkable and not uncommon experience to witness an analyst presenting a case to a supervision group, and for the group members to "read the field" and access depths of the analyst's and the analysand's psyche, aspects of which the presenting analyst had had little or no awareness. Yet this information was latent in the field that the analyst transmitted into the group process. Even more remarkably, the analysand often makes changes, on his or her own, before the next therapy session, as though he or she had been present during the supervision session.

Yet in teaching about non-ordinary forms of perception I often meet with what I think is a collective form of resistance: people are often frightened to believe in what they see because they expect ridicule at the hands of the rationalist. This is the first level of resistance. The second level lies in the analyst working with his or her visual image, or body sense, or inner voice, or feeling state that fleetingly appears in awareness, and seems unrelated to anything he or she knows about the analysand. These—what can be called potential perceptions—often push the boundaries of what the analyst has been taught in his or her training, and so they are readily discarded.

In group supervisory sessions, I have stopped presentations to ask the group, "What did you hear?" Rarely does anyone answer, until I urge the group to listen carefully and have the person presenting repeat what he or she has just said. It's as though people often do not have ready access to their "inner hearing," which perceives an odd quality in a statement, or to their "nose," which smells out something not right with what has been said. They often need help to recover their subtle, perceptive faculties, which operate on a nonrational level.

Whether discussing perception through vision, affect, hearing or kinesthetic sense, I generally meet with questions such as "How do you perceive that way?" Or "Why should I trust such images;

why aren't they idiosyncratic aspects that have no real value?" Or "I feel narcissistic in assuming my images have any importance." Yet, though the analyst may consciously refuse to grant any importance to his or her fleeting, non-ordinary perceptions, such perceptions will often inwardly and uncomfortably persist. Furthermore, analysts will often refrain from mentioning such experiences in case seminars because they don't want to seem crazy or risk ridicule or criticism for their "magical" attitude.

I generally approach this by suggesting that the analyst can choose to notice the perception *and* notice the tendency to deny it. On the one hand, he or she may glimpse the state that has been perceived. Then, on the other hand, he or she may find that awareness has shifted to the opposite of rational denial. If this apprehension of opposites is successful, the analyst is at the edge (in the biblical scheme of creation) of the Second Day.

Stories, such as myths that describe the proper relationship to the opposites, can help people deal with complicated opposite states of mind and body. One such myth, which I have dealt with in detail in my book *The Mystery of Human Relations*, is that of the fearsome sea god Sisiutl, told by the Kwakiutl Indians of the Pacific Northwest. Sisiutl is a terrifying, double-headed sea monster that contaminates anyone he touches; he rouses terror in anyone who sees him.

The myth essentially says: If you encounter Sisiutl, stand firmly rooted to the earth (i.e., stay connected to your body). Use any power words you know to avoid fleeing (into your mind), for that leads to a greater danger. Bite your tongue if you have to (i.e., don't prematurely speak to avoid your anxiety), but stand firm. Then watch how one head rises from the sea, and then, after it disappears, another head rises. As you stand firm, and see first one and then the other head, overcoming fear that would cause you to flee and dissociate from the experience, the myth says that the two heads will eventually turn and see one another. A great prize

comes out of that experience: One is granted vision from behind one's eyes.[21]

We can apply this myth to an analyst presenting a case in a supervisory session. He had been trying to be open to *seeing* with an analysand, he said, and something odd had happened. For an instant he had seen his analysand as having his head attached to his body only by a thin string. The analysand's head sort of bobbed about, and the body seemed lifeless. The analyst noted that the image created anxiety for him. As he shared it with us, several days after having seen the analysand, his anxiety was still palpable for everyone in the group to experience.

Rather than believe or discard the value of the image, the analyst needed to "see one of the heads of Sisiutl and then the other"—first the image that shocked him, and then his disbelief and rational rejection. When he respected *both* opposites, and held them through the sight of his unconscious (like Melville's metaphor of the whale), or, when this imaginal perception was impossible, he stayed in the field of the opposites and allowed himself to experience one and then the other, as a sequence—he began to discover the capacity to trust and further consider the meaning of his initial vision. It was as if he was being granted vision, as in the Sisiutl tale, vision that he could own, as a form or perception different from his rational model of knowing, and the momentary vision that developed in his practice, when he dared to make room for it, began to have an "otherness" worthy of respect and interest.

In this case, the vision of his analysand's barely attached head revealed a powerful form of mind-body splitting that in turn was a defense against psychosis. For with his vision the analyst also opened more to the field with his analysand, and began to perceive psychotic, i.e., chaotic levels that seemed to have no meaning. That was why the analyst had felt so anxious.

It later became clear that the analysand suffered from a strong

Fusional Complex. He was terrified of any separation; hence, as the analyst complained, there was no "progress" in the case. For the analysand, separation from any habitual behavior, destructive or otherwise, would have led to experiencing the psychotic process at the core of the Fusional Complex. It was only by moving into modes of perception beyond his normal, rational approaches that the analyst could begin to perceive and eventually name the Fusional Complex. That act of *naming*, akin to the magical action of gaining power over a demon by learning its name, but carried out through aperspectival, rather than magical awareness,[22] created the containment in the field that allowed the case to gain momentum and the analysand eventually to be able to risk the changes he had to make in his life. None of this seemed on the way to fruition until the analyst could own his vision, which is to say until he was granted it by suffering the opposites of perception and its rejection with his analysand.

In another example, an analysand who was a financial analyst was feeling ashamed for not having the energy to meet the demands of his new supervisor, and after telling me the details of his situation said, "I only blame myself." My mind blanked for a moment. Why did I feel blamed, I wondered. Was this just my own complex of feeling blamed? Perhaps so, but something else seemed involved. I went back to the statement "I only blame myself." I tried to stay with it, and as I attempted to be clear about what I experienced I got nowhere. However, when I allowed myself to be less clear, and to hold the statement in between my consciousness and my unconsciousness, I intentionally allowed my experience to become more hidden.[23] I allowed the field between us to become my focus.

With patience and careful attention to my body-feelings, noting the meandering of my thoughts and imagination, something consolidating appeared out of the field, like an epiphany. Vaguely, opposites began to separate out: their contradictory nature

became somewhat more manifest, but not within a clear consciousness of "yours" or "mine," or of "inner" or "outer" life.

In such an "intentionally vague" state I again felt blamed, but then that vanished; instead, as I glanced at my analysand, I "saw" a person who felt ashamed, and the statement "I only blame myself" took the place of my feeling blamed. Then the sense of being blamed again appeared, to the exclusion of seeing his humiliation. From this, it made sense that his initial statement, "I only blame myself," carried the opposites "I only blame myself / I only blame you," and each was total and excluding of the other. I experienced the mind-disturbing effect of the logically impossible condition that both A and –A were simultaneously true.

If I was to help my analysand, I could not simply notice this in an intuitive leap and talk about the contradiction. Rather, I had to go through the stage of feeling confused, often painfully so, both physically and mentally.

Generally, in such an encounter one must take note of one's various attempts to deny that something odd is occurring, for the combined opposites yield the characteristic sense of strangeness created by psychotic areas of the mind. For example, one may notice tendencies to dissociate and to normalize the analysand's statement. Then one must manage an intentional act of leaning into the field with an embodied presence, becoming interested in the confusion and the contradictory quality that one barely perceives and prefers to avoid. This activity on the part of the analyst is an essential aspect of perception, and is in opposition to a rational-scientific approach, which would insist upon the world's reality separate from, and independent of, such subjectivity. The chaotic experience is itself the dimension that opens up to the kind of perceptions that are required.[24]

After the conscious suffering of the pain attendant to this Fusional Field, I could talk about the contradictory states to my analysand. Only then did my words or voice tone feel safe to him.

It seemed as though a container had been created in which he and I could see the opposites and could go deeper into the experience of them. Without my preliminary processing my words would have been of little consequence.

Whether space is experienced between an individual's conscious and unconscious or between one person and another, it is in this space that one can perceive and at least momentarily contain contradictions. One feels and senses the opposites. If one fights off the tendency to ignore this contradictory state or to dissociate from it, one can then experience the psychotic feature of the communication. The ability to think and connect is restored in the analyst and, in large steps forward or little by little, in the analysand.

* * *

The following example further illuminates the subtle play of psychotic opposites when the Fusional Complex is organizing the field in relationships. An analysand, Kevin, reported having had a very passionate evening with a woman he had been slowly getting to know; this was their first sexual experience. While they were in bed together, having made love, she said, "I like your masculine energy." Kevin told me he had felt somewhat jarred by this. He thought about what she had said and decided that, while she hardly knew much about his sexuality, she had intended to give him a compliment.

When Kevin reported the comment "I like your masculine energy," I felt something odd about the statement. When I look at it now, as I have written it, it seems perfectly normal, an open communication of the woman's feelings. The "oddness" of the statement does not communicate in a transcript, as though another dimension were foreclosed on the written page.[25] Psychotic qualities, which can appear as opposites that annihilate

each other as well as one's capacity to think and reflect—one's ego-functioning—have the capacity to break through structures of repression and manifest in the field with a potency that other psychic contents do not possess. This is expressed in a sense of strangeness in the field.

My own perception was enhanced or focused by the field between us, which I felt might have contained responses Kevin had disowned when he heard the comment. One never knows if such a feeling is correct. Thinking about it rationally can easily cause the entire enterprise to evaporate. Paradoxically, one has to suspend the poison of such reason, and allow it to become the best of a science that will eventually test, as much as possible, the outcome of such imaginal acts—their truth-value for the analysand. In the meanwhile one must believe in them.[26]

Inquiring further about what he had felt when his date said she liked his masculine energy, Kevin said he could remember feeling that it was an odd thing to say, that he didn't quite believe her. At first he said this feeling stemmed from his belief that she really didn't know him well enough to say such a thing so soon. However, this was only one of his many attempts to give a rational explanation for something he felt that was not rational, namely a sense of an odd or strange quality to her statement.

Feeling a hazy, unclear quality or dissociation in my own thoughts and in how I perceived what he said, I encouraged Kevin to delve more deeply into how he felt, especially his body-feelings. As he did so, he began to sense opposites in what his date had said. He felt that "I like your masculine energy" was opposed by a contrary statement, something like "And there are a lot of things about men and ways they relate that I don't like." He refined this to the pair: "I like your masculine energy" / "There are things you might do, that I won't like." And finally: "I like it" / "I don't like it," where "it" now referred to his larger energies, many of which he hadn't begun to show her. By taking my own feeling of an odd quality in

the woman's statement as important, and penetrating into it, I helped Kevin gain the consciousness he needed to embrace the mad quality of her communication.[27]

Kevin suffers acutely from a Fusional Complex, and it is not surprising that he would need some help from my chthonic energy (leaning into the field in an embodied way), which would not be distracted by his defenses, in order to engage the necessary energy and structure to deal with such interactions. If he fails to so engage, he will begin a new relationship with a serious deficit, for he will have internalized a vague injunction not to be himself, but to always filter what he does and feels through some concern for what his partner approves or disapproves.

The Fusional Complex could be seen as a structure that was organizing the field between Kevin and his date, and then between us as well. He did not have the strength, at the time, to distinguish himself from the field and take his own perceptions seriously. He felt an injunction to not do this, and instead remained merged in the field. He would have had to trust his imagination and non-ordinary perceptions that he thoroughly believed his partner would deny. Beyond that, he would have to become aware of the nature of the Fusional Complex in the field between them and thus experience the terribly contradictory poles of his own deep fusional need and his simultaneous disconnection. In the following chapter the discovery of the Fusional Complex in relationships is more fully examined.

3

UNCOVERING THE FUSIONAL COMPLEX

THE FUSIONAL COMPLEX, LIKE THE SYMBOLIC MERCURY OF the Renaissance alchemists—known for its hidden, deceptive ways, for its madness and nonrational operations, and for the great difficulty encountered in "fixing" or "coagulating" it in order to perceive it as existing in the here and now—flows through life in all its inner and outer forms. In a sense, the Fusional Complex is always hidden amidst more apparent forms—such as narcissistic, borderline, schizoid, psychosomatic, hysterical, or other disorders. The elusive Fusional Complex often exists within all of these and other diagnostic categories that psychotherapists treat, and perceiving it is the only way that the analysand is helped.[1] Our rational-discursive maps may deceive us and prevent us from seeing what is *there*.

The Fusional Complex is not the first thing I look for in trying to understand an interaction. Often, it is only after I've exhausted all other explanations that I realize that the Fusional Complex is at work but has escaped detection until now.

For example, a man came to his session "hung over," as he said, from the previous night's drinking. He did not usually drink too much, especially the night before coming to his therapy hour, and the circumstance of his drinking was puzzling to him.

He and his wife had been invited to a friend's birthday celebration:

We knew it might have been a problem. It always is with him, because there is something about him that is irresistible. It's hard to define, but it isn't only my wife and I who are so affected; everyone who knows him feels the same way. Our friends all joke about it. It seems we cannot say no to him and leave any meeting with him when we want to. I set midnight as my limit, and I didn't get home until three o'clock in the morning. I planned to have one or two drinks, and wound up drinking shots of tequila. I never do this, and my wife usually has great control when she says she won't drink, but even she drank too much. It's like he has an effect . . . he is mild and gracious, yet no one seems to be able to leave when they want to.

The friend clearly had a power to evoke something like a spell. I thought of the hypnotist Svengali in George du Maurier's novel *Trilby*, from which "a Svengali" has become the term for someone who completely dominates and controls another. As my analysand told more of the evening's events, and of his and his wife's bondage to the dinner table, I wondered if the man was somehow hypnotizing them all. Why was my analysand so susceptible to him? Such was the sequence of my thoughts. I was clearly grasping for explanations, but all of them failed in the face of the statement that everyone who knew this man said the same thing: it was impossible to separate from him or disappoint him by refusing an invitation. Everyone dreaded these invitations despite liking the man—for they all thought he was a loving and sensitive guy.

Feeling at a loss, I was tempted to ask the analysand about his dreams. Fortunately, my impulse wasn't too strong; my analysand was so puzzled and interested in why he was so affected by this person that I was able to refrain from straying, due to my growing anxiety, from the material at hand.

When I could finally consider the possibility of the Fusional Complex, I was able to mention it to my analysand because we had already worked with his Fusional Complex in recent sessions. I reminded him that if the situation with his friend were hiding a Fusional Complex, there would be a simultaneous and powerful sense of unrelatedness in the interaction.[2] My analysand replied, "That's one of the hardest things. Every time my wife and I are with him, *our* relationship goes flat. We seem to lose all connection to one another. And others say the same thing!"

Until I mentioned the Fusional Complex and its opposites, the analysand had not noted the peculiar absence of communication with his wife. Unbeknownst to me, and despite my resistance to staying with the material he had brought to his session, it became clear that he was in fact dealing with the same material that had formed the core of our analysis in the preceding weeks, while I had tended to take his tale of drinking too much as an escape from his process.

As is usually the case, naming the existence of the Fusional Complex, and reflecting upon its "impossible" mixture of opposites, freed the analysand from the sense of possession that had lingered from the previous evening. He could recognize the existence of the Fusional Complex as dominant during the evening, and in future times, focusing upon his own Complex, and silently naming it in the field with his friend, greatly reduced the hypnotic power of this person.

As always, such discoveries tend to go deeper. Analysis of this incident developed into exploration of *his* similar effect upon others, and beyond that, to discovering levels of trauma that had blocked the unfolding of his individuation process.

* * *

Generally, when the Fusional Complex is present and affecting

the field between analyst and analysand, there is a tendency for both people to organize this experience through more familiar concepts, or through a complicit dissociation. They both enter a hazy, trancelike state. If the analyst manages to point out the uncomfortable feeling they are both avoiding, the analysand usually knows exactly what is being talked about. Yet, until the analyst manages to *see*, both analyst and analysand go on as though the Fusional Complex did not exist.

I first met Kyle when he was forty-five years old. He had had over eight years of Freudian analysis, some of it four times a week, yet he had very few memories before he was ten years old. In his close relationships, Kyle had known only pain. He talked about the propensity to become severely dependent upon others, to feel lost in them, and at the same time to feel suffocated by the relationship. He couldn't embody himself and be present in any relationship, nor could he separate from the other's needs. Much of Kyle's life was spent in avoiding this "impossible" fusion state by retreating into his mind seeking a container for his thoughts and feelings.

The energy drain of a schizoid-like withdrawal dominated our sessions. Staying awake and focused was often difficult. Letting down whatever focus I had, in an effort to attain an embodied, imaginal mind-set, seemed only to court further dissociation into a trancelike state. At these times I was unable to reflect upon the existence of the Fusional Complex. In retrospect, it existed in my fusion with Kyle's hazy, withdrawn state—as though we were both bewitched—and in my difficulty in relating to much of what he said.

This took various forms, but its most obvious manifestation was in my forgetting several important experiences he had told me about, something that greatly annoyed him but which he took as part of the "endless misery of analysis." These failures surprised me, for I rarely experience such memory lapses. Nevertheless, with such symptoms of the Fusional Complex in plain sight—perhaps

someone supervising my case would have clearly seen them—I lacked the capacity to perceive its existence in the here and now of the therapy process. In every session it took an extreme effort to organize my thoughts and gather up an awareness of Kyle's psychic state and the ways in which it related to his maternal and paternal experience, as well as to the transference process.

I don't know why, but the session I will now describe was different from all the others; my imagination was more alive and I could focus upon the tangible nature of the energies between us. In our work together, Kyle was becoming aware of the ways in which his life seemed to have played out according to the agendas of other people—first his rage-filled mother and narcissistic father, then his wives and bosses. In this session, he wondered whether he would ever feel an inner sense of having a self. We had spoken about the self before, usually from dream images, but these discussions seemed purely intellectual and of little consequence to Kyle. Now his question seemed to reach out toward me, but I could also feel his expectation that I would avoid it. I did not let his question slip away.

Instead, I explained that it wasn't that he had no self, but that his self was not embodied or activated in his space-time existence. When the self enters space-time life, I told him, it passes through a complex state, characterized by the paradoxical condition of neither being able to join with another person nor to separate from him or her. As I said this I carefully watched to see if he dissociated, or became only intellectually interested in what I was saying. He did neither, but listened carefully, as though he felt I was making sense.

Then I began to see our connection in a totally new way, and to enter into a different relationship to the field between us—now not receiving insights only from a mental-spiritual level, from what Jung called the *psychic unconscious*, but instead allowing my awareness to shift more toward my body and away from anything

mental. I felt in my body as though my consciousness slid along a spectrum, beginning with a mental-spiritual vantage point and moving toward the body and the *somatic unconscious*.[3]

Moving toward the somatic unconscious with Kyle opened both of us to experiencing the field through aperspectival awareness, in distinction to the mental-perspectival form of consciousness that I had previously felt to be my only option for relating to him. In this newly embodied state, and seeing *through my eyes* rather than with them, like an epiphany—not trying to see anything, but being penetrated by the field—I *saw* that strands of a nearly physical nature were coming from Kyle, very hesitantly, reaching toward me.

A few moments later, I found myself abruptly shifting from this body-centered state and moving more toward my mind and rational awareness. Where previously we had been *in* the field and subject to its dynamics, now we had oscillated to being subjects, as though we were now perceiving from the *surface* of a containing field. I could sense that Kyle and I were mentally relating, but the connection was tenuous. (In the past we had experienced only a marginal mental connection, as a schizoid state of extreme psychic distance and non-relatedness dominated our interactions.)

While our mental link existed, the potential to experience the body-oriented state left. The connection could no longer be sensed, only remembered and talked about. Similarly, when connecting through the somatic unconscious, I could not simultaneously reflect from a mental-spiritual point of view, or through the psychic unconscious. I could sense the growing contact of Kyle's subtle body as it tentatively reached toward me, and I could *remember* the nature of our more psychic or mental connection, but I could not experience it.

In the mathematical discipline of topology there is an image known as a Klein bottle (a surface with no distinction between its inside and outside surfaces, first described in 1882 by the German

mathematician Felix Klein), that captures and reveals these oscil-lating opposites. Steven Rosen has shown that the mysterious alchemical vessel, the *vas hermeticum*, is topologically equivalent to the Klein bottle.[4]

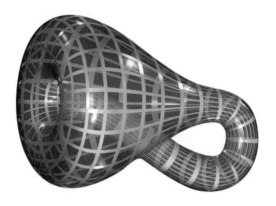

Figure 2. Klein bottle
Courtesy of Jeff Beall and Thomas Banchoff at Brown University

If one were to imagine walking along the inside of the bottle, eventually one would find oneself on its outside. Similarly, in the consultation room, Kyle and I could be *in it*, together, and then *on its surface*, looking at forms of our mental connection. When we were *in* the field we were *its* objects, experiencing a sense of Oneness that gave rise to perceptions that appeared like epipha-nies. From this vantage point—"in the bottle"—what had been felt as psychic connections, or various degrees of relatedness, ceased to be perceptions in the here and now and became memo-ries. When on the surface, so to speak, the mental connection was more palpable, and the somatic link was only a memory.

This movement is not continuous. There is a discontinuity between the "outside" and the "inside" of the Klein bottle. As Steven Rosen remarks, some mathematicians have assumed a

higher, four-dimensional nature to the Klein bottle, and Rosen daringly posits an understanding of this extra "dimension" that includes human subjectivity and thoroughly reflects my experiences with the field's topology.[5] For example, I had to consciously lean into the field with Kyle, and in that action break into a different quality of space. Likewise, the Klein bottle has to break into itself to be constructed; hence the discontinuity. This action is often felt as taboo, much like Jung's understanding of the incest taboo as a prohibition against entering the unconscious. I mention this because I have found this quality of taboo to be the source of resistance to consciously owning the chthonic energy necessary for penetrating the field.

When we configure our experience of the fusion-distance opposites through the duck-rabbit image, we will also obtain a discontinuous sequence of states—first a fusional experience, then a separation—both with varying degrees of intensity. However, these states are mental, perceived through the psychic unconscious. In contrast, when we experience the field of the Klein bottle that accompanies the Fusional Complex, we experience a container for the opposites of fusion and distance, which includes the bodily dimension of the somatic unconscious. This is a useful way of considering the fourth dimension mentioned above.

Kyle noted that the two experiences were totally contradictory. When he felt the subtle sensate link there was no mental connection, and when he felt a mental connection there was no "physical" linkage. Yet both were present. At any time, if one of us asked, "Are we connected?" the answer was yes, but then at the same time it was no. The situation captures the "true contradictories"[6] of the experience.

Kyle responded to this field experience with a solidity I had rarely known in him. He immediately could reflect upon many of his relationships in which a "person got too quickly and totally involved, when I allowed myself to come toward her in this

sensate-like way," or when a person would sense his movement, "and he would instantly vanish." His mother fit the first category, and his father the second; and numerous other people—his two previous wives, his friends and his children—easily fell into one or the other, wanting to "eat me," as he said, "or totally abandoning me." What is remarkable is that Kyle knew exactly what I meant by his subtle fibers reaching out, or withdrawing in fear, and he could freely give these examples, which would never have been forthcoming if my own perception had not led the way.

Kyle's conscious engagement of the Fusional Complex during that session led to a period of disorder and chaos. One source of this was his mother's madness. As a child Kyle had been terrorized by his mother's psychotic anxiety, which he had defended against by incorporating it, unconsciously swallowing it whole, so that it lived on in him as something of a foreign object. It would appear, in sessions and in his outer life, as a violent shaking of his entire body. Imaginally perceiving his mother's uncontained and invasive anxiety now acted like an exorcism, and in this sense his conscious suffering of these states now was like expelling the madness.

The other aspect of the disorder Kyle began to experience was a result of the entrance of his self into space-time. This process always engenders disorder, often felt as non-containment, a "falling through," or even being pulled, into nothingness. As numerous myths of creation tell us, the hero bringing a new form of order into space and time results in a strong counterattack of disorder—or the god who creates order also creates disorder.[7] The disorder "clothes itself" in many forms of the shadow, notably an internal, powerful rage or violence, or envy. Suffering the disorder is functional: it breaks down body armoring, so that the self can embody.

Kyle had known this level of archetypal rage (that is, a rage that is much larger than the ego) before, in a dangerously destructive form. On one occasion, after he had physically attacked his wife,

Kyle had attempted suicide. Now developing some awareness and experience of this rage without acting on it became the key to gaining the strength to keep from fusing with objects that no longer served Kyle's individuation needs.

Experiencing his Fusional Complex led, as it so frequently does, to an unfolding of Kyle's individuation process, which had been dormant for much of his life.[8] A growing self, seen in dreams as a new child that he saved from dangerous situations, or as an unknown, powerful man, was forming. In turn, the field between us was gradually less dominated by dissociation and despair. Schizoid withdrawal ceased to be his main form of operation. Energy drain in the field between us greatly diminished.

As Kyle began to realize the extent of his mother's psychotic anxiety and how it had so ruled his own life, he understood that much of the anxiety from which he suffered was not his own. In a remarkable change he could exclaim, "I am not my mother. I don't have to be afraid of everything." For the first time in his life Kyle was moved not by a set of rigid, superego opinions, but by something inwardly authentic.

* * *

The *prima materia* for Kyle's process lay in perceiving the opposites in the Fusional Complex organizing the field between us. The Renaissance alchemists speak of the transformative power of a single drop of their *elixir*. Similarly, in a number of cases over the last ten years, I have witnessed the transformative power of a single session in which the Fusional Complex is seen and identified, and one's relationship to it consequently changed.[9]

One such example involved a fifty-year-old man we will call Norman. He had a girlfriend who for years was a continual disappointment to him. It was jarring to witness his rage and contempt for her. Norman himself would often be surprised at his relentless

and venomous portrayals of her. Still, he went to extremes in our sessions to justify his attitude through examples of "how awful she was." His apparent delight in "exposing" her "incompetent behavior" was totally out of character for him. His ruthlessness was unique to this relationship, as was his callousness in continually using his girlfriend for errands and domestic chores, as though she were, to use his term, "a maid."

Norman was frightened of the "bad karma" he was creating. He knew his behavior was ethically and spiritually wrong, but he could not stop himself. He was out of control. Week after week I heard him complain about his girlfriend, and was amazed at how no interpretation of what he was projecting onto her, such as his own feelings of inferiority and incompetence, had any effect, save for a moment's interruption in his glee at disparaging her.

I did my best to interpret Norman's attacks on this woman as a displacement of negative feelings toward me. It was so clear to me that he was involved in a strong negative transference in which I, as well as his girlfriend, stood for the incompetent mother he still secretly idealized and also hated. Yet, no matter how much time and effort were spent upon trying to lead him back to a perception of his early abandonment experiences with his mother, Norman would always pick out some way his mother was "at least intelligent," or "at least held the family together," to distance her from his girlfriend and from my interpretation.

My insights usually followed from issues raised by Norman's dreams, which gave me the impression that they might help us understand his attitude in the relationship. However, all of my attempts seemed to lose their value for him after a few moments of reflection. Though during those moments he could see that these dream-founded insights were true, the next session always found him back in an attack mode, as if our discussion had never even happened.

Generally, Norman was not an unconscious person. He was a

popular and extremely gifted psychotherapist with twenty years of experience. When Norman was with his analysands he had a safe, containing space in which his considerable empathy and intuitive gifts could function. Through his work, he was quite familiar with notions of an "inner child," or a young part of his soul, that in his case had extremely negative feelings toward women. I urged the adult part of Norman to relate to the child part as if to an analysand in great pain. In sessions I perceived a "child" within him, about six years old; but Norman could not relate to the "child" on his own. He could only report the truth of his experience: when he tried to relate to the child, he *became* the child.[10]

After several years of attacking his girlfriend in sessions, one day Norman brought up a problem with an analysand. As I inquired about how he experienced her, it was clear that a severe state of fusion was dominating their interaction. He reported feeling that the analysand wanted to "totally stick to him," that he was choking and had no space of his own.

As Norman continued to describe his reactions I had a new insight. Just as his analysand revealed aspects of a strong Fusional Complex, Norman's girlfriend was deeply captured by her own Fusional Complex, unable to function as a separate self, always clinging to his every word and wanting to be physically close, but at the same time completely unrelated and distant. At such times Norman felt repulsed by her touch. "Enslaved to him," as he contemptuously described her, she could be mute, totally unable to bring anything of her own, such as a thought, into reality. She insisted that she only wanted to be with him, yet she never invited him into her apartment; there were also numerous other contradictions in her behavior.

Norman saw that he was most terrified of what he sensed to be a deep core of madness and rage in both his girlfriend and his analysand. He also realized that his fear of being contaminated by

what he felt to be his girlfriend's madness recalled an early experience he had had of his own mother. We seemed to be approaching bedrock: his girlfriend's Fusional Complex repulsed him, and he had to belittle her because he was afraid of her, just as he experienced and feared his mother. Knowing this, perhaps he would be able to change his behavior.

No such luck. The next session Norman was back in high gear with tales of how "terrible" his girlfriend was, especially focusing, as he often did, upon her "stupidity" as a lawyer. He claimed to know more about the law than she knew; yet she had credentials Norman lacked. This led to yet another avenue of approach. While his girlfriend was a prominent lawyer, he had no legal certification as a therapist, and thus in his view she was more collectively accepted than he was. When he met her, he had believed that the relationship would result in his greater acceptance in their social world. Important dreams further illustrated how desperately Norman wanted to be accepted. Through them we began to uncover intense levels of envy of which he was ashamed. But there was still no letup in the barrage against his girlfriend.

Several months passed, with Norman's attacks continuing with all the vigor of a grievance aired for the first time. Then, and for reasons I cannot rationally understand, I began to see Norman differently. I perceived subtle fibers reaching toward me and connecting us. Unlike the pleasant, near-union state I felt with Kyle, however, the field with Norman felt uncomfortable, as though it was not only connecting us but drawing my energy toward him in a way that felt sticky and slightly dangerous. It seemed that the sole purpose of this subtle link was to attach to me, not to be a pathway for a mutual flow of energy.

I could sense a field with Norman that we were both *in*. At first, we were the field's objects. Then, as we oscillated to being subjects, I perceived a very thin mental link in which we were far less connected. I felt like we were talking to each other over the Grand

Canyon, whereas before I had glimpsed the fusion-distance opposites I had thought we were better related.

I told Norman my experience, much as I had described the similar state with Kyle. And as with Kyle, and with any analysand I have encountered at these levels through such hard-won perception, Norman corroborated the simultaneity of a kind of subtle, sensate linking and a mental disconnect. This state was *there*, a quality between us, *seen*.

In the next few moments, Norman's relationship with his girlfriend gained a new transparency. He realized that the state he knew with me was the same condition that he experienced with his girlfriend.

Our next meeting was two weeks later, and for the first time Norman did not mention his girlfriend. Near the end of the session I noted this and asked him why. The only explanation that made sense, he said, was that the last session had had a strong effect. There were slight residues of his contempt for his girlfriend, indicative of levels of envy that would have to be encountered. However, the change was dramatic; he had begun to feel compassion for his girlfriend, and his contempt eventually vanished.

Why does such an experience have so powerful an effect? *Naming* the condition, as it exists in the here and now, seems to have a power far beyond any interpretation or otherwise achieved insight, much as someone can be affected by having a powerful vision. This act of naming must be an observation of experiences apprehended within the geometry of the four-dimensional field. Before one can make a statement to the analysand such as "I feel totally connected and even merged with you, but then I have no connection with you at all," the oscillating nature of the field must be palpable, so that the analyst can experience being enclosed, so to speak, with the analysand in a field characterized by the geometry of the Klein bottle. Otherwise, the statement will be experienced as a judgment, not as something both people are in

together. Only this palpable realization of a mutual field quality has a creative potential.

* * *

Often the Fusional Complex can largely reside in an inner, childlike part of the person. This was especially the case in my work with Elaine, which resulted in a remarkable transformation in the capacity for separation in relationships, and in the manifestation of the self, all accomplished through perceiving the presence of the Fusional Complex.

We initially focused upon Elaine's avoidance of deep-seated negative feelings toward her mother, feelings that seemed to stem from her mother's preoccupation with appearances, but especially from double-bind messages. In one example, Elaine at four years of age was told to play outside after it had rained and the streets were muddy. Her mother dressed her in white and told her to not get any dirt on her shoes or clothes. When Elaine first told me this, she was so dissociated—a typical defense against such mind-destroying messages—that she simply thought her mother cared about how she looked.

I only discovered Elaine's Fusional Complex after I had been seeing her for twenty-five years. The occasion that finally opened my perception to its existence was the imminence of her mother's death. She felt the impending loss and talked about feeling love for her mother. With sadness that seemed sincere and measured— "Mother was difficult, but was always there for me"—she recalled a fantasy from the previous day in which she had imagined herself as a young girl. As she related the fantasy, she seemed to become the child, breaking into loud sobs and convulsive movements. She then managed to separate from this inner, childlike state, and returned to a more adult status, but this oscillation repeated several more times.

I thought of Elaine's grief and love as expected reactions, no matter how difficult her relationship with her mother had been. Yet I also sensed that I was "normalizing" her behavior, for there was an odd quality to the sudden and explosive nature of her emotion, and to the way in which it abruptly settled down and she returned to being her adult self.

I asked again about "the child," and after another paroxysm Elaine was jolted by a further memory from the previous day. For she recalled that in the fantasy the child had felt "totally glued," as she said, to her mother. She had never used this image before, and we had never spoken about such deeply fused states, for they seemed totally absent in her maternal relationship, and I had never perceived them between us.

Several days later, to further explore the intense "glued state," Elaine tried to return to the fantasy of the child. However, "the child would not talk. It was like the child was totally cut off from me and lived in a glass container."

This child part of Elaine's psyche was a new and unexpected discovery of a deep and hidden truth of her maternal relationship. In her experiences with the image of the child, we see the lack of space between subject and object, and also a totally cut-off condition, with no verbal communication possible. (The opposites in Elaine's Fusional Complex were displayed at this stage as a sequence of states, the awareness of which was useful to me in indicating the existence of the Complex. But such awareness is generally not transformative for the analysand, as is the perception of the opposites existing simultaneously, which Elaine later experienced.)

Before she discovered the child in the fantasy, Elaine was completely in denial of her own anger at her mother, and employed peculiar, collective pronouncements such as "one should love one's mother." These statements sounded strange and jarring, not as if Elaine believed deeply in the Ten Commandments, but as if

she was identifying with a slogan that she hadn't thought about, let alone applied to her own life, and using the words to expel feelings rather than to communicate. It was only after Elaine was able to see this child part of her psyche in its attachment to her mother that she could begin to have feelings about her mother that were heartfelt.

In the next session, Elaine told me something new about her fantasy of the child being "stuck" to her mother. When she saw this image, she said, her adult self felt attached to her mother, and felt a strong desire to separate, but this was difficult, and for some moments she felt a very uncomfortable condition of being simultaneously "stuck" to her mother but emotionally and mentally disconnected from her. When I asked her about not having originally reported this part of her fantasy experience, she could only reply, "It felt bad, I didn't like the feeling." Her major focus had been on "getting rid" of bad feelings, rather than containing and focusing upon them—but this now began to change.

There was a transformative quality to this discovery of her Fusional Complex, much like the changes that occurred in Norman. Elaine's relationship to her mother changed. She could now accompany her mother to her death, not as an overwhelmed child, but as a sorrowing adult woman who cherished her mother as a source of strength in her life as well as suffering.

Elaine then reported an incident that she found remarkable: A homeless woman had approached her on the street and asked for help in dealing with a problem. Elaine reported that for the first time in her life, she had been able to say no. She emphasized that this was a totally new act. She had never demonstrated this capacity for separation from anyone in her entire life. Elaine was eighty years old at the time, and her mother died at the age of one hundred and three.

It is extremely common, as with Elaine, to find the Fusional Complex hidden away within a person's psyche (here as an inner

child-part), and creating symptoms that seem intractable, while itself remaining all but invisible to any form of perception. The levels of confusion and mad opposites that permeate the field with analysands like Elaine seem to preclude its perception until a moment in which, like an epiphany, the strange opposite states of fusion and distance can be glimpsed.

Characteristically, such explorations also led to the recovery of memories. For example, Elaine remembered how the dynamics of the "stuck" and unrelated condition always created a terrible feeling whenever she was with her mother. That is to say, she could now sufficiently contain and be conscious of feelings of pain at being with her mother, and of neither being able to separate from her mother nor be connected to her.

Now, for the first time in my work with Elaine, spanning a period of over twenty-five years, I began to experience her as related to me, rather than wanting her "bad feelings" taken away amidst only fleeting moments of connection. Her psychotic process was diminishing, and a sense of a person was emerging, finally, even at the age of eighty-three.

* * *

Uncovering the Fusional Complex is the beginning of the energizing of an individuation process that urges the integration of previously unconscious material, or engages a long-denied creativity issue or conflicts in relationship, or the fear of embodiment, or a phase of work in the transference relationship. In Elaine's case, the focus moved toward the transference and other object relations. Norman was faced with finally feeling his distinctness from his girlfriend. As is often the case, there were several regressions into Fusional Fields with her, accompanied by remnants of his old complaints, until he finally gained the courage to make the leap toward embodiment. This included experiencing

anxieties that the fusional world and his projections had masked. Finally, Kyle became conscious of having incorporated his mother's anxiety, and the transference relationship became a vehicle for the unfolding of his individuation process. In all instances, the self was enlivened in a new way, leading to a living and tangible sense of having an identity and a process in relationship to the unconscious.

Many oscillations, between progression into new attitudes and behavior, and regression back into the restricted domain of the Fusional Complex, seem to accompany this journey, even to be an essential part of it. Appreciating the mystery of the emerging self through this process is becoming essential, for the Fusional Complex nowadays is ubiquitous.

4

UBIQUITOUSNESS

AFTER TEN YEARS OF INTENSE EFFORT, A WOMAN FINALLY finished writing a book. However, she could not manage to write a five-page proposal for her agent; every effort became a dispiriting ordeal. Whenever friends asked her about the book, she was ashamed and confused at not being able to clearly and succinctly say what the book was about, sometimes even becoming mute. She worried that she was losing her memory.

I was familiar with her book and spoke to her about the importance of its central theme, hoping that would jump-start her ability to think. She responded, "Yes, but that's not the main point. The point is that my inability to talk about the book is the same way I feel about trying to talk to you now—unable to think and say anything—and that I have often felt that way."

Her response helped me shift to another level of engagement; my effort to help had really represented a compulsive search for a familiar solution, for some relief from my own discomfort with the conversation. From this reflection I gained some distance and could begin to see that my analysand was so deeply fused with her own book that she had no capability of reflecting upon what she had written. It was all a blur to her, and all her attempts dissolved, as any mental containment she could muster seemed to fragment. She could not even remember what she had just said to me about being unable to think and say anything.

When I could finally experience the fusional pull toward the analysand (as in my compulsion to say what the book was about) and my simultaneous lack of relatedness to her (seen in her reaction to what I said), I realized the presence of the Fusional Complex as it was enlivened between us and with her book. The Complex, having been perceived between us in the here and now, could be named, and she was released from her agony. After several days she gained a new equilibrium in which her book became an "object" that she could think about. She then had little difficulty saying what the book was about.

The Fusional Complex can mask itself as a determining factor in many such humiliating difficulties. In this example, the writer and I had long before wrestled with her Fusional Complex, and so a relatively minor struggle was all that was needed to establish its existence.

Several years after the experiences I recorded in Chapter Three, the analysand I referred to as Elaine interviewed an interior decorator to help with the furnishing of her home. The decorator told Elaine she had a contractor who was especially good at finding and installing wallpaper. Elaine paid the decorator her consultation fee but decided not to further use her, for, as she explained, "the feeling between us did not feel right." However, Elaine then found herself in a terrible and painful conflict. Was it right to call the contractor the decorator had recommended, even though she was not going to further use the decorator? Was this ethical?

After several sessions spent agonizing over what seemed so obvious—she had paid for the consult, so what was the problem?—Elaine could finally be clear about what she was feeling:

> I'm intensely anxious, deeply in my core. I feel stuck to the decorator, totally committed and responsible for using her services, even though I have paid her and I have no further

commitment. To call the contractor on my own feels overwhelming, like I'll fall in a deep hole or dissolve unless I also include the interior decorator. After all, she gave me the reference.

Exasperated by the absurdity of Elaine's situation, I managed to curtail several outbursts exhorting her to be realistic before I realized that her Fusional Complex was activated. "That's it," she immediately felt; something clicked inside her, like "pieces of a puzzle falling into place." The decorator had become her mother whom she could neither stay with nor separate from.

The Fusional Complex does not disappear. Rather, it can lose energy and become dormant, and then arise again at a later time. Then seeing it, and naming it, becomes the act that allows for separation.

* * *

The Fusional Complex underpins a variety of situations. For example, it is always a major factor in addictions. Generally, addiction is a way of fusing with an object, whether a drug or a behavior such as gambling or sexual addiction, and distancing from the real object of desire, usually fantasies of a soothing, maternal body. The addictive behavior is a way to temporarily feel some respite from the agony of the "impossible" opposites in which one can neither stay with the desire for fusion with a soothing object, nor separate from it. One man who was trying to stop smoking said, "I'm disgusted by smoking and I can't leave it." The addict is in an *agony* of consciousness. *He cannot be soothed.*

The workings of the Fusional Complex are operative in the following reflections of a man in recovery from addictions to smoking and alcohol:

I go to my wife for a fix, something to soothe me; a hit of love will do, but I also want more—ecstasy, something transporting. But without that, at least love satisfies for a while. Then I can step back, until the next time. But if I can't get the fix I'm frantic and I go into my mind like a searchlight, looking, looking, my whole body is in pain, a pain I avoid as best I can by using my mind. Where is she? I see nothing but danger, an impenetrable forest, and I keep looking, until there is an opening, perhaps coming from her. Then another fix and I'm safe again, for a time. At the worst, I feel both a distant, unsatisfied searching— through my mind—and at the same time a desperate reaching from my body, in a way that both tries to feel her and tries to withdraw from rejection or disappointment. I can oscillate between my mind and body states, some-times rapidly, but the fragmentation I feel is too painful and I have to split away by hating her or by jumping into some activity without her.

The compulsive and dysfunctional pattern known as codepen-dency, which has become a widely used term in our culture of twelve-step programs and their complementary groups (such as Al-Anon, for the friends and family members of the addicted per-son), can be seen as a clear example of the working of the Fusional Complex. The addict and the enabling person share an intense fusional state with little or no relatedness. For while the codependent's behaviors can be filled with love, or with anger and deeply felt experiences of betrayal, there is little actual, conscious relatedness between the addict and the codependent partner. If there were, it would become clear that the addiction was being enabled because of a great resistance to leaving the fusional sphere of the Complex.

The extreme fear of separation created by the Fusional

Complex fuels the dysfunctional, codependent behavior, while masking it in illusions of a selfless love. For this reason, the antidote of "tough love" is widely taught as the only way to break the codependent state. The importance of group support in such behavioral changes is a measure of the intensity of separation anxiety that accompanies any departure from the fusional state. This anxiety is of the same magnitude as the psychotic anxiety that drives the madness of addiction.

When the Fusional Complex is enlivened, separation from a person or activity, indeed *change of any kind*—paying a new bill, opening a letter from some authority, saying how one feels, having a sexual desire that has one iota of personal relatedness to it rather than a compulsive, impersonal quality, filling out a form such as a tax return that would yield thousands of much-needed dollars—is felt as extremely anxiety-provoking. The slightest deviation from a terribly constricted "inner territory" that feels safe and warm can threaten the ego with the panic of being suddenly disorganized, or even the terror of vanishing altogether.[1]

Hence the Fusional Complex is often the cause of chronic behaviors such as a lack of focus or severe procrastination. Chronic difficulty in getting to appointments on time, or in ending meetings on time, can indicate the severe problems with mobilizing energy and overwhelming fears of separation that exist when the Fusional Complex is enlivened. People often speak of physically tensing up as such moments of separation approach, feeling humiliated by an inability to act, and watching minutes tick by as they miss yet another appointment.

Since one is simultaneously fused with objects and not related to them—not focused on their separate existence—the Fusional Complex can be the source of chronically losing things. Objects are not felt as *put* anywhere, because separate places don't exist. Papers, keys, clothing, and money can seem to disappear. Under

the effects of the Fusional Complex a person is subliminally threatened with a fall into nothingness, and in the moment, the person really believes the object is not only temporarily gone but will never be found. No amount of rationality helps, and the total belief in the loss of the object feels odd and disconcerting to anyone trying to be helpful.

Another example illustrative of the ubiquitous nature of the Fusional Complex, and the often impossible difficulties with separation it creates, is in cases of people who linger in graduate school, taking years beyond normal, leading to the state of ABD, "all but dissertation." Finishing the dissertation feels impossible, and depression, anxiety, compulsion, and dissociation often defend against the shame and humiliation accompanying the degradation of energy by the Fusional Complex.

The Fusional Complex can impede efforts to complete any creative project. For example, a man attempting to gain a tenured position in mathematics is kept on the faculty because he is recognized as exceptionally bright. Yet he can rarely finish a paper and publish it. He has many papers going at the same time. He finds links between the papers. Maybe they should become a book, he wonders. Preparing to submit a paper to a journal, he "somehow" erases it from his computer. Separation, meaning the capacity to have some semblance of a self, distinct from being fused with unconscious life and its expansive potential, is overwhelming for this man.

The entire drama is often played out on an inner level. That is, a person can feel bound to his or her unconscious feelings and fantasies, with no capacity to separate from them. These states are often desperate, such as a pull toward a deadened or chaotic inner state of incorporation[2] of depressed aspects of the mother—powerful psychic remnants of actual infant experience. Since separation from this state feels impossible, the person becomes trapped in passive defeat and withdrawal into soothing fantasies, or the

opposite: an incoherent rush toward mindless action that only leads to even more shame.

A person with a strong Fusional Complex rarely consciously, or through an act of will, leaves his or her constricted "territory"; he or she experiences a sudden drop in available energy with any attempt to initiate change. A man who often languishes in this condition said to me:

> Once I do something, I can do it forever. Doing it stops being a problem; it's beginning that's impossible, and I manage to "forget" about what I have to do in my daily life, like return phone calls, until I begin to drive to my appointment with you, and I then feel like a total wimp. Sometimes I'm too embarrassed to come.

So much shame accrues to potentials that cannot be actualized that many people in this man's situation remain painfully mute. Images of powerful people acting aggressively in the best sense— stepping forward in word and deed in ways felt as serving one's deepest values—fill the inner world of dream and fantasy. One may practice "what to do" in some situation over and over again in the secret confines of fantasy, yet, when reality strikes and action is required, one can barely state one's intentions, or suffers in awkward silence, betraying the inner calling yet again. These experiences can become so painful and recurrent as to create a very limited life, organized around protecting oneself from falling into intense shame. Yet compromises always fail; at times suicide beckons as the only way out of the agony.

This man feels excluded from the world of sexuality and aggression. Such qualities remain outside of him, beyond reach. "I want to be sexual with my wife," he insists. When he isn't with her he wants her, and she excites him in his fantasies during mastur-bation. However, when he's with her, he says, "I go away, I'm not

there, and I hate being this way." This state is often too painful to accept, and he retreats to a world of passive fantasy, "spacing out" from the inner burden he would otherwise feel.

All of this is painfully evident to him. His entire life has been ruled by knowing he has desires that he cannot actualize. Nor does he have the strength to be "in his body" and penetrate into the field between him and his wife—to dare to feel what he feels, or see what he sees.

For some time I blundered in dealing with the dreams of this analysand, for they often portrayed powerful men emerging from underground chambers, seemingly waiting for him to engage them, to "integrate" them into his more spiritual and mental ego. After all, why else would such imagery appear? So often we find the hero struggling with dark, primitive forces that he finally over-comes, then reaping the benefit of their strength. Wasn't this urge in him, and wouldn't exhorting him to take hold of his strength be therapeutic?

However, in the suffocating embrace of his Fusional Complex, such heroic impulses, which he so highly valued, not only failed to become real strength but only led to more humiliation. Over the course of several sessions I learned that suggesting he heroically overcome his fears and speak to his wife only added to his despair. It was possible that even thinking this way transmitted negatively in the field between us, so acute was his suffering and so sensitive was the field. Thinking in terms of the heroic was my own defense against experiencing his pain and my own.

At one point, when he could not confront one of his employ-ees who was not showing up for work, he dreamed of a person whom he thought of as masculine and capable of standing for himself. Still thinking along heroic lines, I urged him to consider that getting the work done was a goal that meant a great deal. Trying to tone down a pointed appeal to the heroic, I recast it by

suggesting that the proposed confrontation was not *against* the other person, but something *for* himself. Angrily, he replied, "That is exactly what I tell myself, over and over again. Yet I can't do it, and I only feel ashamed of myself." I was able to recognize at this point that his capacity to be angry with me gave a glimmer of hope that he could own his aggression. At least that much came out of my wrongheaded approach.

Several common types of dreams having to do with falling, or with motion being severely retarded, are organized by the Fusional Complex—for example an analysand's initial dream of walking backwards up a hill, trying to reach a bus and barely able to walk. Not only can the Fusional Complex of the dreamer be portrayed in dreams of falling, characteristic of a lack of a felt container, but someone other than the dream ego may be the one who falls, as when a woman dreamed she was walking with her husband, who suddenly fell through the pavement. This dream reflected the activity of the Fusional Complex in that the dreamer was in danger of suddenly losing any object relations. The complex can vary in strength; thus, another person dreamed of his partner falling into a hole, but only sinking up to her neck.

The Fusional Complex can create strange dream images that depict the sudden and humiliating way that useful energy is lost through this Complex when one tries to bring perceptions or creativity into space-time reality. Thus an analysand trying to write an article dreamed of body fluids draining out of his fingertips. Numerous chronic and seemingly intractable physical complaints are often somatizations resulting from the anxieties of the Fusional Complex. For instance, several men I have worked with have reported a history of sudden and inexplicable premature ejaculations that seem to run out without any orgasmic intensity, and triggered by the mildest touch or sexual interest.

The fusion dimension of the Fusional Complex can be repre-

sented in dreams and fantasies by a deep sexual attraction. A person may find these desires perplexing, since consciously he or she registers no sexual feelings for the person at all.

For example, a woman dreamt that she and her mother were in two rooms, separated by a door, and that her mother asked her to come into her bed, to which the woman replied, "If I do that, you know we will have sex." In the dream she felt sexual feelings toward her mother. In reality, it was all a puzzle, for this woman was far from shunning such thoughts or feelings, but they made no sense as far as the dream of her mother was concerned. Was this just an example of a powerful repression, wrought over many years of alienation from her mother?

I initially thought this might be the case, just as I have in other instances. However, what proved to be far more accurate was the awareness that the field between the woman and her inner maternal image was highly activated. Thus there was a strong fusional dimension, but at the same time one of distance and noncommunication. Hence there was no way for my analysand to associate conscious feelings with the physically erotic feelings toward her mother; the association did not exist. Rather than repression, she had to encounter the perplexing interplay of completely incompatible opposites of the Fusional Complex.

In another instance, an analysand realized that her sense of identity was very bound up with another woman because that person afforded a kind of "mirroring," an empathic reflection of her being, that was very deep and otherwise absent in other relationships in her life. Yet, along with the "creative times" she had with this woman, there were always arguments and her need to find distance. This gave the relationship a ragged and strange form. When the existence of the Fusional Complex became clear, the analysand could realize that her friend's sexual desires, which the analysand had no interest in engaging, were creating a powerful fusional

dimension that she put up with because of the mirroring she had been receiving.

What is special about discovering the Fusional Complex in such interactions is that the perception of the simultaneity of the incompatible opposites of fusion and distance—rather than acting this out temporally, in a series of "good" and "bad" intervals—creates a container for reflecting on the interaction. As is common when dealing with the Fusional Complex, the analysand did not discover this simultaneity on her own; rather, by virtue of information carried by the field, I perceived the perplexing fusion-distance opposites. This rang true to the analysand, allowing her to realize the extreme stress she was under as a result of her friend's fusional desires. Before this, she had only periodically been able break loose from the relationship to gain breathing room, and had never been able to feel her feelings until they became explosive.

When I next saw her she remembered what we had said, but during the week she had not been able to feel the Fusional Complex between her and her friend. She had not been able to perceive the simultaneity of the fusion-distance opposites, even though she had no doubt this was the ground for a true description of their interaction.

I then learned that the night after our session in which we discovered the Fusional Complex activated with her friend, the analysand had dreamt that a young child had an eye problem and was being successfully operated on. My analysand, a very sensitive woman, recognized that when she tried to perceive the opposites in the fusional field, *she became like a traumatized child.* She lost her sense of adulthood, and since the young part of her had to deny her vision (like so many people, she had gotten the message from her mother, very early on in her life, to not see things as they actually were), it fell to me to open the way to non-ordinary per-

ception. I took the dream to be a stage in the healing of this "programming," and the next phase to be the analysand's gradual capacity to perceive the Fusional Complex, and to relate to her inner child from the position of an adult.

* * *

In order to create a container to mine the essential value of the Complex, both people in a relationship must be willing and able to understand the maddening conflicts they experience as qualities of a field they both share—qualities that are not reducible to individual projections. This is not only key in relieving the torment of the Fusional Complex, but relationships in general, if they are to be more than economic arrangements, often either fail or thrive depending upon this willingness.

For example, John (see Chapter One) had a very telling dream after an interaction with his wife in which he lost emotional control:

> Military planes were towing large metal containers and were coming in for a landing. They dropped the containers, which held soldiers, and then the planes crashed. A man was with me and he was totally nonchalant, as if nothing was happening, while I was very anxious. A tall building was also in flames after the crash, and was destroyed.

The metal containers could be understood as the aggressive, warlike "container" that John employed in his relationship with his wife, a metaphor for the vigilant guarding of his needs and psychic space that helped him feel contained when strong emotions threatened to overwhelm him. John is very gentle and has a remarkable caring for all forms of life; one would hardly think at

first that he was so warlike. Yet this form of container was revealed by the dream, and it must crash. The person accompanying him could be a self-figure or perhaps a reference to me in the transference.

What could replace this warlike container? I suggested that John might wonder about ways in which the field dynamic between him and his wife was something she suffered as much as he did, and a pattern that was theirs, rather than experiencing what "she did to him" or "he did to her." In other words, was it possible to move the fusion-separation torment to another focus, the "in-between" world?

John reflected on this possibility, and on his mistrust of his wife:

> When I try to bring something to her attention, like the way she slams the door when she leaves the house and disturbs the neighbor, who complains about the noise, I expect nothing but attack. I expect her to erupt and insist that she has no space to just be, so it will be her experience that is at issue, not the door and our neighbor. I know I contribute this image—I've held it for years—and it may not be the way she would really react.

I noted that an unconscious dyad, separation and violent attack, seemed to rule the expected interaction. If John separated from his wife in expressing his concerns rather than hiding, he believed an attack would ensue. But whose attack was it? Could he be certain that it originated in his wife? In other words, might they share an unconscious dyad, so that separation, as a conscious action, led to extreme anxiety for either of them?

John realized that he "put it all on her," and in therapy he allowed himself to play out the side of his nature that was so frightened of his wife:

I can't bring a field idea of a mutual, third thing to her. I can't talk to her. She's problematic. It's going to be turned on me. She goes ballistic. I'll feel terribly frustrated. She'll only feel a need to be separate and have her own view respected. I'll wind up feeling angry and misunderstood.

As John "owned" this darker aspect of his nature, he began to see the possibility of having a shared reality with his wife. He also recognized his fears at giving up the power of his warlike defenses. If he and his wife could submit to the reality of the field as theirs, and give up the defense of blame, they would move toward love and union, rather than difference and aggression.

Reflecting upon his life with his wife, John knew this was his task. He could see that his worries about his wife's "brittleness" might be overblown. He could become more compassionate toward her, and especially toward himself. He could imagine becoming *for* her, not against her. "I know I have to distill out the poisonous aspect of my desire to live in power. I know I have to see her defensiveness as my own."

In fact, when John had the courage to trust his wife, he discovered a depth in her that he had never known. She could empathize with his terrible suffering and humiliation at being so "stuck" to her and simultaneously absent and unrelated, and saw similar patterns in her life with her father. In a couples session they had with me, she said, "If I have anything my father will destroy it." She had received the impression from her father's behavior that "any man is totally 'embedded in his mother,' but never in me." She believed, "There will never be a loving man in my story, never a man as my companion."

John's wife had fused with a terrible belief system, and was unable to separate from it. But only through their shared experience of the field as something they were both in, as well as outside of, seeing it as an "object," did they gain a container for their

Fusional Complex, and enable love to rule over hate, suspicion and a need for power.

* * *

Generally, the Fusional Complex is like the despised alchemical *prima materia*, said to be vile and worthless, ubiquitous and easily discarded, and yet essential for the creation of that most highly prized goal of the alchemical *opus*: the *lapis*, a symbol of the self. Like the *prima materia*, the Fusional Complex is found everywhere—in the intractable behaviors and rigid habits that secretly create a person's inviolate "safe territory," fortified by masochistic submissions that sacrifice essence and potential, in the dark corners of relationships that are fixed in old patterns and simmer in contempt and resentment, and in the array of the character disorders. When the Fusional Complex goes unseen, these disorders often do not transform. Any sense of essence and meaning stays trapped in treadmills of compulsions: narcissistic demands and disastrous needs to control other people; frantic searches for idealization; and doomed patterns that split people into different, contrasting selves and never see a whole, human person.

The Fusional Complex flits in and out of all these patterns, and we easily can be tricked into thinking that the behaviors in question, and the categories of diagnosis that dominate the rational-perspectival psychiatric world, are the essential matter of psychotherapy. Yet, unless we find a way to "coagulate" our easily fragmented perception of the fusion-distance opposites, we shall forever stay committed to interpreting or relating to rationally understandable states of mind, and eternally believe in the power of empathy.

However, when the Fusional Complex is "fixed," as the alchemists would say—engaged and sufficiently contained so that it ceases to appear and vanish, not coagulated "inside" or "outside"

a person, but in and through the creation of that higher-dimensional world so aptly portrayed as a Klein bottle, and, centuries before, by the alchemist's *vas hermeticum*[3]—then not only can the various rigid behavior patterns and character structures be far better dissolved, but the self, the core of the human being, can begin to blossom. Like an animal or person transformed into stone by a witch's spell in a fairy tale and then released from the enchantment, the self can enliven, and a previously disincarnated or suspended individuation process can begin to unfold.[4] The despised *prima materia* of the Fusional Complex then can be seen as not only a dangerous state but as the pathway to individuation.

Deeply hidden and vulnerable states of "mirroring needs" finally begin to emerge from impenetrable structures that never allowed this "grandiosity" to see the light of day;[5] the deep-seated hatred, envy, anger, and fears of the destructive power of such emotions begins to dissolve as a person "enters" a suffering of how his or her negativity affects others;[6] and, amidst numerous other symptoms of an "unfolding self," a person finally begins to know the self, not as an abstraction, but as a living reality that moves one out of the narrow confines of the ego and into a fullness of love, compassion, and mystery.

5

THE SOUL'S SUBTLE BODY: THE PROTECTIVE GARMENT OF THE INNER LIFE

AS A DEFENSE AGAINST THE "IMPOSSIBLE" FUSION-DISTANCE dilemma and the chaotic aspect of the Fusional Complex, some analysands develop a protective "skin" such as dissociation or schizoid withdrawal. When these or any variety of containing structure are breached—by internal affects or outer intrusions—the field can become so turbulent as to set hurdles for, or even preclude, perception of the Fusional Complex. Indeed, when the protective "skin" takes the form of a hardened narcissistic shell, any perception is not only difficult to achieve, but is even experienced as intrusive.

I had just such difficulties in perception in my work with Naomi (Chapter One) until we discovered the fusion-distance opposites governing the field between us. Naomi had created multiple protective "skins," which were rarely cohesive; hence chaotic fields ruled many of our encounters. Though the powerful, psychotic-like energies of the Fusional Complex dominated the field, we could not perceive the fusion-distance opposites themselves as a regular quality of our interaction until we dissolved these protective "skins."

My work with Naomi and others offers us images of a "garment of the soul" or *subtle body*, a necessary container for the inner life. The notion of a containing garment, composed of a substance that

is neither spirit nor physical body, but rather a quality *in between* them, is ancient. It appeared in Stoic Greek thought and was further developed in the early centuries of the Renaissance, before perspectival consciousness developed and gave birth to science. Ancient cultures thought a great deal about this "garment of the soul" that allows for an exchange of energy between man and the universe of relations, and through which a sense of order prevails. Pre-scientific cultures approached the dilemma of chaos, and the relationship between order and disorder, very differently because they *saw* differently. The modern, scientific mind has developed at the expense of shutting down other forms of perception. Generally, people no longer perceive a kind of covering fabric that protects the soul from becoming too disordered by chaos, both internal and external.[1]

However, one can perceive this fabric of relations by focusing upon the interactive field, the in-between realm one can access through aperspectival awareness. This requires "bracketing out" the consciousness of "insides" and "outsides," notably of projections or knowledge of one's own or another's inner process. In a sense one sacrifices the power gained through the knowledge of inner contents or projections, and opens to experiencing the third area.

In this aperspectival mode, the inner life of another becomes visible as the spirit takes on a concrete form. Gebser speaks of the *concretion* of the spirit.[2] This imagery, when *perceived and experienced* by both people within the third area, is the source of healing.

The activation of the subtle body is an autonomous, archetypal process, but requires the perception and imagination of an involved, related other person. If this "garment" is not formed in the months before and after birth[3] or during later, transformative periods of adult life, one creates "substitute fabrics" that can take disturbing and rigid forms. In turn, these must be dissolved (through revealing and re-perceiving the nature of the intrusive

anxieties—often related to maternal depressive or psychotic process—that kept the garment from taking shape) so that an original "subtle embodiment" may form into a containing presence. Assuring the continuity of a felt sense of existing, the subtle body protects against a variety of intrusive states—both inner and outer—and especially against the engulfing chaos of psychosis. As we saw with Kyle and Norman in Chapter Three, the subtle body can also communicate, as it were, various degrees of a felt sense of connection and (simultaneously in the case of the Fusional Complex) disconnection. Due to the disordering effects of psychotic process, it was many years before Naomi and I experienced this communication. Generally, a person suffering from a strong Fusional Complex creates a variety of substitute containers or "skins" to ward off unbearable anxieties in the face of a non-functioning subtle body container and an absence of that crucial achievement of a dependable and safe relationship. In my work with Naomi, her own "object relations" grew as her substitute skins were revealed and dissolved.

<p style="text-align:center">* * *</p>

When the subtle body is damaged, as Naomi's was, the invasion by a dangerous and disorganizing psychotic process is an ever-present danger. Such damage undermines a person's sense of safety and requires severe, rigid defensive coverings for survival. Naomi had created a narcissistic "bubble" structure, in which only she existed, that defended against her becoming engulfed in a terrible confusion of psychotic anti-worlds, in which anything she felt or thought could be immediately annihilated by something else, which could be annihilated in turn. To this difficulty was added incorporations of her mother's madness that were unknown to us at the time, all hidden by the bubble structure and seeping out through a field characterized by a quality of oddness.

For several years, I accepted this defense as representing part of Naomi's narcissistic need for being "mirrored," something that she was surely terribly starved for. Mirroring is a complex process of empathically reflecting another person, "getting in her shoes," using one's own experience in the process, but adding very little, if anything, of one's own thoughts or imagination. Mirroring needs characterize people with a narcissistic character disorder, whose psyche, to one degree or another, emits an energy that transmits the demand that the analyst "shut up and listen"—something that he or she, unless conscious of the nature of the interaction, will tend to strongly resist.

This form of control is common in everyday life, and when it is experienced in the interaction transmitted by the field, it creates a feeling of physical tension in the person experiencing the silent injunction to only mirror. Often one's breathing becomes shallow. When the controlling demand is strong, such physical discomfort can be painful. Characteristically, after waiting in vain to find some opening to speak, one is left feeling hollow and empty.

Unless the analyst has a sufficient sense of a self—that organizing center of the human being that infuses a life with an individual sense of meaning and purpose—the attempt at containment through mirroring will be particularly unpleasant and stressful. The self contains the wisdom, the innate knowing, that can appear as an epiphany if the ego withdraws its controlling influence. For example, if a person says something that evokes an emotional response or a fantasy in us, and through being connected to the self we are able to delay any response to such states, it is remarkable how these tendencies change, and completely different responses emerge within us. Often, the best response is to say nothing. Then it may become clear that any statement at all would have been either defensive, or perhaps only manifesting one's own need to be validated, to be seen or mirrored by the analysand.

The self's capacity to help one to delay acting upon such needs demonstrates the containing function that calms anxiety and gives rise to a sense of centering, akin to the age-old metaphor of being in Tao. However, in my experiences with Naomi, when chaotic, disorganizing fields became dominant, any containing sense of the self that I possessed failed. Instead, an emotional turbulence that I could barely reflect upon prevailed.

In maps of the ancient world one finds a serpent circling what is known, with chaos outside the circle. The self, in an individual, also has limits to what it can order. These limits may be continually expanded, much as explorers enter once-unknown domains. However, chaotic states, and especially trauma, are a formidable obstruction to this enlargement.

Generally, in the early years of treatment with Naomi, I succeeded in focusing upon what I could inwardly contain, and excluding what I could not. In those years I found it impossible to relate to the odd moments, or states of contradictory opposites that arose, sometimes as frozen states of muteness in which I felt physically attached to her, even trapped, a captive audience. Here are several examples taken from notes I made after such sessions:

I am never pleased with the way I greet her in the waiting room. I feel false if I try to be effusive and mean-spirited if I am reserved. I open the door to the waiting room with apprehension, never knowing if I'll "get it right." I believe she knows and watches and computes the number of ergs of energy I emit, but she is pleasant and smiles, though I can see she is distressed. She's in the consulting room now, sitting down and talking. Her good mood remains, but I know it will quickly pass. Will she say something about "how I was" in the waiting room? She once did, and proceeded to train me in ways of greeting her—asking me to

show my pleasure in her arrival and comparing me to a
yoga teacher who greets her with such happiness—and
further noted "how wonderful I feel to ask for what I
want." She always asks for what she wants. I know no one
who would ever ask for the things she asks for. In this
instance I was hoping she wouldn't ask me how I felt
about her request, for I felt like an observer watching a
freak show, while knowing that I was also the freak. I felt
weird when she spoke, strangely unreal.

Each time she enters my consultation room from the
waiting room, I breathe a very slight sigh. I may have gotten
away with something; I'm never sure. I'm never real. I wish
my slight sense of being unreal, false, were the worst of it. I
hide how I actually feel by not feeling. I feel absolutely noth-
ing for her, and this begins in the waiting room.

After another session, I noted:

I feel suspended between liking her—feeling I'm with
someone who will really understand me and be inter-
ested in me, who will be the very fine, empathic person
she can be—and feeling tense, held back, stifled, and
totally disconnected. I reach across this gulf of no con-
tact with a nod that signifies I am with her. I'm not. I
have the thought: "Why am I even thinking that she
would really understand me? That's not why she is here,
and besides I know she'd resent it very soon." I'm afraid
of failing her, but I cannot easily say why. It's like my
mind is a ball of twine that I cannot untangle. I hide my
feelings. I don't know why. What she wants most is that I
honestly tell her anything I feel, no matter how awful it
may sound. She really wants this. I know no one with so

fervent a quest for truth. I know there is nothing I can-
not say to her. Yet in the moment I forget all of this. It
goes out of my mind without a trace. Instead, I lie. I pre-
tend to be present, hoping a moment will appear in
which actual connection occurs, and I will have gotten
away with my charade.

I am embarrassed at having had such reactions, although I
think they are not merely idiosyncratic, but often occur when
strong levels of the Fusional Complex are engaged. I would surely
prefer to not have had such feelings, since I was fond of Naomi
and respected her. I have offered these session notes to describe the
atmosphere in the room when a narcissistic defense such as
Naomi's is activated, and why it can be so difficult to reflect rather
than become defensive or dissociated.

For over five years I wrestled with a feeling of being totally
excluded from interacting with Naomi, apart from mirroring her
conscious states of mind. However, this exclusion was peculiar to
the somewhat atypical nature of Naomi's narcissistic defense,
which I eventually realized was not the mirroring need of a nor-
mal developmental process, but a more primitive narcissistic need
related to the Fusional Complex.

Normally, the analyst will have an empathic understanding of
the analysand's mirroring needs, and when this understanding
crystallizes, there is a quality of empathy between them. With
Naomi, who seemed to live within a "narcissistic bubble" in which
she was both speaker and listener at the same time, I experienced
no empathy or understanding. When Naomi was in her "bubble,"
I felt like an observer, with no active role, no matter how minor, in
what was taking place. For example, she would tell a story about a
conversation with her son, and then respond to it herself, like an
audience, and often with an exaggerated mirroring and congratu-

latory sense of herself.[4] Throughout this odd spectacle—"Can this be happening?" I often asked myself—on the one hand I found her behavior strange, and on the other I felt strongly coerced into behaving as if it was normal. I felt impelled to behave as though whatever she said and did was absolutely wonderful and special, and if I didn't, I felt withholding and cruel.

The bubble structure was a "substitute skin" that was different from any manifesting in the so-called narcissistic transference that I had known up to that point, though I have seen it since then in other cases.[5] For example, my work with another analysand, Leo, included the identification of the bubble structure, the discovery of the Fusional Complex underlying it, and the use of the communicative tools available through the subtle body to move a person through the Fusional Complex toward a sense of self.

* * *

The Fusional Complex largely determined the field between Leo and his wife, who played out its dynamics in a repetitive, exhausting manner. "She clings to me violently but keeps me at a distance," he complained. Meanwhile, his own terror of separation kept him fused with his wife in a bond of some love, but mostly hatred. He desperately sought autonomy but clung to her at the same time.

Leo and his wife clutched at any moments of shared calm and love, as if these were life rafts in a storm whose power they tried to deny. However, feeling unmirrored and criticized by the other dissolved any newly found sense of connection they managed to create.

During these painful episodes, Leo would consider separation, seeing no value in his marriage, which for him was characterized mainly by pain, energy loss, and exhaustion. Yet, after weeks of

total disconnection, the couple always managed a fragile reconcil-iation, usually achieved through a sexual connection.

On these occasions, Leo might begin a session by saying that he now felt committed and at ease about his marriage. He would tell me about his plans to buy a new apartment with his wife, explain-ing that he wanted to be totally committed to his marriage and to "give it a good try for a year." He would say he wondered why he needed therapy.

Each time he would say this as if for the first time, despite the fact that these words and sentiments were becoming a frequent pattern. This made these episodes feel strange: when he was happy and optimistic he had no memory of all the times in between, and no awareness that he had been optimistic before—many times—and had always crashed. I would feel like the work we had done together during the "bad" times was completely erased, as if there was no history. Just like with Naomi in her "bubble," I would think: "Can he really be saying these things?"

It became clear at these times that Leo was in a narcissistic bub-ble. He apparently felt so threatened that I might question the love and stability he could sometimes feel, that this extreme form of narcissism came to his rescue, essentially isolating him from relat-ing to me. As with Naomi, the sense of oddness that prevailed dur-ing his communication signified the leakage of the psychotic levels of anxiety that his defenses attempted to contain.

After we reflected upon our experience of the bubble transfer-ence together, Leo could then realize that he adopted the same defense with his wife. When he talked with her he usually wasn't talking *to her* at all, for he was in fact both speaker and listener. He could also see that he was driving her crazy by acting *as if* he was talking to her, creating a double-bind message.

Furthermore, Leo could begin to see that his compulsion to talk was part of a Fusional Field with his wife in which he felt

pulled into her, as though a magnetic force far stronger than his ego was operating that could annihilate any sense of identity he felt. His narcissistic bubble was a defense against becoming vulnerable to the extreme anxiety of this state.

At other times, when this extreme, narcissistic defense was unnecessary, Leo could reflect more upon the nature of the field between himself and his wife. The field between us in our sessions also proved a valuable source of information about the fabric of the Fusional Complex.

For years I had wrestled with my inner reactions to Leo and to the somewhat odd nature of his long-standing complaint—"she refuses to give me any power"—as though someone could give him his power. Then, in one session, I chose to see differently, to look outward into the field. I lowered my attention somewhat and focused upon the space of the field between us, in order to see if I could perceive its energies and patterns.

It took some time for images to arise. Then I described the experience as best I could to him: "There is a kind of sensation-fabric between us now; it's just there, and at the same time I experience us as somewhat mentally distant, not completely so, but there is little body in it." I had never seen this before, perhaps because I had not tried to, or perhaps because the field had never produced the possibility for the perception to occur.

Leo found that he too could experience the subtle sensate fabric of connection between us. We felt this fabric as though we were inside something together, then noticed how this sense of being "inside" something shifted, so that, feeling as though we were on a surface of this "container" occupying the space between us, we could note our rather distant mental connection (the same dynamic of the Klein bottle described in Kyle's case in Chapter Three).

The exercise of feeling into the field brought Leo down from the mental level and more "into his body." This caused him to remember a disturbing encounter with his wife in which he had

not only sensed strands of sensate-like fibers between them, but also felt like he was nearly glued to her. Any attempts at separation then opened him to the terror of a fusional pull into a void from which he could not return. Leo could sense that he felt this pull as coming from his wife, who completely denied she was having any effect on him, or that she was involved in fusion in any way. Leo would then feel so vulnerable to the fusion-distance dilemma that he would disconnect from experiencing his body and attempt frantically to connect with his wife "safely" through endless "talks."

After experiencing the sensate fabric connecting us, Leo could see how he rejected the sensate fabric linking him with his wife. If he allowed himself to perceive the fabric, he felt in danger of becoming engulfed in chaos—but if he avoided this perception and split into his mind, he also lost any sense of self.

Then Leo discovered something remarkable. It was not that his wife somehow withheld giving him his power; rather, he could see how he unconsciously projected his own power onto his wife in order to maintain a fusional state. He could begin to see how his denying this would energize both opposites of the Fusional Complex.

Such discoveries of the fusion-distance opposites, in numerous configurations, are always part of working through the dissolution of "substitute skins" that once provided safety but have become a hindrance to individuation. The next chapter further examines this fundamental issue of transformation of substitutes for the subtle body.

6

TRANSFORMING SUBSTITUTE SKINS

THE EXPERIENCE OF THE FIELD IN WHICH LEO AND I could realize the simultaneity of fusion on a body level and degrees of disjunction on a mental level—those very states that had existed in such a chaotic, entangled condition during my first session with Naomi—was not available to me while I felt subject to Naomi's "bubble structure." For years, Naomi and I both avoided experiencing the edgy, chaotic state that could characterize the field between us, while I assumed these dark energies to be Naomi's. I tried with great effort to relate to her but often failed miserably, until one pivotal session.

Naomi began the session by saying that she was concerned about the coherence of the story she was about to tell me. It felt as though she was taking care of both herself and me, mindful of the numerous experiences we had had wherein I had felt fragmented, mentally blank, and only able to catch bits and pieces of what she was saying. This prelude helped us to begin perceiving the field, in which I could imaginally see Naomi as being simultaneously embodied and also withdrawing, as if she was escaping from her body. My own body began to feel tormented and very tight, and I felt on the verge of a headache, something I rarely get.

I began to feel the familiar sensation of being mindless and deadened, like an observer with no real contact with Naomi. However, in this session, I found it strangely difficult to *not* talk,

asking questions about topics that had absolutely nothing to do with the subject at hand! I was obviously not in a clear consciousness, but rather carried along by a trance-like state. Naomi jolted me out of it with her startled response: "What in the world are you talking about?"

Making contact with me in this way opened the door to a subject-object level of relating: her narcissistic bubble began to dissolve. Suddenly, I could feel her deep commitment to discovering the truth of our encounter. A sense of trust replaced the urge to blame or defend, and I found myself able to ask a question that I had never uttered before: "What is it that gets created when we sit together like this?" To my surprise, she replied after only a brief moment of reflection: "You're like my mother. I reach forward, and for a moment she is there, but then she is gone." She said she felt she was in a state of extreme deprivation.

I also felt deprived of connection and of any feeling that would take away my pain and confusion. When I admitted this, Naomi was surprised, because she had never imagined that she might have this effect on me. The field between us oscillated between feelings of newfound real connection and withdrawal, with each state annihilating memory of the other.

We agreed that we were both experiencing these opposites. It was important that these states of mind were *ours*—that it was not Naomi's projective identification at work, and that this chaos was also *my chaos*, which lived in the space between us. The chaos, nothingness, and pull into a void were *our condition*, not something we were doing to one another.

We could only arrive at the humbled state of realizing that our chaos existed as a conjoined, mutual process when Naomi could trust that another person's anger, abandonment tendencies, envy, or especially a kind of entrapping madness that she knew in her mother, which threatened to destroy her very sense of existing, would not take over an interaction in which she was vulnerable.

Likewise, I needed to be able to trust that Naomi would not emotionally retaliate against me by misusing the vulnerability I felt. I discovered, however, that when someone was honest with her, for example when I shared my experience of our interactions, her seemingly impenetrable defenses would fall away and reveal what almost felt like another person.

With the dissolution of the bubble, opposites of self and other came into existence for Naomi, and "the other" could be known as real, rather than taking an idealized or depreciated form. In later sessions, the bubble structure occasionally returned in a much-diminished form. When it reappeared, Naomi would be aware of it and would ask me to notice if she was "in her bubble" or if she was contacting me. This indicated a transformation in Naomi's relationship to her inner mad states, for in madness there is generally no desire to relate to another person.

Yet, before positive and stable "object relations" could develop in Naomi's outer life, another transformation in her narcissism had to take place. As the "bubble," which had been so extreme as to suggest a state of "primary narcissism" in which there is no outer object at all, continued to dissolve, Naomi began to ask for mirroring—a normal developmental need that surfaces as the Fusional Complex is uncovered—but in a way that was beyond anything I had ever encountered in my psychotherapy experience. The mirroring she requested was not only precise and verbal but ruthless and exclusive of any individual input from me.

This need appeared with such an odd quality that it was difficult for me to experience it without having a strong negative response. I felt as if Naomi was thrusting her mirroring need at me like a weapon, with no regard for me, let alone interest in anything I might have to say.

In my practice, I have witnessed an extreme resistance in analysands—probably arising from shame—to allowing the *scale* of so powerful a narcissistic level to become apparent in one's

interactions. Yet some people, such as Naomi, find the courage to act out their intense narcissism, feeling that anything less seems to foreclose any possibility of becoming who they are. They persevere despite the humiliation that comes from realizing the power of their need to be seen in a way that *totally* excludes the needs or reality of the person from whom mirroring is demanded.

To begin to break the deathlike hold of the Fusional Complex, a person has to come a long way from acting as though he or she has no needs at all, to daring to be outrageous in showing his or her narcissistic needs in extremely primitive forms. Then the Complex becomes the doorway through which a new self emerges.

Naomi asked me to repeat her words back to her, not adding anything of my own, and to repeat *only* when she asked me to. Her request would have been easier to understand if she had been protecting against expressing hatred toward me, or if she were terribly masochistic and self-destructive. Instead, in her insistence that I repeat her words, she presented a strange mixture of compassion for herself, a ruthless control of me, and a sense of vulnerability in taking a risk by stating such her demands. It was like these components were all playing at once, but the "symphony" was not harmonious.

At this point in our work together, Naomi would also tell stories that reflected her mirroring needs with friends or family. Often, I could barely restrain myself from saying, "How could you say that?" But I waited, listened to her, and eventually discovered how vital it was for her to say what she did, as when she asked me to only repeat her words. Somehow she soothed herself by making such outrageous demands. For Naomi, this was progress, and she knew it. Though she felt humiliated by this state of affairs, her desire to grow won out over her shame.

When Naomi first asked me to repeat exactly what she said, on cue, as if I was an actor in her play, I felt I wanted to end the treatment. I had an urge to send her to someone who might practice

this kind of therapy. For a mixture of reasons I restrained myself. Having seen Naomi for many years, I couldn't bring myself to demand so abrupt an ending, and, even amid the psychic pain I felt, I still liked her and sensed that she was doing something she needed to do. However, I wanted to end the torment. Each session I knew I was in for yet another hour of "having to do it exactly right," and each time I sensed that it was going to be excruciating.

In a rare moment of reflection I became embodied and considerate of my own feelings, thinking, "That's not what I do. I see into people, and I make sense of chaos and I embrace their mad parts. I write about this, publish books on the subject, and now I'm to give up everything of myself and do precisely what she says!" In this inner dialogue, my narcissism was so blatant, even to me at the time that I was further able to restrain myself from saying anything of my own.

Still, these sessions for me involved actual physical pain. A tightness in my chest worsened whenever I dutifully repeated what she had said, exactly when she asked me to. I suffered, but she seemed to grow from such experiences.

In an example of her "mirroring demand" during this phase of our work, Naomi said:

> My son is focused on losing weight, is obsessed with his diet, goes to the gym every day, and his wife is getting annoyed with his behavior. I told him, this obsession is a serious symptom. I'm going to help you. You're going to get into treatment and get help with this.

Feeling a demand to praise Naomi, but also serving my need to retain some of my identity by being a bit parsimonious with the exuberance of my response, I noted that she had done a wonderful thing. Naomi took time to reflect on what I had said, those few seconds feeling like minutes, for I knew I hadn't "done it right."

Then she explained that she wanted me to say, "That was terrific, look how you were so there, so open in offering assistance, and totally caring for him."

I was dreading that she would "ask" that I repeat this, when she looked at me and said, "It seems like you see something else." "Yes," I said, "there also seems to be some anxiety." To this she quickly said, "I don't want to deal with that. I only want to deal with what I know; I don't want to have to reflect on what you may perceive or what may be in my unconscious. So please tell me again about how well I did. I need to hear the words."

After some inner struggle with hating her request, I decided to oblige. However, I couldn't quite manage it, for I began by saying, "It seems so odd to me that you're uninterested in knowing what may be going on within you." Only then could I manage to add: "And sure, I can tell you that you did so well with your son, you really were courageous in telling him exactly what you knew, and in taking charge in such a good way."

I had hoped to explore why Naomi didn't want to see more of her process, but she stopped me and said, "That's enough. That's all I want to hear. I can do the other stuff myself; it will come up. See, what I'm asking of you is that you totally and completely keep yourself and your creativity out of this. I know I'm asking something very difficult of you."

I felt softened by her reflection, but silently I wondered, "Then why come here?" My question obviously stemmed from feeling so cast aside and unseen, and it was not difficult to "answer" that she came because she encountered a situation where another person must show total self-control and respect for her process.

I could see that she was terrified for her son, but I could not insist upon her knowing this. Naomi's sense of containment faltered if she tried to accept any input that was not something she already knew. What I had to say to her was a truth that she could

benefit from knowing, yet saying it had to be sacrificed. My drive to speak the truth was madness. My actions represented the dynamism of the fusional dimension between us along with a total absence of relatedness. In the madness of the Fusional Field there is no desire to relate. At that moment, I could later understand, I didn't want to relate to Naomi. I wanted her to hear me so that I could feel that I existed.

In such situations, the work of analysis is mostly occurring through the unconscious field. As I was able to better control myself, and to suffer the field experience between us, it is possible that the compulsive force of her/our madness was somewhat transformed.

Of course, Naomi didn't want to relate to me, either. And she could also distort; for example, it wasn't necessarily true that the deep anxiety I saw in her was something she would later discover. Naomi's omnipotence led her to believe that it was true. But it was more important for me to understand the terror Naomi could experience at the slightest autonomy imposed upon her by another person.

For example, Naomi had a birthday and a friend asked what she wanted, to which Naomi replied that she wanted a CD player that was very simple to use. The friend gladly acceded to this wish, and Naomi was overjoyed, feeling that she was getting just what she wanted. Then the friend called and asked if Naomi wanted a special microphone attachment. Naomi felt this as painful beyond words. Usually articulate, she could barely describe to me the physical and psychic "burning pain" that she felt. To her friend, all Naomi could muster was a near scream, saying, "Please, just get me a CD player!"

Naomi grew through experiencing her extreme narcissistic need to be mirrored with absolutely no input from me, and

according to her own script. Over the next two years, her bubble structure and associated affects in the field between us continued to weaken until they were only rarely disturbing. Following this, she entered into another level of healing—perhaps the most significant—which required us to engage with the very essence of the Fusional Complex.

7

THE BLACK NIGHTGOWN

PERHAPS A YEAR AFTER THE NARCISSISTIC BUBBLE STRUCTURE dissolved, I began to experience what felt like an awful spell in the room during my sessions with Naomi, a pervasive sense that my mind and body were being taken over by some heavy, invisible force. Containing that was a greater challenge than dealing with the bubble protecting from the chaos and opposites within the Fusional Complex. The "spell" proved to be a symptom of another "fabric of the soul" that also covered and contained the Fusional Complex.

Naomi reported the following dream:

> I am wearing an old black nightgown, heavy and coarse, that comes down to my ankles. It is a dress of my mother's that I played dress-up in as a little girl, and the hem is narrow and makes it difficult to walk. I have to get up and begin my day's work, but I cannot remove the garment, and no matter how much I try it sticks to me. I think of taking a shower, but I know that would only make it heavier. The only way I can stop what feels like torture is to wake myself up out of the dream.

Naomi's dream of the Black Nightgown addresses a theme that is extremely important for healing. The shower water will only

make the Nightgown heavier: the "upper waters," symbolizing spiritual energies, will not transform the "substitute skins" of the Fusional Complex.

Naomi was dedicated to spiritual issues, and her capacity to embrace the reality of this dimension was enhanced through years of meditating. However, the field and its dynamics, as they manifest through a mutual interaction and partake of the somatic unconscious, afford a more powerful level of healing.

Spiritual awareness can be of the essence in avoiding the pitfalls of fusing with a shared field rather than maintaining a sense of a separate identity while mutually experiencing it. However, the most intense spiritual awakening will usually heal neither the torn subtle body nor the traumas that created this disturbance in containment.

In a sense, an individual spiritual awareness is necessary but not sufficient for healing at these psychic levels. When spiritual experiences incarnate and create an inner self-structure, and even as this structure is embodied, this valuable and transformative experience does not necessarily engage and heal all of the psyche's wounds. Traumatic areas may be healed, or their intensity may diminish, but often such areas stay outside the domain of the created self, and still require "substitute skins" for containment. However, when the spiritual level is combined with mutual field experience, a far deeper healing can occur, especially including the repair of the subtle body.

Therefore my task was to try to understand what the Nightgown represented from experiences of being with Naomi:

> I am strangely attached to her, sensitive to every voice tone, and to everything she says or does not say, and at the same time I'm separate, disconnected, pretending to be connected. My pretense pains me, but a far deeper pain is present. I feel wrapped up in something, not a rigid con-

tainer like glass, for I can feel feelings and at times perceive her feeling. Yet I am wrapped in something that obliterates my mind. Part of my brain seems missing, or damaged. Any sense of embodiment is absent. My body feels rigid and invisible; I'm not in it. I am not present to myself or to her. I might be any age.

Throughout this excruciating time I am acutely self-conscious, hoping she doesn't notice my avoidance of her and my distractibility. Usually I don't have any thoughts. I'm just in a holding pattern until something like a spell passes.

The Black Nightgown proved to be another protective container that, as it shielded Naomi from the dangerous, chaotic states at the core of the Fusional Complex, also isolated her from others even as she tried to relate. Without it, she could "fall through" into totally unmanageable anxieties and panic states. This "substitute skin" was an awful compromise, but a life-saving one.

In sessions occurring in the months that followed the dream, Naomi was able to describe what the Nightgown felt like.

When I feel the tightness [of the Nightgown] I feel a vengeance. My skin is tight and painful. I do what I know is wrong for myself and for my health. I cling to everything: I want to do this, this, this . . . and I won't stop. If I stop, I get into a panic. I have no container, everything threatens to falls through; it's like a psychic diarrhea. I feel myself regressing but I don't allow it. I try to hold myself together, frantically. I have no resting place.

The Black Nightgown is a symbol of a key experience of the Fusional Complex: the containment by a rigid form of the subtle body, protecting against the dread of separation. Without the

Black Nightgown, without "clinging to everything," total disinte-
gration seemed to threaten Naomi.

Naomi's terror of separation affected her ability to take a
stand in the most blatantly clear situations of ethical, moral, or
logical certainty. For example, in a remarkable development of
trust she had formed a serious relationship with a man, "Bruce."
They were planning to move into an apartment together and
share expenses.

When Bruce called to say that he had figured his expenses
incorrectly at first, and asked Naomi to pay a larger share, she
rationalized that he was just anxious. He easily had the money to
justify their original agreement, she said, and furthermore their
budgeted living expenses were strongly tilted toward his needs.
But she was upset by the way he spoke to her, the insensitive tone
in which he had asked her for the money.

I learned all of this several hours after Naomi had spoken with
Bruce, when she appeared for her session. Naomi said she knew she
was flooded with emotion and in danger of being irrational, and
that she needed help figuring out how to answer Bruce's request.

The notes I recorded after this session state:

> Naomi writes down everything I say, even though I am
> only trying to offer possible modes of talking to him in a
> related way. Yet she writes as if taking dictation; she seems
> to have no voice of her own and no mind. Naomi reads
> back what she has written: "Bruce, we're in this together,
> and I'd like to discuss the money issue," but then, on her
> own, she adds, "I want to pay less because I think that's a
> real test of your commitment to my creativity."

When Naomi said this, I cringed because it was unrelated and
hostile. I tried again: "Perhaps you want to stand for the relation-
ship, and explain what you've told me you know—that he is an

ethical person and it's difficult for him to not follow through on what he hoped to accomplish." She began to take this down, word for word, as if I was writing a speech for her. She then read it back to me, adding, "but I have needs too!" The latter phrase was jarring, like a weapon glued onto the prior part of the statement, and entirely wiping out any empathic understanding the first part might have accomplished.

Generally, in copying down what I said and adding to it—compulsively, it seemed—it was as if Naomi glued together two things that didn't join, making her communication a bizarre object. She was unable to psychically detach from Bruce (desperately wanting empathy) yet unable to connect with him, hating him for being so unrelated to her and to her financial-security needs.

To state the financial facts, as she knew them, would have been to separate from Bruce, and her desperate need for connection didn't allow this. When I reflected upon this with Naomi, she spontaneously said: "I'm addicted to empathy. Without it, I can fall into a chasm. Empathy is the only rope that can save me from falling. I'll deny reality to get it. At such times, I have no belief in the efficacy of things as they are."

Naomi's fear of separation filled her with shame and self-hatred, as she told me following a dream in which she failed to graduate from a course:

> I'm not who I present myself to be. I pretend to be totally separate and strong. That's how people see me. I'm not authentic; I don't want to be differentiated from Bruce or from anyone. I want to stay in a fog. That's why I don't graduate in the dream. I hate him for his inauthenticity. I allow myself to be lulled to sleep into an unconscious fusion with him, and then I hate him more.

This fog or sleep characterized the enveloping spell cast by the

Nightgown in our sessions, which seemed to make the field dark, dull, diminished in energy, and devoid of any sense of relatedness. These qualities may well have been an archetypal aspect of the Fusional Complex—an aspect taking the form of the Witch in fairy tales, a figure of the Negative Archetypal Mother, who creates unconsciousness and trance states.

During these times, what I experienced with Naomi was totally beyond what I could feel as happening *within* me. Rather, I felt *in something* and subject to it with her. My own feeling of anxiety and tension was the easy part to discern in this state; the hard part was the uncanny sense of a kind of spell in the room, and accompanying feelings of mental deadness and muteness. I could not tell if these states were only "mine" or if the field between us created them. In this deadened state, I had no emotional or mental connection with Naomi, or with myself. It was more a bodily feeling without mental content, and it made no sense to me to think of it as "coming from Naomi," or as a clue as to what was going on within her. Such ideas would have been my own defensive constructs.

It was only by going over such experiences with Naomi many times, examining what I felt, that Naomi eventually began to remember, as she had done with regard to the bubble structure, that in childhood she had experienced her mother in the way she experienced me, as dull and deadened. Through experiencing the dark and disordering state of the field with me, Naomi made the crucial discovery that the Nightgown was directly related to her experience of her mother's body.

The Black Nightgown can be understood as an archetypal image of Naomi's subtle body, which had been negatively affected by her relationship with her mother. This formation represented the result of attempts to fuse with her mother's body to gain safety from her mother's psychotic rage and depression. However, this "substitute skin" was itself filled with misery—like the poisonous

garment of folklore, seen in the robe that tormented the Greek hero Heracles[1]—and Naomi found protection from its extremely disturbing effects through the creation of the narcissistic bubble.

Normally, when the relationship between mother and child is creative and healthy, their mutual projections, and especially the mother's fantasies about her child both in utero and after birth, bring about a healthy form of the subtle body. Union states between analyst and analysand can have a remarkable healing effect upon the subtle body,[2] while the incorporation of maternal or paternal madness can severely limit the possibility of creative union states and tear the fabric of the subtle body. Naomi and I realized that the Black Nightgown carried her mother's madness, depression, and despair, all states Naomi intuited as related to her mother's having been an incest victim. As the "containing skin" of the Black Nightgown was dissolving, Naomi became vulnerable to experiencing psychotic qualities of her mother that she had incorporated, for such "skins" had previously served to protect her from both internal and external attack. She dreamed of tiny red balls lodged in her eye, and then of a large penis that her mother owned. The penis was inside of Naomi, and she was trying to vomit it up.

Naomi's transformation required that she regain her early, disowned perceptions of her mother's madness. This incorporated aspect of her mother strongly contributed to Naomi's inner chaos and terror of both the power of other people's emotions and any lack of relatedness to her.

Healing in the sphere of the Fusional Complex requires that the person gain the courage to perceive what he or she once *saw* and then denied. This act of re-perception has a healing structure that is akin to what so-called primitive or magically oriented cultures would call exorcism.[3] This would turn out to apply to Naomi's mother's madness, especially to her frightening and unstoppable aggressiveness.

Naomi was subject to chaotic, mad states originating with her

mother's psychic intrusions, which took up residence, so to speak, as inner states that had to be excluded, "spit out" in the language of certain shamanic cures. The madness that Naomi had incorporated during her early years became part of an amalgam between us, and it had to be seen.

Such mad states, called demons in past cultures, may, depending on their strength and the person's psychic structure, be integrated and thus felt as an inner part of one's personality—but at other times this is impossible. Then they must be exorcised, i.e., totally excluded from influencing the ego. The path of exorcism is non-ordinary perception. Just as the shaman first must name the source of his patient's illness, and then go into a trance state in which his own powers do battle with the demon, so too the analyst must use his or her own powers of perception and self-knowledge to help the analysand name the demon, and then to perceive its particular form.

Analogous to the shaman's quest for the source of a curse responsible for an illness, my perceiving the field between us facilitated Naomi's recovered perceptions of *how* her mother's madness got into her, and opened a pathway to discharging it from her psyche and from the field between us. By recovering memories of her mother's deadness, Naomi could begin to sense the deeper terror she had of her mother's madness, and ways that she totally split off from experiencing it. Later, and largely through dreams, she could see that her main line of defense had been to incorporate this madness, unconsciously swallow it whole, and split it away from her conscious awareness. Such mad contents lived on within Naomi, seeping out of their "vault" but essentially sealed away until the field experiences we shared began to unlock them. These interactions had to occur several times, but they had a remarkable healing quality.

In the process, disowned memories returned. For example, Naomi started a session by noting that she had discovered a mem-

ory that she recognized she had repressed for over forty years. This memory emerged as she was feeling an extreme sense of fear and dread: "My mother was talking on the telephone with a girlfriend, being contemptuous of men, as she always was. She said: 'If he were the last man on earth I wouldn't have anything to do with him.' "

Naomi went on to say that she had been so struck by this statement that she had imagined herself totally alone in the world, the only person left alive. For years after that she had had awful fantasies of being alone on earth, with dead bodies scattered around the landscape.

This state of complete isolation was hidden, never spoken about. It persecuted her, and was surely related to ways she experienced her mother: totally without connection to her, refusing to "marry her" even if she were the last person on earth. Naomi lived with the unconscious belief that no one would ever want to be with her. In this isolation, fortified by her autistic-like narcissistic bubble and her Black Nightgown, she essentially remained in a Fusional Complex with her mother, terrified to separate and equally anxious about staying in this limited condition.

A dream marked the change in this "impossible" fusion state. After our work on regaining perceptions, Naomi dreamed: "I have had an enormous bowel movement. I look into the bowl and see a spiral object, white and at least four inches thick. I am concerned about it being able to flush down, and I take a knife and begin cutting it into smaller pieces."

The spiral is an ancient form connecting to the energy of the Mother archetype. As we focused upon the dream, we both had the idea that the bowel movement represented the expulsion of Naomi's mother's madness.

Over time, this insight continued to make sense. (It was also consistent with her earlier dream about trying to vomit up her mother's penis.) The dream was pivotal, and after it the level of madness in the field between us, and in Naomi's life as well, diminished.

For example, Naomi could begin to question assumptions that had undermined her past relationships. On an occasion when she was being extremely judgmental of Bruce, experiencing him as rigidly resistant to examining his unconscious motives during an argument, she had the presence of mind to remember the Nightgown and the madness it carried with it. She then noted how she was feeling:

> I don't want to relate. I'm frantically running from an apocalypse, a catastrophic anxiety. I'm now with a man who is afraid of psyche, phobic! I want to vomit. Get out, now! When I see something mad in him, like in my mother or father, I am scared. I can't count on him.
>
> Lately, I haven't had this conditioned response, but I was in a different place. Somehow, I wasn't wearing the Nightgown. In the Nightgown I'm phobic about my madness, so I hate him, I'm terrified of it. I am conscious that he is the enemy. I'm a saint; he's a pariah. How can I be with him, especially as I so value the psyche and growth?

Naomi recognized that the Black Nightgown seemed to carry her mother's judgmentalness, and that her judgmental reactions to Bruce were destructive. Someone with a strong Fusional Complex is ruled by "blame" and "fault," and by an absence of belief that conflict can be worked out.[4] It is thus extremely significant, perhaps properly described as a qualitative change in the structure of the personality, when the person can own a "shadow quality," such as judgmentalness, without feeling totally responsible—blameworthy—for what may be dysfunctional about a relationship.

<center>* * *</center>

When a person's protective structures—such as Naomi's nar-

cissistic bubble or the Nightgown—begin to dissolve and lose some of their controlling and containing power, that person can develop distressing symptoms. Naomi experienced a severe digestive ailment that lasted for several years. From someone who could eat any food, and in great quantity—having, as she said, "a cast iron stomach," in which she took great pride—she could eat only certain foods, in small amounts, and even then with resultant stomach pains that could be debilitating. At one point, she became unable to digest her food. A time of severe weight loss followed. Yet Naomi could now better face into and consciously feel her digestive problems as a metaphor for the foreign "matter" (of her mother's psychosis and depression) that she had incorporated and could not digest.

Shorn of much of the protective power of her "substitute skins," Naomi then began to feel extremely vulnerable toward Bruce, especially to his anger and moods, and their relationship became very shaky. Without her "old skin" she was frightened of him, but having experienced her digestive crisis and its meaning, and having survived it, she was stronger, and could work through her distrust and fears while feeling committed to her own truth, whatever that would bring.

Naomi's felt vulnerability was a remarkable gain. In a sense, she began to move from the invincibility of psychotic omnipotence toward being more humanly neurotic, but especially toward the capacity to have a real relationship that she could depend upon for its containing quality.

As Naomi continued to reflect upon the Nightgown's power and the ways her identification with her mother had in turn dominated so much of her life with Bruce, she offered the following series of observations:

> I'm not sure I can take care of myself. I have so much compassion now for people who relapse. I'm scared. The

energy of the Nightgown feels like dread and being over-whelmed. Yet I see this is a defense against a deeper vis-ceral discomfort.

My emotional distress is not as bad as the body sensa-tions of my digestive problems, bloating and choking. In a sense dread, self-hatred, and loathing myself are not as embodied, and are a slightly "higher level." They block my deeper, chaotic body feelings.

After her digestive symptoms began healing, Naomi could see how she and Bruce were alike in their desire for unconsciousness. The ability to see an unpleasant quality in oneself, instead of only projecting it onto one's partner, is key in forming a relationship based upon trust.

A new state introduced this change in attitude: "I'm experienc-ing gluttony—wanting to eat everything—[eating] with my hands has great appeal. I want to be in a stupor . . . wanting nothing to do with consciousness." Prior to this awareness, for Naomi to reject consciousness would have been tantamount to a deeply reli-gious person rejecting God. Yet she could realize that her new-found gluttony was her version of Bruce's rejecting any desire for deeper awareness. She could see that she and Bruce shared an unconscious process in which both were against consciousness, albeit in totally different ways.

This kind of awareness continued to soften her criticisms of Bruce, and she eventually began to see that he did desire greater awareness, but in his own way. Bruce became more whole for Naomi, both "good" and "bad," and both qualities became more and more tolerable to her. Naomi's capacity for relationship con-tinued to develop into an ability to be with Bruce in more realistic ways that could contain conflict, and to continue to deconstruct the Fusional Complex.

Generally, the Fusional Complex will continue to raise its head in relationships, and Naomi and Bruce's was no exception. Their relationship, while growing, was also plagued by what Naomi felt to be Bruce's extreme lack of relatedness. At one point, she wondered if it was too destructive to stay with him. She complained, "I can't stop controlling him, changing him, insisting upon making my point when I know I should stop, and feeling critical of his absence of relatedness. Everyone we know, my family and friends, see how impossible he is. Maybe this isn't good for me."

Then Naomi had the following insight:

> I'm an addict. There I was again trying to get comfort from Bruce, a narcissist, and ending up agitated, frustrated, and despairing. This is a spiritual issue. In a Twelve Step perspective I am at Step One. I am powerless against my desire and actions to get empathy from Bruce. It makes my life and me unmanageable.

Naomi was totally fused with Bruce and totally unrelated to him. When she could recognize her Fusional Complex in action, she gained composure and could "let go" and enjoy a relationship that was not perfect but good at times, and tolerable.

8

UNCOVERING FANTASY, FEAR, AND RAGE

A S NAOMI COULD LIVE IN HER OWN FANTASY WORLD, encapsulated in the protective shell of her "bubble," many people suffering from the effects of a strong Fusional Complex are deeply immersed in fantasy. The shame they feel about this addictive behavior can be a major stumbling block for uncovering the far-ranging extent of the Complex.

The theory of the Fusional Complex can help us focus upon an analysand's discourse in ways that help reveal this hidden fantasy life. For example, the way a woman described her relationship to her mother as "painfully disconnected" and at times "incomprehensible," along with her extreme sensitivity to the emotions of other people and to noise, suggested the presence of a strong Fusional Complex. Based upon the guideline of the theory of the Complex, which includes the use of passive fantasy as a "substitute skin," I asked the analysand if she spent much time in fantasy—whereupon she revealed that she had been immersed in fantasy for her entire life, possibly for three-quarters of every day!

If I had not been led to initiate exploring this area, I am quite certain that the analysand's shame would have kept her from telling me about it. She was also an avid fan of movies, seeing several daily—a practice she normalized by calling it her creative outlet. When the true extent of her fantasy life became conscious, however, her attachment to movies was revealed as compulsive,

helping her sustain an inner, ongoing fantasy life that distorted her relationships with other people. Fantasy was a "skin" that had once been lifesaving, protecting her from experiencing her childhood trauma, but was now threatening to undermine her most cherished relationships with her husband and others who had complained that she was not "present" with them.

Fantasy can be the only "safe place," the only protection against unbearable emotions. For example, a man explained that when he turned away from fantasy and tried to be fully present with his wife, he felt fear and grief: "Nothing will come of it." We discovered that leaving his fantasy life brought forth the feelings fantasy had protected against in his childhood—especially his fear of his father's irrational rage and his mother's abandoning coldness.

Any thorough analysis of the Fusional Complex must uncover the analysand's hidden fantasy life, and the discovery process is a slippery path. Even if the fantasies revealed at any time appear to be extensive, the analyst must not fall into the trap of prematurely believing the revelation to be complete. The analyst's exploration of the pervasive nature of fantasy in an analysand's life is easily sidetracked by two factors. On the one hand, the analyst may unconsciously avoid the topic out of sensitivity to the analysand's unstated shame; on the other hand, an analysand who is capable of functioning well in his or her profession can easily hide the extent of his or her involvement in fantasy.

We can see an example of the discovery process in the case of Alice, an analysand who was so completely fused with her mother's mind as to sustain few ideas of her own. It was only after three years of our work together that—led by the theory of the Fusional Complex—I began to inquire about her use of fantasy. This uncovering had several significant precursors. First, Alice had engaged the difficult inner work of discovering young aspects of herself.[1] She spent perhaps an hour a day in an active imaginary dialogue[2] with them, sometimes painting the feelings that she

experienced, and eventually realized that these "alters" comprised something like an inner group of children. The presence of this group was palpable in our sessions, and I could often imaginally engage them as well.

The next discovery before Alice's fantasy life was revealed was the awareness of her anger. Alice had been reflecting upon her drive for perfection, which she said felt "forced onto me." She realized, "I'm mad about it. I feel I have to live with this; I have to work harder than others. I'm always held to higher standards. I really resent it." She explained,

> I trained myself to be perfect because I felt that was the only way I could get my mother's approval; otherwise, I felt I would be ignored or not seen. My drive for perfection became a kind of cloak. It was a physical and mental thing I thought I couldn't live without. But now I know otherwise, and I'm enraged by it.

Alice imagined her "cloak" as "thin and light," adding that "what's so disgusting is that my [internal] mother says, 'It's beautiful, so why take it off, it's so light?' " She continued:

> If I take it off I'll explode in rage . . . [the rage of] my soul wanting to live. It is totally against my mother, who essentially said, "Be tight, keep the cloak on, don't dare be a shooting star." I realize I was terrified of her envy if I ever became a star, in anything. And she did all of this in the name of protecting me. My inner child has an intense rage that feels like it's boiling over.

Alice, who was fifty years old at the time of these discoveries, had never before felt any anger, let alone rage, at her inner mother's attempts to control and suffocate her.

Some time after these developments, as I became more famil-
iar with the field between us, leaning into it more, I caught a pass-
ing glimpse of Alice's inner life, which I sensed was teeming with
activity. When I asked about the role of fantasy in her life, her
response to this was startling: "I was in fantasy for much of my life.
Between the ages of thirteen and eighteen, I would jump on a
trampoline in our back yard, often for more than an hour at a
time. I fantasized about imagined characters who were perfect,
popular, beautiful, and saviors of the world."

Alert to the possible extent of such fantasy, I queried, "Once a
day?" and Alice admitted her shame at its often having occurred
far more, at least several times daily.

> I never told anyone about this secret life. I was so humili-
> ated by it. I'd look forward to it. My parents never won-
> dered what I was doing; they just left me alone. At one
> point, I imagined that my favorite inner heroine had been
> appointed U.S. Secretary of State. People would consult
> with her and she'd always have the right answer. She also
> had many children and hired someone to take care of them.
>
> At eighteen I went to college and studied intensely,
> because I had to be perfect. There was no trampoline for
> relief, and constant thinking took the place of fantasy as
> my protective shield. But without the fantasy, my mind
> alone couldn't protect me, and I had a breakdown.
>
> I still engage in some fantasy. This weekend, in my car
> listening to music, I could get lost in fantasy. It was not as
> totally gripping as when I used to imagine characters solv-
> ing the world's problems as Secretary of State, but it was
> very strong as I imagined that I was a great singer and
> admired by many men.

Soon after these revelations, Alice began to feel an inner con-

flict with her fantasy life. She felt "a little girl" inside her, a part she had gotten to know well over the last few years, say, "Alice, when you go into fantasy you leave me." She reported feeling a strong conflict: relating to the young, inner part meant giving up the omnipotent fantasy life in which, as she said:

> I control everything, and everything goes exactly as I want it to. In this I am my mother; Mother was always perfect. There is also something new happening, for I'm feeling enraged at this not being true in actual life.
>
> I'm also becoming conscious of actually living in a lot of fantasy. I think my mother lived in a great deal of fantasy. How else could she have stayed married to my father? Actually, I can now see this about her. Fantasy was her outlet.

All of this felt to Alice like she was revealing a shameful secret, but it also led to a very important realization: "I hate my work because it takes me away from fantasy. Fantasy is still my safe place. I still live it out through omnipotence, like eating things that make me sick, even though I know I am allergic to foods like sugar. I hate limitation."

An "inner child" now seemed to be the main opposition to Alice's elaborate fantasy life. This was an important advance, because an *inhibition* from within her own psyche, not a collective *prohibition* that says fantasy is wrong, was contributing to her awareness of how her fantasy life prevented her from incarnating into an embodied existence. Then a dream capped this off: "A five-year-old child is being bitten by horse flies. She has been sleeping in a blanket that is infested with the flies."

Alice felt the "child's" terrible pain, and immediately recognized that the flies represented her fantasy life. In another dream, an older "wise woman who is distinctly her own person, and not

driven by collective values," said, "Fantasies are okay only if they relate to the deeper self of the child."

It must be emphasized that for Alice, extensive passive fantasy was a container for her rage that in turn threatened to puncture or shred her substitute subtle body, the containing fabric of the "cloak of light." In a sense, Alice needed several layered "garments," fantasy and perfection, to create some degree of safety from experiencing her mother's madness, her own rage, and the terror of separation and the overwhelming anxieties that could erupt and overwhelm her. The lifesaving function of these "skins" makes an extensive fantasy life especially difficult to uncover in the depth and detail Alice would eventually provide. Her separation from the impossible ideal of perfection was likewise difficult to effect.

* * *

The case of Gerald, a thirty-five-year-old male, illustrates the significant diminishment of the strength of the Fusional Complex when a secret life of fantasy is revealed. It was through my work with Gerald that I first discovered that at the core of the Fusional Complex lay a psychotic process that created not only massive confusion, emptiness, and a terrible fear of disappearing as a self, but also the fear of an extreme form of anger, like the phenomenon popularly known as "road rage." The size of this anger is so far beyond the scale of the human ego that it can be called archetypal. Gerald felt it put him in danger of metamorphosing into some nonhuman form that would act with dreaded, destructive consequences; hence he needed to hide this dreaded state from his own awareness, as well as from others.

As we uncovered much of the tormented world that Gerald inhabited, each discovery had to be "extracted," so to speak, through my efforts to perceive what for most of each session was invisible. Gerald was often incapable of having a memory or an

idea without the immediate experience of an opposite notion that denied, and caused him to forget, what he had just said or thought. Finding his thoughts amid these psychotic anti-words, Gerald said, was like

> reaching for moisture falling from the sky, and I try to extract some of it to form thoughts and words. Nothing forms, and I continue to try to extract more. It's not really thoughts, but movements of some kind in my head, sort of pre-thoughts. The more I try, the more my chest hurts. The pain can be unbearable.

In order to help Gerald to "render visible"[3] the thoughts and images that were hidden in his near-muteness, I had to perceive these psychotically structured opposites through focusing my attention upon the field while being open to the imaginal realities between us that were also specific to his life situation and history.

I was pleased and surprised, therefore, when Gerald and I began one session, after nearly a month's vacation, in what was for us an unusually open way. Gerald was much more verbal than he'd been able to be in the past, and I could feel a comfortable energy flow between us. After a few moments, however, I sensed something strained about our interaction, as though Gerald had a script that might soon run out. I then realized that, for me, the easy talk between us had been achieved at the expense of my hardly breathing, and being removed from experiencing my body.

I regained my normal, rhythmic breathing, opened my focus to encompass more of our interaction, and "leaned into" the space between us, feeling more embodied and "out of my head." I saw that I was fused with Gerald in a peculiar way, as if he and I were glued together through an interface that was strangely rigid and also dangerously porous.

As I continued to experience this embodied state with Gerald,

I could recognize an extreme disconnection between us. I hadn't really been talking *to him*, nor had he been talking *to me*. Only a moment before I had thought we were relating to one another, but in fact nothing either of us said was meaningfully connected to the other person. Typical of a strong Fusional Complex, we were in "parallel universes," acting *as if* we were communicating.

In the years prior to this, my work with Gerald had focused upon his layers of defense against experiencing his psychotic process. Typical of this was a narcissistic bubble like the one that surrounded Naomi; or trancelike states of passive fantasy that could last for hours; or the "substitute skin" of a persona that was totally "into" the other person, completely fused with her every word or feeling, with no concern for himself.

Now Gerald's Fusional Complex was perceptible in the analytic session for the first time. For the rest of the session the sense of a field characterized by a compulsive drive for attachment to me, and a simultaneous absence of empathy, diminished. There was even some free flow of associations, with Gerald offering thoughts and asking questions. This state was tenuous, dependent upon my exuding a quality of warmth, and becoming unstable when that warmth faltered.

In the past Gerald had told me about his fantasies of hurting people even as he was fused with them. He had come to understand that he hated them because he was so identified with them and lacked the power to separate from the Fusional Field. After becoming conscious of the shared space of the Fusional Complex in this session, Gerald said, "Just before I came in from the waiting room I had the thought of us talking together, and then of suddenly punching you, and seeing how surprised you would be. The fantasy just came up." Later, in the same session, he was able to say: "Just a moment ago I had the urge to stab you with my pencil." When I told him that it was special that he could share this with me now, he began to cry, and in this softened state he realized, "I don't want to hurt you, just jar you, but actually break the fusion between us."

To share this fantasy, and find that it did not destroy me, was a pivotal point in our work together, perhaps *the* pivotal point.[4] Even though he had spoken about his violent fantasies, for example with women, to actually have them with me, face to face, was remarkable, for it began a process of exploring his paranoid feelings and also of revealing the extensive nature of his passive fantasy life.

Contrary to his usual pattern of waiting for me to initiate speaking about his inner life, Gerald asked me, "What do you think about all this paranoia I have?"[5] As we discussed his paranoid fears, I learned that I had had no conception of just how strong and active his paranoia was. It was clear that in this moment he was also "telling me" that he was a bit paranoid about having revealed his violence toward me.

Now realizing I had probably underestimated the frequency and intensity of his paranoid ideas, and that I had assumed they were infrequent, I asked Gerald for examples of when he felt paranoid. He answered that the fantasies were nearly always there. For example, "At the coffee shop this morning, before seeing you, a patron mildly said to the waiter, 'Where have you been?' I expected a fight to break out and I felt very tense." When I inquired about how he dealt with his paranoia, he told me about the omnipotence he achieved through his "Superman fantasies."

Gerald explained that when he was walking along the street, or had time alone, say on weekends, he fantasized about being Superman. He felt out of his body, nearly flying. When he told me this, I tacitly assumed that these fantasies were only fleeting—such "normalizing" thoughts, as I have noted, are common when dealing with psychotic process—but from experience I asked how long they lasted. He said they could go on for twenty to thirty minutes. As I waited for another topic to emerge, I realized that I was again avoiding inquiring further, and asked him how often this fantasy occurred. It was a bit shocking to hear the answer: five times a day. When Gerald was in his fantasy life, he was nearly totally

divorced from reality, and when he was aware of the real world of people and tasks, he had no awareness of his fantasy life (and could only talk about it with me because I had first perceived it in him). The two, fantasy and reality, were not part of a continuum. Rather, they existed in a discontinuous and psychotic quality of anti-worlds, so that experiencing one state precluded any awareness of the other. After engaging in fantasy, it seemed that it took time for his soul to return to earth, and until then he was barren, anxious, and very disoriented. The "return" also felt physically jolting, as though he had been abruptly awakened from sleep.

The intense fusion state with his fantasy life that made this frequent transition between fantasy and reality so difficult had protected Gerald for most of his life. Both of his parents were orphans. His father, a severe alcoholic, was filled with rage, and his mother was depressed and nearly autistic. Both parents lived in continual hostility toward one another. Gerald, the eldest of three children, had begun rocking himself when he was nine months old. When he later asked his mother about this early behavior, she told him she had taken him to a pediatrician who had assured her that there was nothing to worry about. Beginning in adolescence, Gerald rocked to a fantasy of being a fighter pilot until he was twenty-three years old. At that time he went to an analyst but left treatment after one session, feeling shamed by his rocking behavior. At that point he changed the behavior to fantasizing about music, often while driving a car, rocking to the rhythm. Rocking to the ebb and flow of the music gave him the feeling of a containing fabric, which he described as a kind of sensation at his skin surface.

The fighter-pilot fantasy was Gerald's most elaborate creation. Obviously, there was a great deal of anger in these fantasies, but only when I noted it did Gerald reveal their extent: "I am the best fighter pilot in the world, and usually I am attacking the French army. I have destroyed 670 jets and 10,000 men. Initially, when I was younger, it was my father whom I would bomb."

Each time Gerald engaged his rocking, his fantasy of total power would continue for hours. There were numerous variations of the fantasy. In all of them, he was omnipotent and a loved and admired hero. There were also numerous subplots, intended to confuse anyone who sensed that the fantasies were occurring, for the excessive nature of his fantasy life filled him with shame.

When Gerald could verbalize his hostile fantasies toward me and know that I could continue seeing into him, i.e., that I would not be destroyed by his anger, we could see how his paranoia was closely linked to his intense rage, and how passive fantasies were ways of containing the rage. A sense of warmth, and the container created by the here-and-now perception of the fusion-distance dilemma between us, seemed to further Gerald's capacity to reflect upon his own process without my first perceiving and speaking to him about it. I have the impression that our capacity to *both* register the fusion-distance opposites gave Gerald a sense of trust in my dedication to being with him, so that reflection and discovery on his own did not risk the loss of me—i.e., it softened a belief that if he had his own power I would vanish, for he would no longer need me.

In later sessions, Gerald spoke about "getting his mind back." For example, at times he could be with people without feeling fused, or could notice when he was fused and to what extent. "I can say what I want," he declared, "and see when I'm fused. Then I feel anger at this fused state. . . ." Gerald's anger signified a new awareness, a sense of the "other" having reality, that gave him some release from his own Fusional Fields.

He was elated at having perceptions without being fused with others, a new ability that was like a birth of consciousness. He spoke of "seeing the anger in many places, in anything I was doing. It was there. I could feel it in my chest. After four days I became anxious that this state of clarity might leave." Indeed, the next day he felt paranoid at work because of a dispute with his boss, and he

"lost the good state." He again became fused with people at work, and when he spoke with me he had forgotten about the anger. When this happened, however, I could remind him, and gradually Gerald could again feel more separate from others.

An important ingredient of Gerald's process at this time was something that occurred totally without my input: he began to actively enter into and experience certain fantasies, rather than be passively fused with them. "The other day I felt fused with people at work. I imagined that I was angry, and I even was able to feel it a bit. Then there was a relief that I felt in my body. My chest pains left. I was less tense and I could relax. I said to myself [about the anger], it's right, it's true!"

Gerald was gaining the beginnings of freedom from the deep pull of the Fusional Complex. When he felt I was not totally attuned to him, he could regress and feel that he had stopped existing unless I first saw into him. When a new love relationship waned, he would revert to passive fantasy as a container. However, this was never as intense as it had been, and when he felt connected to me, or to another person, his fantasy life would sharply diminish. As his Fusional Complex lost strength, Gerald felt a self that was growing, as though, he said, "It had been lost in my fantasies."

Some of this work was represented in his dream life. In one session Gerald related the following dream he called a nightmare: "A man kills a talking fox. I go to call the police to apprehend the man, but he is much stronger than me. I try to fight him off." Gerald reported that he tried to go to sleep after the dream but soon awakened to another nightmare of being attacked by the same man, who was terribly strong.

The man represented energies of Gerald's paranoid process, perhaps associated to me, as someone who was also now danger-ous, for he had revealed his deeply aggressive feelings toward me. The fox, as so many fairy tales demonstrate, represents instinctual

wisdom, and is often the only figure that can help the hero in his tasks—in Gerald's case, developing the capacity to take ownership of his own feelings and body-instinctual awareness, especially with a woman. A talking fox would mean that this capacity for feeling and instinctual wisdom was approaching a human form and conscious awareness. Injury to instinctual life, common in the dreams of people with severe trauma, shows how paranoia can kill the energies and capacity represented by the fox.

Gerald was disturbed by the fox's death in the dream; still, the very existence of the talking fox was a good sign. To have a "talking fox" as an internal image would register as a newfound capacity for creative imagination along with body awareness, neither of which Gerald had ever known except in brief intervals.

The following night there were dreams in which a man, whom he associated to me, was helping him fix a bathroom, probably symbolic of a place of instinctual release. Gerald said, "The man has no fear of abandonment." He further associated his severe and chronic chest pains to his abandonment fears, which would erupt if he separated from the fusion of any interaction.

In the next session Gerald reported that the previous day he had been anxious and thinking about his paranoia, and felt severe chest pain. He added: "I felt I had been in fantasy life so much that I was getting sick of it. The paranoia was also annoying me, rather than frightening me."

Then, rather than actually rock his body to music to quell the pain, as he would usually do, he had *imagined* swaying.

> In my head I imagined movement, like a swaying movement in my chest. I did this for about ten seconds, and the pain left! In the past, actually rocking was a way of escaping the pain. Now I felt like I was wrapping something around the pain, and I think this covering was the swaying fantasy.

This was another remarkable change, from a total immersion in passive fantasy to making the fantasy process active. In a later session I was surprised to hear:

> This morning I imagined I was a very young boy wanting milk from my mother and not getting it. The pain suddenly increased so sharply that I couldn't stand it, but I was able to back it off by managing to stop thinking. In the past, I would have had to go into passive fantasy and rocking myself to avoid the pain.

Gerald's process was a birth out of a chaos that he had survived through a tortured existence—or, better said, through a battle with nonexistence, suspended in the fusion-distance opposites. The terror of not existing ran through his life, and after we had worked through his Fusional Complex, especially uncovering his rage and the extent of his passive fantasy life as a substitute skin, Gerald experienced being a separate self. He no longer needed me to think for him. He began to approach the chaos within him, rather than frantically clinging to thoughts or outer objects. His subtle body was gradually repaired so that he could feel some of the dreaded state that had once dominated his life without becoming engulfed by it. For example, he recalled, "I remember a time when I would get a feeling of being engulfed, like I could fall into a black hole, and I'd immediately get up, go into another room, and begin rocking. The memory comes from age eleven, but was probably what I always experienced." Such reflections and growing ego-strength became commonplace in our work together. A self had finally begun to incarnate, as though Gerald's life had begun.

9

ABJECTION, BLAME, AND TRANSMISSION

OUR ABILITY TO EMBRACE A DEEP CONVICTION, AND THE expression of our essential nature, falters under the possessing power of the Fusional Complex. Instead, we become something else—false, partial, unrealized. What lies deeply within us—our best and most cherished desires, of which we may only have a glancing impression but which we know exist—remains stillborn, suspended in the "impossible" opposites of the Fusional Complex.

Rather than embrace suffering the Fusional Complex as a path of individuation, we tend to take refuge in an inner, safe territory of fantasy and passivity. However, this merely adds to our burden of shame at our unlived life. In a vicious cycle, we exclude the Fusional Complex from our awareness, disown our desires, and exclude the self, fearing the risk of attack that comes with being a separate person. Ultimately abject to ourselves, we feel unlovable, without value, even disgusting.[1]

This ancient and ongoing script of the human condition is replayed in analysis whenever the analysand's Fusional Complex is enlivened. The analysand is experienced as abject—even disgusting, contaminating—by the analyst. Abjection rules the field, creating a tendency in the analyst to withdraw both from the field and from the analysand, to avoid being contaminated by the other's energy, desire, body, and madness. Especially when the

fusion-separation opposites are far from consciousness, deeply entangled within the unconscious, a sense of strangeness and revulsion seeps into the field.

For example, an analysand reported that someone had approached him asking if he wanted a job doing electrical work, which was his specialty. He knew that he didn't want the job, but he said that he didn't exactly say no. He "sort of said no," and described his process as being "viscous"—a good metaphor for the abject quality of the Fusional Complex.

This man cannot fully say yes or no because to do so—to consciously own his authority—seems taboo. Hence his clients often feel confused. The abject quality of his Fusional Complex blurs and opposes boundaries, for the separation they signify would threaten the fused form of safety he achieves through not being clear. His "viscous" behavior is also self-castrating (typical of the Fusional Complex), e.g., he has difficulty billing clients.

As this analysand described his "viscous" process, I felt as if I was pulling back from him, anxious to avoid any emotional contact. In my own experience, and in supervision of many cases where the Fusional Complex is the central issue, the analyst shies away from a sense of "stickiness" with the analysand, as though any emotional contact would result in the irreversible transmission of something foreign and deeply disturbing.

Jean-Paul Sartre's conception of *slime* addresses this condition. Slime is that "which reveals itself as essentially ambiguous, because its fluidity exists in slow motion; there is a sticky thickness in its liquidity" that threatens to form an "appallingly new substance."[2] Malcolm Bull comments:

> Slime does not merely melt into itself; it threatens to dissolve other boundaries as well. To touch the slimy is to risk being dissolved in sliminess; [as] slime sticks to the fingers, so too, in the act of appropriating the slimy, the slimy pos-

sesses me, eliding the distinction between self and non-self. The dissolution of difference is instantly contagious.[3]

Fearing a transformation into an "appallingly new substance" through the dissolution of boundaries, an analyst will often recoil from emotionally joining with the analysand. Often he or she will hold back from sharing such experiences in supervision, ashamed of his or her resistance to leaning into the field with the analysand.

Abject states, in analysis, can cause irritation and confusion over what would appear to be straightforward issues, such as scheduling. An analyst in my supervisory group asked an analysand, in an attempt to clarify what had been said the previous week, "Will you be here next week?" Dismayed, the analysand pointed out that he had said, four times, that he would be away! Indeed, in a transcript of previous sessions that statement would clearly appear in four instances. Yet each time there had been an opposite slipping about that "said" something like "Maybe I will be here, I'm not totally sure." This opposite did not have the form of a clear statement, or even an "anti-world" of psychotic process, but rather of a hidden, lurking doubt enfolded within the analysand's answer. That murky, strange quality of the abject inner life of the Fusional Complex was communicated in each statement, so that the analyst inwardly questioned the analysand's response each time it was given.

Another analyst reported being confounded by his analysand's seemingly clear statement, "I won't be here in two weeks." Hearing this, he found himself wondering if the analysand really meant it, or if there was a chance she might actually come to the appointment. He was unsure of how to respond to the statement,[4] feeling that to express his doubt would have been to infantilize her, as if she could not know what she actually wanted to say.

The analyst reported his reflections on his inner process and past experiences with the analysand:

If I say nothing and delete her appointment from my schedule, often she will later ask for the time. Furthermore, she will ask in a way that infers that she has been abandoned by my giving away the hours in question. Yet, if I keep the time available, she will ask me if I still have it open, and then, while still unsure if she wants the time, will complain that it is unfair to be charged for the hours. This has happened several other times, and I feel bewildered and disturbed by the interaction.

This time I said: "You gave plenty of time for the cancellation. I chose to keep the time open." She replied, "Do you do this with everyone or just with me?"

Then he explained that he began to feel a desire to get rid of her and felt guilty. In turn he then tried to convince the analysand that she was special. Anything to stop the pain of the interaction!

The communications of someone with a strong Fusional Complex are filled with contradictory opposites. Rarely do we hear a sentence that communicates a clear sense of pain. Though we hear of the terrible suffering and humiliation of a soul unable to get anywhere near to its beauty and potential, whatever is said is subtly wiped out, so that at the end of any attempt at listening we feel as if whatever we have thought or felt has drained out, like water from a sieve. This alone could be helpful if we could realize that this absence of a container is exactly what the person suffers. However, our own confusion and pain at such times too often precludes such useful reflection.

* * *

When the Fusional Complex is activated, the subject can display the acute sensitivity associated with deep psychic capability. This "gift of sight" can prove a curse, as the person compulsively

uses it to stay fused with others, who in turn find the person abject.

One such analysand, Frank, would experience massive panic attacks whenever he went away to camp, or to an academic program in another state or country. If he was not brought home, he would become suicidal—yet upon returning home he would be fine, as if nothing had happened. Antidepressant medication never seemed to help for more than a week or two. Frank and his parents were desperate, and wondered if he would always have to be near home.

Over a period of four years Frank had seen numerous psychotherapists and had been given many diagnoses, including depression, dissociated identity disorder, infantile personality disorder, and panic disorder. Another analyst stressed family dynamics as a major toxic issue. These various diagnoses always held out some initial hope of understanding, but they were of more use to the particular therapist than to Frank, and none amounted to much as far as treatment was concerned. This changed when Frank began working with an analyst whose work I was supervising, who could focus upon him through the lens of the Fusional Complex.

The analyst discerned that Frank's extremely sensitive scanning ability kept him at a distance from her, and that it was primarily Frank's body, and not his mind, that was flooded with fragmentary feelings and sensations. In interactions with another person, when his anxiety suddenly mounted, Frank would often blurt out the question: "What just happened?" The person, for example a family member Frank was addressing, would usually feel annoyed and accused of doing something wrong. What was "wrong" for Frank could be the other's slight withdrawal from the conversation—not a total, manifest act but a voice tone, a bodily gesture—or a perceived shift in the other's emotional state. Irritated and angered by Frank's demands for relatedness, his family and friends

found him a terrible "pain in the ass" and withdrew, leaving him feeling isolated.

It was essential to Frank's healing that the analyst give words to his distress. This meant describing back to Frank what he was experiencing. However, this technique was only effective when the analyst was relating from her own awareness of this level of sensitivity and her own felt danger of "falling into nothingness." Furthermore, she needed to engage these states of mind and body as field qualities she experienced as she leaned into the field with Frank, and not envision them as *induced* states of mind and body from Frank's Fusional Complex. If she spoke "from her head," no statement, no matter how accurate, was of use.

In this instance, the analyst felt her back to be vulnerable, as if it was open to being invaded by psychic attack. Having the courage to breathe into her body and feel her fears as inner aspects of her being that she did not identify with, but related to, she could go to the edge of experiencing this frightening state without falling into it. As she felt her fear, she could begin to perceive Frank in ways that enabled her to give words to his experience—his dread of annihilation and the nature of his lack of feeling contained. She could especially notice and find words for Frank's extreme vulnerability, related to a sense of a kind of torn psychic skin covering his back.

Frank could appear to be extremely pathological when observed from a mental or psychic point of view. However, when the analyst perceived Frank through an embodied and aperspectival awareness, engaging the information transmitted through the subtle body field, he appeared not primarily as pathological, but as extremely sensitive.

One might say that Frank's disorder had a strong cultural component, for he was easily overwhelmed by the kind of logic and incessant "doing"—his own and that of others—that drives modern, technological society. In earlier cultures, people like Frank

were healers, shamans, and seers. From a modern, scientific viewpoint they can appear as very ill and in need of medication to help contain their panic and anxiety, yet such people are very difficult to successfully medicate. From a "primitive" or "magical" awareness they appear as sensitive tuning forks that can offer a great deal to society and to relationship. They are among the more sensitive psychotherapists I have known. Often these therapists suffer terribly in the world of personal relationships, but in the safe, containing confines of their consultation room, they can work wonders.

People suffering in this area of psychic life are very connected to the archetypal core of the Fusional Complex, and seem to have exquisitely sensitive fibers that are invisibly attached to an object. They register the minutest instances of physical, mental, or emotional withdrawal. As in Frank's case, this can be extremely disquieting to the person receiving this unwanted attention, especially because he or she is usually unaware of having withdrawn at all. However, the sensitive person is actually uncovering areas that the other person, targeted by this unwanted vision, would prefer remained unknown. Slight feelings of irritation, discomfort, or mild anger in the object strike the sensitive subject as powerful and dangerous currents that are only more dangerous as they are denied.

Another's anger or mechanical, unrelated way of being, which the object may even feel he or she is containing and toning down, can feel like a dagger that goes right into the sensitive person, creating great physical and psychic distress. The object is often bewildered, feeling only a slight change in voice tone, a barely significant sense of irritation, etc. Yet the subject responds as though a catastrophic event has occurred with major consequences for the relationship.

Because even un-projected unconscious states existing in potential can have a very destabilizing effect on the sensitive subject, the analyst must be willing to take ownership of what the

analysand perceives, and must search for where the analysand is right, not where he or she is exaggerating or distorting (which is not to say that confrontation when one believes distortion exists may not also be appropriate). Frank strongly desired the truth, and in the face of the truth, he was remarkably forgiving of the pain he suffered from being regarded as a pariah.

Generally, in the face of the Fusional Complex, the analyst experiences a mental blankness or fragmentation, a feeling of becoming overwhelmed and disembodied, and sometimes severe body and psychic pains, leading to desperation: "I can't do better. Everything I say is wrong, nothing is received." At such levels of the Complex one often faces fundamental issues of good and evil. The analyst can feel up against something so dark and destructive in the field with the analysand that all he or she can do is realize a fundamental limitation in facing the nature of the chaos between them. The analyst must accept the subjectivity of his or her experience, and never default into a belief that no one else could help the analysand.

There has to be a conjoined willingness to face the demons of madness and other abject states, and not place them inside one person or the other. It is when one or the other's paranoia is very strong that trust fails in such a joint effort. Then the "dragon" of fusion and chaos is not killed, but the treatment can be. Generally, in relationships, psychotherapeutic or otherwise, my experience is that it is rarely sufficient that one person alone deals with his or her Fusional Complex. Rather, the fate of the relationship will hang upon a joint willingness to recognize that both people are subject to a field transmitting the extremely difficult states of mind and body that each would prefer to attribute to the other.

* * *

Abjection leaks through one's defenses. Georges Bataille under-

stood abjection as "the inability to assume with sufficient strength the imperative act of excluding abject things (and that act establishes the foundations of collective existence)."[5] The abject quality of the Fusional Complex is never gathered up into a three-dimensional, containing clarity of insides and outsides. Its nature is to void any form of subject-object distinction.

The sensitivity to transmission of unconscious affects in this abject condition can be so extreme that it feels intolerable. The analyst's unconscious psyche affects the analysand far more than his or her conscious intent. For example, an analyst's desire to "be helpful" can be unmasked as a need to end the painful interaction with the analysand and stem the analyst's own feelings of impotent rage. At such times, any of the analysand's perceptions, strengthened by proximity to the archetypal level of psyche, may be paranoid but also have elements of truth.

The analyst can then feel seen or unmasked in a devastating way, as though his or her deepest secrets have been exposed. To somehow break the pain of these perceptions, the analyst is tempted to agree with the "truth" of what the analysand says, yet any such agreement also feels dangerous to the analyst, as though he or she were committing to a marriage, or to a relationship in which his or her life depended upon agreeing with the analysand.

Another analyst began his supervisory session by saying he felt anxious about having told an analysand a lie. He knew that she knew, although nothing was said. They had been talking about a movie the analysand had seen, and, noting the analyst's interest in the movie, the analysand offered to give him her copy of the book the movie was based upon. "I felt frozen," he told me. "I had no words or feelings, just a vague anxiety. I said, 'Thanks, but I already have the book.'"

He was about to go on to the next case when I realized that I had been somewhat dissociated while he was talking. Thinking that this might be an indicator of something important being

evaded, I asked him to say more about the lie. Why, did he think, had he lied? He said he didn't know. Then, after reflecting on this, apparently for the first time since he had seen her, he said, "If I expressed my feelings, which I think were confused and perhaps angry and distancing, I would have hurt her tremendously. I would have had to express my confused state, while she was apparently so loving."

"What would have happened then? Did you feel that an honest response would have been hostile?"

"My words wouldn't have had to be hostile. My response might have been caring, and she would even have taken it as such. But later she would have collapsed and phoned me. She would have become suicidal, and I would have felt blamed."

"Blame" is a major coin of the Fusional Complex. It is one of the main affects transmitted through the field's abject quality,[6] and it can feel traumatizing to an analyst, as it did in this case.

The analyst further revealed that he was repelled by a lurking fear of his analysand's perceptive capacities. Feeling that she might uncover his anxiety at being differentiated from her, rather than reacting to her every word and feeling, he lied to avoid the interaction about the book and its potential for their closer connection.

To him, the analysand was abject, and someone to be avoided at all costs. Yet, as her therapist, he could not allow himself to own these feelings. Thus he descended into the maze of contradictions that often attends any analyst who experiences his or her analysand in such ways. With considerable effort and moral resolve, the therapist managed to reconstruct his actual feelings during the session:

> If I tried to think she was offering something good to me, and accepted the gift, I would have felt false, because in the moment I really did not want it. I felt it as an extension of

her power over me. But I felt I would be destroying her if I rejected the gift, or accepted it less than enthusiastically. The book threatened to become a kind of glue that fused us together, and allowed me no distance and individuality. I felt no choice but to lie.

In a field that precludes connection while at the same time demanding total fusion, an analyst is left with one healthy choice, namely to begin to experience his or her own inner life, as it is affected by the Fusional Complex, and to inwardly care for the soul's anxiety-ridden state. This is a courageous act of separation from the analysand's psyche, an act of autonomy in service of the soul. Clearly, to achieve this, the analyst must be capable of relating to the chaotic feelings engendered by the Fusional Complex without becoming engulfed by them. In this case, the analyst had to develop the ability to contain his feelings of being blamed, while not assigning them to something his analysand was *doing* to him. Rather, blame had to be *there*, as part of their field.

In general, the analyst's fear of engulfment is precisely the thing that threatens the analysand, who cannot achieve an inner relationship with the Fusional Complex through his or her efforts alone. The analysand needs help, but the help can only come from the therapist speaking and feeling *through awareness of this same complex within his or her own person.*

The masculine, rational-discursive forms of awareness that dominate our culture especially hamper facing into and perceiving abject qualities of the field. Generally, where men tend toward separation and expansion of one's state of being, women are far more comfortable with stasis and non-differentiation. It has thus been said that women are liminal, meaning capable of staying in the "in between" world. Whatever can be said about feminine modes of being—which certainly encompass a tendency toward *being* over

doing, and a quality of consciousness that is lunar rather than solar[7]—they surely represent attitudes that can "stay with" and, moreover, value abjection rather than recoil in disgust.

The domain of the Goddess, as it was once a living reality for women, is not ruled by the masculine predilection for separation, logic, and dependable, repeating objects. As Mary Douglas explains in her book *Purity and Danger*, from a matrilineal point of view, rejected qualities of life, for example true contradictions or the weaving, bizarre opposites that Sartre's term *slime* often captures, are sacred. However, in a patrilineal society they are taboo and to be rejected.[8] Perhaps the idea of a shared field, with its own archetypal qualities, is in line with feminine wisdom, while the patriarchal thrust toward separation, understanding, and control only adds to the sense of abjection.[9]

10

THE ARCHETYPAL CORE OF THE
FUSIONAL COMPLEX

ISTORICALLY, THE FUSIONAL COMPLEX IS NOT NEW. ITS madness and tormenting dynamics, taking the form of an inability to either separate from an object or stay connected, are found throughout recorded history, in myth and literature. The archetypal core of the Fusional Complex is probably best represented by the myth of the Anatolian Great Goddess Cybele and her boy-lover, Attis. The most well-known rendering of the story—there are several versions—comes down to us from the Roman author Ovid. He tells the myth as a recounting of the answer he received from the Goddess to questions about why the followers of Cybele mutilated themselves.

In the woods, a Phrygian boy of handsome face, Attis by name, had attached the goddess to himself by a chaste passion. She wished that he should be kept for her and should guard her temple, and she said, "Resolve to be a boy forever." He promised obedience, and, "If I lie," quoth he, "may the love for which I break faith, be my last love of all." He broke faith; for, meeting the nymph Sagaritis [a nymph of a neighboring tree of the river Sangaris], he ceased to be what he had been before. For that, the angry goddess wreaked vengeance. By wounds inflicted on the

tree she cut down the [nymph], who perished thus; for the fate of the nymph was bound up with the tree. Attis went mad, and, imagining that the roof of the chamber was falling in, he fled and ran for the top of Mount Dindymus. And he kept crying, at one moment, "Take away the torches!" at another, "Remove the whips!" And oft he swore that [the Furies] were visible to him. He mangled, too, his body with a sharp stone, and trailed his long hair in the filthy dust; and his cry was, "I have deserved it! With my blood I pay the penalty that is my due. Ah, perish the parts that were my ruin! Ah, let them perish," still he said. He retrenched the burden of his groin, and of a sudden was bereft of every sign of manhood. His madness set an example, and still his unmanly ministers cut their vile members while they toss their hair.[1]

The myth begins with a state of equilibrium, with Attis in a paradisiacal state with Cybele, who wishes that he be "attached to her" through a "chaste passion," resolving "to remain a boy forever." Thus Attis pledges himself to a state of perpetual fusion with the Goddess, never to separate.

Then he finds the river nymph Sagaritis, and through his passion for her he betrays his vow to Cybele. His separation, a move toward individuation, is severely punished.[2] He is afflicted by madness: he hallucinates the Furies attacking him and flees to the top of Mt. Dindymus (i.e., a split from the body), where he takes his catastrophic action: "Ah, perish the parts that were my ruin!"

Mt. Dindymus is also Cybele,[3] and Attis's flight is a desperate attempt to bond with her again in the safety of the mental-spiritual world. He has no remorse for Sagaritis! His only remorse is in having betrayed Cybele, and in his madness he castrates himself.

Thus we see a two-stage process.[4] There is a deeply bonded

state, and then there is a separation from that state, leading to psychotic anxiety. The *galli* (whose actions the myth attempts to explain) re-bonded with Cybele through their own self-mutilation, imitating Attis.

In a version by Arnobius, found in Hesiod's *Theogony*, Zeus tries to rape Cybele as she is sleeping; his seed falls instead on the rock Agdos and produces the hermaphroditic monster Agdistis, an alter ego of Cybele. Such myths have more ancient Bronze Age roots in Anatolia[5] and tell of the ensuing castration of the lustful monster by male gods in order to subdue her, for she is too difficult to control. Her energies cannot be easily contained, and certainly not by qualities of rationality or spiritual life. Male gods castrate her, depriving her of her phallic nature, and in some tales she becomes psychotic as a result of this castration.

The Greek myth of Marsyas, who at times was identified with Attis, contributes another aspect to this study: an important reflection upon hubris (which was anathema in Greek culture) and upon the fate of the subtle body at the hands of the God Apollo.[6] Hubris is an inflation of the personality through identification with an archetypal power, especially through extreme passive fantasy. The subtle body cannot contain power on such a scale and suffers damage.

Marsyas finds a flute, created and then discarded by Athena, who has laid a curse upon anyone who finds and plays it. He plays the instrument beautifully; in fact, his music has a healing and seductive influence on Cybele, who is inconsolable over the death of Attis. He also, however, has the hubris to believe he can play better than Apollo, who then challenges him to a contest. Naturally, Apollo wins, and Marsyas's hubris brings out the "dreaded aspect"[7] of the god, who flays the mortal and hangs his skin from a pine tree.[8] However, when one can, unlike Marsyas, sacrifice the fusion with an inflated fantasy life, Apollo can have a healing, purifying effect upon one's madness. The wisdom attributed to this god, and

engraved at his temple in Delphi, urges mortals to do "nothing in excess," and to "Know thyself," or, more accurately translated, "Know that you are not a god."[9]

Numerous features of the Attis-Cybele myth qualify it as the archetypal core of the Fusional Complex. 1) The "impossible" fusion-separation dynamic is a central feature of the myth: Attis can neither stay with Cybele nor separate from her. 2) The madness of the Great Goddess, the negative numinosum, represents the madness at the core of the Fusional Complex. 3) Attis's madness when he attempts to separate from Cybele illustrates how separation from a safe, fused state can lead to severely destabilizing anxieties of a psychotic scale. 4) The central role of castration in the cult of Cybele has a psychological correlate that is a strong feature of the Fusional Complex. 5) As the hermaphroditic Agdistis, Cybele manifests not only madness, but also powerful passions and violence, reflecting these facets of the Fusional Complex. 6) Attis's despair and regressive return to Cybele, after she kills the nymph whom he desires, is a major behavior pattern of the Fusional Complex, taking the form of a regressive clinging to a "safe territory"—notably unchallenging jobs, rigid relationships, and failure to take up a creative challenge—all of which lead to qualities of an unlived life. 7) Cybele's madness, at the core of the Fusional Complex, breaches defenses and dominates the field between people, leading to a sudden change in the scale of experience, whereby a person can become immersed in emotional turbulence, as though gripped by a riptide in a once-navigable sea. 8) Heroic attitudes fail in dealing with Cybele, just as they largely fail in dealing with the Fusional Complex. 9) Experiencing the madness of the Complex, and the limitations it creates, is a healing path, just as those in the mysteries of the Goddess were cleansed of their mania. 10) In the form of Marsyas, Attis is flayed, emphasizing how inflation results in the loss of the protective skin of the subtle body.

The nymph Sagaritis, in Ovid's myth, represents the more unconscious, feminine side of Attis, and that is exactly what the dark energy of the Goddess attacks. When a man is deeply affected by the negative numinosum in the Fusional Complex, his capacity for relatedness fails, both to others and to his deeper self. He is left without any sense of containment, and tends to go up into his mind, or submit to whoever unconsciously carries his Cybele projection, all in hopes of regaining a sense of potency. His masculinity takes on a castrated form, so that he constantly fuses with other people, taking cues from them as to what is permissible, rarely feeling his own autonomy.

In a woman, the nymph represents her own attractiveness and beauty as an individual self, beyond identifications with her mother (or with her father's feminine side). Under the attack of Cybele, positive self-qualities pale, and a woman can feel ugly and worthless, deeply abject, while her masculine side is also castrated. Thus, for example, she loses much of her capacity for the clear thinking, reflection, and inner connection to the unconscious that masculine images of her psyche usually carry. Also, she has difficulty relating to the outer world without losing her identity in fusion with outer objects.

The unconscious structuring of a male-female interaction by the Attis-Cybele myth can be seen in an analysand, John (also mentioned in Chapters One and Four). John related a conversation during which he became impatient with his wife, and she reacted by, as he said, "giving me the cold shoulder." Throughout that day and the next, his experience of her reaction lingered with him. The hurt he felt did not dissipate, and he and his wife felt very alienated from one another.

John proposed talking about what had occurred between them, but he also realized that he also had another need, which was to continue working on a poem he had been writing. He suggested talking for forty minutes, then getting back to his work and

returning to their conversation if necessary later that day. His wife agreed to this. However, as the forty-minute limit approached, he and his wife were, as John said,

> . . . in mid-process, and I was torn between continuing to talk and attending to my own need to write. We went on talking. I felt unheard, she felt unheard. I then had what felt like an inspiration, and I told her that I realized that she had been put through a lot of pain by my being impatient with her the previous day. But my attempt was shunned, totally rejected.

In what follows we can see the effect of the more forceful activation of the archetypal core of the Fusional Complex, illustrating a sudden "change in scale" of John's emotional life:

> I snapped and became enraged at her coldness. I screamed at her: "What do you want from me?" I felt a searing pain in my chest, as if I had been shot with an arrow. Totally uncharacteristically, I started beating my chest, pacing, loudly ranting. I ran into the other room and smashed a chair. I felt young, anxious, and totally humiliated. I have never, ever reacted in this way to anything.
>
> But I felt I reached her. She held me and gave me some sense of physically being contained. Though I was warily "scanning" her for danger, I was also comforted that she held me, and glad that she was no longer being cold, or angry, or crazy, and especially that she no longer blamed me for everything while taking no responsibility herself.

As Attis goes mad and castrates himself, John had an episode of madness as he broke a chair and lost emotional control. In the process of regressing to a young state, he found protection with his

wife, as in the cult of Cybele her followers, the *galli*, found protection by castrating themselves in total devotion to her.[10] But, like Attis, he sacrificed his need to work creatively.

In a sense, John served Cybele by being loyal to a kind of limited psychic "territory" that he rarely ventured out of, and that kept him from fulfilling his considerable creative gifts. When he dared to separate and care about his own needs, extreme anxiety pushed him back toward his safe territory and away from serious creative work. In this way John's story shows a failure to positively and lovingly relate to his own feminine side, represented by Sagaritis in the myth. This ability would have enabled him to separate from the sphere of the Fusional Complex as it dominated interactions with his wife. Instead, he "separated" in the inferior way of becoming moody and "irritated" with his wife, then abandoning his creative work.

Recall, too, that after Sagaritis is killed, Attis feels grief—not for the nymph, his love object, but for having betrayed Cybele. John, too, felt guilty and at fault for not being connected to his wife, and for his forced and disconnected attempt at being empathic. He saw his betrayal of his wife, but not of his own creative needs. Any sense of a living, inner reality had vanished for John; his attention was all on his wife and his remorse toward her.

At times, telling the Attis-Cybele myth—a process Jung called "amplification"—can be useful. Seeing the mythological parallels to personal experience can provide a larger and often containing context that may engender a sense of meaning. In this case, John felt he gained a kind of personal narrative, and that the myth "encapsulated many issues, especially chronic feelings of blame or fault, which I have been swamped by in my life, rather than feeling my grief for abandoning my own soul."

John realized that his life was, as he said, "laced with blame." In his mind, any possibly conflicted situation with his wife was ruled by either his or her *fault*, for such is the economy of the

Fusional Complex. The fear of feeling blamed distorted his perceptions, so that he experienced a simple question from his wife as an attack.

There was little if any possibility, in any of John's relationships, of a genuine interaction in which both people would partake of a shared field or recognize that both have parts of the struggle to account for. Instead, someone had to be blamed. John realized that his "false blame" had been a safe territory where he could avoid realizing his guilt at his abandonment of his soul. The myth, he said, "helped me feel more solid and flexible. It helped me to see that I am not alone. As I look at other men I know, and at collective life, I see everyone suffering in this way." In the moment that John reflected upon being part of this larger reality, I could sense his body relaxed, as though young parts of his inner being could now feel safe.

* * *

Based upon many years of supervision of psychotherapists, and reflection upon my own cases from my earlier experiences, I believe that the jump in the scale of emotions created by the archetypal level of the Complex is far more common than one might assume. This next example focuses upon the inability to contain the archetypal energies of the Complex as an "inner" state, and demonstrates the need for the field as a higher-dimensional container.

Roger, a thirty-eight-year-old psychotherapist who was particularly gifted in perceiving another's psychic states, including the condition of the subtle body, reported having had a very loving experience throughout most of the day with a woman, Wilma. Their conversation had largely focused upon her upcoming graduation from school, a transition that was causing her a great deal of anxiety. On the one hand, Wilma's anxiety connected to this change was understandable. On the other, there

was something in the way she spoke about the situation that Roger felt to be puzzling; her complaints and fears seemed odd to him, but he could not easily put this uncomfortable sense into coherent thoughts.

He explained to me that he had tried to be empathic, and thought he had largely succeeded in being "there for her," not engaging in any intrusive "problem-solving" efforts that only would have made her feel worse, and not asking questions that he sensed would only raise her anxiety. Somehow questions of any kind, "information gathering," seemed to be most difficult for her, leaving her nearly mute; he found this especially puzzling. He repeatedly thought, but did not say, "I'm here to help you, you have skills, so why is this transition so difficult?"

Roger then spoke of what turned out to be a pivotal event during the afternoon: he took a walk outside and smoked marijuana. Wilma had strong feelings about his drug use, which he had reduced over time to perhaps once a month and was considering stopping altogether. After his walk he returned to her, not mentioning what he had done, and they continued having what he described as an intimate, loving time together.

At the end of the evening, he was feeling some guilt for having used marijuana, became unhappy with his secret, and told Wilma the truth. Her response surprised him. She said, "You're deceptive."

Roger knew her remark was accurate. He thought of other instances when he had been deceptive, noting how he hid certain thoughts from her. He was not used to her saying things that were so centered and insightful; usually he was the one to bring awareness to darker, unpleasant aspects in her, or in their relationship. What was so significant, in view of what followed, was that he could inwardly contain this "body blow," as he called it, think about it, and not feel that she was attacking him or judging him. Wilma's remark hurt, but as he heard and reflected upon it, she felt like an ally.

One could say that Roger could *inwardly contain* his reactions. A functioning self existed, and the deceptive "shadow side" of his nature could be recognized as an aspect of his personality. He could own this awareness without dissolving in guilt, without losing sight of his other qualities such as a capacity for honesty, and without feeling "narcissistically wounded," in which case his self-esteem would have plummeted. Instead, Roger had an inner container for the experience, and a capacity to reflect upon a variety of forms of his reactivity, such as anger and anxiety, and not act upon them.

Wilma then looked at him and said: "You've not been present with me today." Hearing this, Roger felt "hit, disoriented, blamed, confused, and unable to think." He described the feeling as a shock to his system, a sudden shift in his emotional state that was totally discontinuous with what he had been feeling a moment before. Anger boiled up within him, and he wanted to insist, "We just had such a wonderful day, you spoke about how present I was, and now you say I wasn't present! This is unfair and deeply wrong."

These feelings were accompanied by an unusual and severe physical discomfort in Roger's chest and head. As his anger mounted, he barely managed to keep from directing it at Wilma. He felt like a "trapped and wounded animal, caught between the desire to run away and the urge to strike out in desperation." After a few moments of silence, he began to think, "She wants to destroy me. She'll kill me if I stay with her. She's dangerous. I have to get away. Thank God I've made no commitments. Maybe I promised too much about being there for her as she transitioned to working." His love vanished. At that moment, his hatred was dominant.

It is no small matter for a man to hear about his darker, unpleasant qualities from someone with whom he is vulnerable and still be able to maintain his sense of identity and interest in the person. Roger could contain, as an inner experience, the first communication about his being deceptive. However, the second com-

munication led to a totally different state in which his functioning self was barely available. Roger could contain some of his reactivity, as when he restrained himself from acting on his anger, and there was some limited capacity for reflection; for example, he was aware of the unusual strength of his reactions. However, much of his response was uncontained, for he was emotionally flooded, overwhelmed with anxiety, disoriented and near panic—a change in the emotional scale characteristic of the Fusional Complex that had constellated between himself and Wilma.

When Roger remembered to breathe deeply and felt a bit more centered, he managed to tell Wilma that what she had said felt very unfair. He told her he felt hit by a low blow. Still, he also realized that whatever was occurring he could not feel as "in him" or "coming from her." The best he could say to her was that whatever was going on was in the space *between* them.

Experiencing his interaction with Wilma in that way took a great deal of will and consciousness. It was tempting to slip into thinking of his pain as something that "she was doing to him as a result of her pathology" or as a repetition of his chaotic early life experiences with a depressed mother. Roger knew such options to be seductions that promised a kind of knowledge rather than openness to the unknown between them. He sacrificed such "pathologizing" and described a feeling of openness returning to him. Silently, this seemed to affect Wilma, who could then recognize that there had been a radical shift or discontinuity in the sense she had of *herself*, between first pointing out his deceptive nature, and then remarking that he had not been present.

As Roger further reported, Wilma realized that she had taken a great risk in saying what she had said. For, even though she knew Roger had been very present throughout the day, in the level of psyche that was emerging in her, and in which she feared an engulfing chaos that could extinguish her identity, she realized that she required even more of him. She needed him to be "psy-

chically glued to her"—and, given her shame at owning her need, acknowledging this dependency took a great deal of courage.

During our next session, Roger stayed with his feelings toward Wilma, remembering the shock and sudden shift he had felt when she questioned his being present to her. His dreams were filled with violence, and he could see that he was still reacting in anger toward her. He could then further reconstruct what he had felt at the time, remembering that he had wanted to rush toward her and say, "It's okay, we'll work it out." Then another, opposite thought totally displaced the previous one: "I'll counterfeit myself, lose or distort who I am if I do this. I cannot be with her." These opposites—working things out, and being unable to be with her—were contradictory states that he felt as a total fusion and a total disconnection. He could not hold one in his mind without the other then manifesting and destroying all memory and awareness of the previous, opposite state. They were mutually annihilating opposites—like the "duck-rabbit" sequence we have described in earlier chapters—forming a madness comprised of contradictory states that were each true. In this way, Roger eventually realized the power of his own Fusional Complex, which he could see existed quite independently of the relationship.

Relationships, like psychotherapy, can be plagued by not knowing what to do with such odd, painful, mad, and uncontained states as Roger and Wilma experienced together. Often, a positive outcome rests upon a single factor: Will both people open to the field and the mutuality in the process between them, or will one or the other withdraw into a paranoid space of "being right"? That is not an easy matter, but neither is a relationship.

*　*　*

There is an especially interesting aspect to the Attis-Cybele myth that it pays to explore: Why did the Roman authorities (in

205 B.C.E.) invite Cybele, known as an ecstatic Goddess in her Anatolian homeland, into Rome? Inviting a foreign God or Goddess into their society at times of great stress was not unheard of, but it was hardly common. Various suggestions have been offered and argued, notably that the Romans were weary of battle with the armies of Hannibal, and consulted an oracle who demanded that Cybele be brought to Rome. Whatever the cause, we must assume that the collective consciousness of the time was worn out and needed an infusion of new energy. But Cybele! Perhaps the Roman collective was so heavily patriarchal, and so cut off from the chthonic realms of the Great Goddess, that a radical change was needed.

I think there is merit to the thought that the ubiquitous nature of the Fusional Complex in our culture is also an unconscious response to dominant patriarchal, martial attitudes, and to the rational-perspectival consciousness that rule our collective life. The Attis-Cybele myth engenders a very different attitude. Embracing the opposites of fusion and separation requires a different form of awareness, such as Gebser's aperspectival consciousness; and valuing madness, indeed being affected and limited by it, flies in the face of rational ruling attitudes as they have existed for thousands of years, and especially in our time.

Tales about Cybele in her Roman time emphasize her danger and her madness. In particular, the poet Catullus wrote: "Great goddess, goddess Cybele . . . may all your insanity, Lady, be far from my house. Drive others to frenzy, drive others mad."[11] However, the cult of Attis and Cybele also records that through suffering madness and feeling its limiting qualities upon our freedom, one is cleansed of madness. Thus a remarkable purpose is given to one's suffering.[12]

The myth and associated cult say that suffering the madness of an inner, overwhelming state in the attempt to separate from an old order is a healing path. Consciously suffering one's felt limita-

tion may be an agony, but it also heals. From another vantage point, the myth says that seeking new forms of union, here as the union of Attis and Sagaritis, results in a counterattack of overwhelming disorder. That is, severely disordering states are seen as a *consequence* of trying to establish a new order. Such awareness often allows one to suffer chaotic states, lending such states a meaning that is otherwise absent. Furthermore, a great deal of literature may be brought to bear upon the function of created disorder, and this especially helps with containing the chaotic fields that must be suffered, rather than heroically overcome through created more order.[13]

The mythical approach gives meaning to our felt limitation, something Lacan enunciated in his dictum that "Not only can man's being not be understood without madness, it would not be man's being if it did not bear madness within itself as the limit of his freedom."[14] It also helps us have compassion for our fears of separation, and for the fact that, to one degree or another, we live in self-limited psychic territories and practice an associated self-mutilation. The myth tells us that people have suffered this condition for millennia, and have grown through it. In the next chapter, which focuses upon the Fusional Complex and creativity, I discuss a case in which such deep, conscious suffering resulted in a remarkable transformation of the self, and of the quality of creative output.

<center>11</center>

THE FUSIONAL COMPLEX IN CREATIVITY

T HE FUSIONAL COMPLEX OFTEN UNDERLIES CREATIVITY
problems, where it can form a nearly impenetrable barrier
to engaging with one's art. Suffering can be so intense and
humiliating that, as the alchemists said, "not a few have perished in
the work." Yet, if the person has the spiritual spine and sufficient
support to have faith that he or she is in a *process*, and that the suf-
fering endured is meaningful, it is remarkable how the Fusional
Complex becomes a doorway to a creative deepening in the course
of recovery. Then, in retrospect, a long and painful process can be
seen as having been a mystery leading to a "rebirth" of creativity
that does not merely take up where one left off, but appears with a
new vitality and depth. This chapter focuses on the story of Phillip,
a man whose creativity languished for years until it was reborn via
his suffering through the domain of the Fusional Complex.

I saw Phillip three times weekly for the first eight years of his
analysis with me. He was a successful artist, with works in major
museums and collections, who entered into treatment at age forty
because he had panic attacks when he flew in airplanes. However,
it soon appeared that a deeper quest for self-knowledge was a far
more important factor in entering into analytical work.

Phillip was from a highly cultured, European background; he
was very well read, and continued to read and explore the frontiers

of art and culture. His work as a painter was his main passion; he would paint at his easel daily, for twelve or more hours, and then have energy for other interests. Yet his outer life was very limited. His relationships were mainly with much older women who adored him. He had once had a love relationship, some five years before he entered analysis, but when the relationship became troubled, the lover's rage so terrified Phillip that he fled and hid from him for years after the event.

Our analytical work initially focused upon Phillip's early history and his dreams. Images of being too high on structures, and anxious attempts to get down, were common, representing his identification with mental-spiritual life and difficulties with becoming embodied. After about two years Phillip mentioned that his flying phobias had vanished and he could now fly with no anxiety at all. It would appear that the work of bringing his ego into closer relationship with his dream world, helping him to become conscious of anxieties linked to aggression and separation issues, and the resulting expansion of ego-consciousness, had achieved the resolution of his symptom. This process also seemed to deepen his relationship to his work, as a high level of creativity seemed to pour out of him. Yet I had all but forgotten about the phobia, which never occurred again, for the real work clearly lay in Phillip's relationship to the unconscious, and to his maternal experiences in particular.

I marvel today, looking at my notes on his case, that for nearly six years I saw Phillip's relationship with his mother—as did Phillip—as perfect and beautiful. During these years, I once considered writing up his case as an example of the most loving mother-son connection I had ever encountered. He spoke repeatedly of his mother's beauty, of how he adored her and only wanted to be with her. As a child he suffered agony when she left him, even for a few moments.

His mother was a painter, and when Phillip was five years old, he began accompanying her to her studio. There he sat on the floor for hours, painting as she instructed him, and gazed at her beauty. In all his remarks about his mother I never felt his splitting of his experience of her through idealization. He conveyed a picture of beauty in relationship with her that I never doubted.

In going over childhood memories he told me about being so enraged when she left him, as a five-year-old child, that on one occasion he had destroyed her cosmetics, and on another he had cut up her clothes. As aggressive as these acts were, he could make nothing of them except as isolated instances of the anger he felt because he so missed her. When he was fourteen his mother had what he suspected to be an affair with his much older cousin, and he recalled pushing her in a rage, clothing and all, into a swimming pool. He said she found this funny; I doubted that somewhat, but this was the only instance in which I remember any sense of disharmony between Phillip's recollections and what might have actually occurred with his mother.

I cannot explain why, but at one point, near the end of the sixth year of our work together, I looked at him while he was talking about his mother, and I *saw* something totally incongruent with the love he was describing. It was like a passing shadow, something dark in my mind's eye as I looked at him. I think this was the first time I *saw into* Phillip, and I told him that I had caught a fleeting glimpse of something dark in his history with his mother.

This act of *seeing* seemed to trigger the uncovering of memories—not events remembered for the first time, but a new ability to talk about things Phillip had always known. The events I am about to describe were so completely dissociated—encapsulated might be a better word—that I had been unable to discern them in the previous six years of treatment.

Now Phillip spoke of different stories of life with his mother

than he had previously shared. His aunt had told him that when he was two or three years old, perhaps younger, his mother had stuck pins into his hand when she was angry with him. On one occasion when he was still a toddler, she had raged at him, yelling that she hated him and wanted him dead. Other family members restrained her.

Phillip did not recall these events as his own memories, but several years after telling me he asked his mother and she confirmed their accuracy. She also confirmed that, after giving birth to each of Phillip's three younger siblings, she had sent them away to another country, where a nurse cared for them until they were eight months old, then brought them home. Phillip was the only child who had spent his first months with his mother. When he asked his mother about her hatred of babies, she agreed, matter-of-factly. That was just how she felt.

These stories had a ring of authenticity, even before his mother acknowledged their truth. Both Phillip and I were perplexed as to why he had never spoken of his mother in these dark ways. He certainly never withheld information, and his picture of a beautiful connection with his mother was something he completely believed and transmitted in a cohesive, credible way. Now the picture totally changed. A monstrous image appeared—a woman who sticks pins into the hands of her children, hates them, at least as babies, and totally abandons them. I felt as if I was hearing about a witch in a fairy tale, but this was a real-life story.

This recognition had severe consequences. It was as if a hidden door opened, and as we explored Phillip's powerful, emerging anxieties, his capacity to paint sharply diminished. I only then learned that for his entire life Phillip had resorted to passive fantasy, often for many hours at a time, which appeared to have acted as a "substitute skin" that protected him from these anxieties. It also helped to maintain a strong split between his experiences of

his mind and his body. Essentially, through fantasy Phillip lived as a mind without body-awareness.

A dream from this time in our work was poignant. Phillip was walking down a mountain to the sea, but there was a road to the left that led to a beautiful garden. He decided to go into the garden and sleep, and not continue down the mountain. For years after this we would reflect on his withdrawal into sleep and fantasy—especially with the use of marijuana, which began later—as "choosing the garden." The sea, in this dream, turned out to represent Phillip's unconscious life of overwhelming anxiety, against which dissociation served as his major defense.

Notwithstanding his passivity and fantasy life, Phillip had been a very diligent painter. When he went to paint at his canvas he felt he was with his mother. However, when the "forbidden door" opened and the witch-like nature of his mother became conscious, Phillip could no longer paint. Now when he approached his canvas he could focus for only a few minutes before he was immersed in intense anxiety. Where once the canvas had been his beloved object, now it was a dreadful place. When he withdrew from painting, and read or wandered in the city in which he lived, he felt no anxiety, yet a terrifying anxiety erupted at his canvas.

Phillip's intelligence and spiritual nature helped him begin to understand that he was in a process kindled by the truth about his maternal background. Yet this process now threatened his career. In our work initiated by this awareness, at times I carried the projection of his father, who had done nothing to protect him from his mother. A therapeutic container was intact, but it was stressed. Help from antidepressant medication became necessary.

Being visual, Phillip had no difficulty creating images of the anxiety he knew whenever he tried to paint. In sessions with me, he imagined birds attacking his head and snakes at his back, lead-

ing to a very painful skin sensation. Such imagery also appeared in his dream life. In other dreams, Phillip encountered powerful figures such as kings or warriors, whom he could "talk" to in an imaginal dialogue[1] in our sessions. His attempts to feel physically close to these figures, to gain the strength he needed to overcome the attacking, anxiety-provoking images and be able to paint, met with limited success: fits and starts of activity that quickly led to withdrawal. Phillip's despair increased, but he never lost faith that he was on a path that was important for his individuation. He continued to deal with the attacking images and reflect on his experiences of his mother.

An interesting development after two years of this agony was that Phillip lost all interest in all the older women friends who had once been very close to him. They were all mother substitutes, and now these relationships bored him. He had a kind of honesty that was admirable in that when he felt deeply about something he did not abandon his belief, even if that meant becoming more isolated while the pain of loneliness became chronic and severe. Yet he kept on for four years, visualizing the attacks he felt and trying to paint, achieving a mere fraction of his previous output.

To cope with the intense anxiety during those years Phillip turned to marijuana, and this became an unsettling addiction. He used the drug to dissociate, for it appeared that only "getting high" gave him relief from an unbearable attacking feeling at the skin of his back. The marijuana blocked his recalling dreams, which was a great loss to Phillip and to the analytic process. However, imaginally relating during our sessions to the few dreams he did recall— dark images whitening, and self-images of circles and squares—kindled faith that even while he was suffering in so ghastly a way, something positive was also occurring in his unconscious psyche.

Psyche often heals on a level of the unconscious that consciousness can barely register. At such times, it is important for a person

to have a mental understanding of his or her experience, even before it has registered in an emotional way. For example, the attacks of snake and scorpion images, which erupted as Phillip approached his easel and began to focus energy upon painting, could be variously understood as the result of incorporation of his mother's madness or her depression, or representations of his inner rage and hatred of her.

It was as though the canvas, once associated with his beautiful mother, had completely changed into his dangerous mother, whose psychotic anxiety was terribly threatening. Much as an autistic child recoils from the mother's body and flees into the head, Phillip fled from his canvas into a fusion with fantasy. Before this panic reaction occurred, Phillip felt a deep pull toward the canvas and painting, yet after a few moments his terror mounted, and, unable to relate to the canvas, he retreated into the safety of fantasy.

Phillip's Fusional Complex thus existed with the canvas. Usually he experienced its opposites, fusion and distance, as a sequence of states; at moments he also could glimpse their "impossible" simultaneity, but to do so brought extreme anxiety. As long as Phillip had remained in a delusional sphere of having a beautiful, wonderful mother, truly living the life of the son-lover to the Goddess, he had appeared to be protected from the terror that eventually broke through and made any work all but impossible. Now the act of painting represented separating from the inner, magnetic fusional pull of the unconscious—mythologically speaking, from the sphere of the Great Mother—and facing an overwhelming separation anxiety, while not losing connection to the canvas. This is similar to the state known as *devekuth* in Kabalah, whereby the mystic *adheres to God* without dissolving in the experience.

Phillip began to feel how a kind of skin layer—not just his actual skin but also an inner, more psychic layer—was attacked when he tried to paint. He could continue to feel and explore his

extreme vulnerability to attacks on this surface, with the concomitant sense of feeling uncontained. His compulsive rush to smoke marijuana and enter fantasies of extreme power and success, becoming (in fantasy) someone his mother adored, was a flight toward a containing structure.

Over the next three years, such explorations and interpretations had some containing effect, but Phillip knew and stated that while they made sense, he could not yet connect the interpretations or images to his actual experiences of his mother. Perhaps the most important attribute of such mental understanding was that it helped Phillip suffer his fate consciously. While he could be angry at his life, at me, and at the limitations he felt, Phillip never felt or portrayed himself as a victim.

∗ ∗ ∗

Amplification from myths such as the story of Attis and Cybele was helpful in Phillip's treatment, for instance reflecting his "castrated" state through a larger, cultural context. As is typical of the Fusional Complex, Philip's behavior could take the form of an extreme fear of and withdrawal from another person's anger into an undermining passivity. His art dealers, both women, terrified him. He could not ask them for what he wanted. The archetypal perspective, and synchronistic events he experienced, helped to defuse the humiliation of this condition, engendered faith in his suffering being part of a larger and even goal-oriented process, and also offered some "breathing space" from his tormented states of loneliness and despair.

The Greek poet Aeschylus wrote: "In our sleep, pain which we cannot forget falls drop by drop upon the heart until, in our own despair, against our will, comes wisdom through the awful grace of God." The numinous level of psyche, through the grace of synchronistic experiences, and through amplification from archetypal

stories such as the Attis-Cybele myth, can create a sense of having a story that seeps into us, "drop by drop." This story, our own story, is larger than the torment of the Fusional Complex. The torment can lessen as meaning arises, but largely through the unconscious—"in our sleep"—whose manifestation can never be predicted. We can "set the table" by the right attitude toward suffering—an attitude that consciously experiences the limitations imposed by the Fusional Complex and its chaos that is never reducible to order. We can realize the necessity for another's containing relatedness during this process. We can adopt the attitude of going toward the abyss of chaos and, as Zen masters say, "taking it"—even more, giving it some description, perhaps through painting or words. Being active matters.

All of this characterized Phillip's process. He could be conscious, or he could dissociate into oblivion. He could realize that he was abandoning his own soul in his regressions into passivity and drugs, much as Attis abandons Sagaritis and stays loyal to Cybele.

While a spiritual component alone—as may be nurtured and even acquired through meditation and creativity, and through an awareness of the effect and guidance of the unconscious in one's life—is never *sufficient* to heal the Fusional Complex, in my experience, a spiritual awareness is *necessary*. Without some sense of the archetypal dimension and its numinosity, attempts to feel the life of the body, especially in the chaotic forms at the core of the Fusional Complex, lead to little but regression into various forms of passive fantasy. Only a caring for soul, a sense of having one's own story and a life with meaning and direction, though it be toward some unknown end, amidst the intense agony and limitations that separation induces, can resolve the Attis-Cybele torment.

Based upon his reading, Phillip became interested in meditation. Several unusual synchronistic experiences helped him to

trust he was on a good path, especially when he called a medita-
tion center, asked for a location near his home, and found out that
the main center was exactly across the street! Such experiences,
through which Phillip *felt* the reality of the psyche, rather than
"knowing about it"—as he still only intellectually recognized the
deeply destructive nature of his mother-experience—were mov-
ing and effective in constellating change. This took the metaphor-
ical form of trying to "leave the garden" through ending his use of
marijuana. At this point, his efforts were only partly successful, but
his struggle was real and worked for brief periods of a week or so.
In addition, Phillip found that he was able to give up his antide-
pressant medication.

With his dedication to meditating and to the unconscious, the
extreme attacks upon Philip's back and head began to diminish, as
though his spiritual life could descend and have a healing influ-
ence. He still could not paint for extended intervals; however, he
was more confident, especially as his love for meditation grew. The
painting he was doing was technically better than his previous
work. It was also deeper in the sense of reflecting ideas about paint-
ing that were on a new and very interesting level for him. Hence,
even though he could not work with anything like the energy and
intensity he had once known, a new process was active, and know-
ing this helped Phillip find some further solace during his ordeal.

* * *

About ten years into our treatment, Phillip's life was beginning
to take a better form. He found that he could paint for longer peri-
ods when he was away at retreats with other people. It appeared
that these retreats helped to allay the severe pain of his isolation
and loneliness. After several long retreats, lasting for a month or
two, Phillip was more committed than ever to giving up mari-
juana, largely because it disturbed the process of recovering his

dreams, and because he recognized that the painting he could manage under its influence was of lower quality.

The result was unexpected. Phillip began to experience an extreme level of anger. This was a completely new experience. He became inwardly enraged at anyone who failed to "mirror" him, whether this was a housekeeper who did not exactly clean as he requested, or a friend who communicated with Phillip's old lover despite knowing how disturbed Phillip had been over the breakup of the relationship. He never acted it out, but he felt his rage as so powerful as to be nearly overwhelming.

It was abundantly clear that marijuana had allowed him to dissociate from his deep-seated anger. Phillip had also stopped smoking cigarettes, after smoking two packs daily for twenty years. He had developed an ulcer that was painfully irritated by smoking, and had tried to stop on numerous occasions, but now he seemed to be successful. Though the cigarettes acted less potently than marijuana, it became clear that smoking, too, had allowed him to dissociate from his intense anger over not being *seen* by others. True to the patterns that unfold when the Fusional Complex begins to become a passage to a new self (as we have seen with Naomi, Gerald, and others), a powerful level of anger and narcissism entered Phillip's conscious life.

Often, important changes in one's individuation process are prompted by external events, and this now became true for Phillip. His mother became quite ill, and when he spoke to her by telephone (she lived in Europe), she began to listen to him differently. Upon his urging, she began to meditate, and Phillip began to feel her as less depressed. She was extremely anxious about her illness, however, and Phillip spoke of feeling her pain as though it was his own. Her fears, he said, went right into him, as though there was no distinction at all between the two of them. He found this upsetting but also interesting. Phillip had never before felt how identified he was with his mother.

We now recognized that Phillip lived in two very separate states. On the one hand, he was totally identified with his mother's anxiety and sadness. Her sadness, especially, was unbearable, as he remembered feeling in childhood as well. On the other hand, he could become enraged nearly at random, lashing out at anyone who did not exactly reflect what he said or needed, whether this was a taxi driver or a good friend.

At this time, I chose to interpret this as Phillip's rage at his mother for her early abuse of him, rarely if ever mirroring him. In most of his recollections of her, she was leaving him for her active social life. The bouts of rage he suffered during childhood, while still not relived memory, were now more meaningful to him, as if a myth of his childhood was forming that made sense. The metaphor of "not being seen" or "not being mirrored" was useful for Phillip, and he could see how this narcissistic injury had led to his explosive anger. Thus he could begin to feel how both states— an intense identification and an overwhelming, distancing rage— were operative in his mother relation.

To help Phillip get a better sense of the opposites in his Fusional Complex, I showed him the "duck-rabbit" figure. He could experience total identification or total rage, but he could not hold these states simultaneously. They formed a level of incompatible, true contradictories. This was the area of madness that the substitute skins of passive fantasy and other methods of dissociation, such as marijuana use and smoking, tried to suppress.

As his Fusional Complex became more conscious, Phillip began to experience his mother differently. On the one hand, he saw and felt her madness of continually contradicting herself in a conflict of anti-worlds. He witnessed her depression and anxiety. On the other hand, he also felt her love for him and his love for her. These opposites were not split: he could feel them both at once, and thus they were not part of a mad world that required

radical defense. They were two aspects of his mother, and of his response.

In a sense, for the first time a whole object relation had begun to form. Phillip was also experiencing more of the mad structure beneath the Fusional Complex, and such experience, especially feeling fear, anxiety, and limitation in the face of his madness, was a vital factor in his healing. Meanwhile, Phillip's painting was improving both in quality and quantity. He was not "out of the woods," but it was clear that a positive healing process was manifesting.

A dream showed something of this process. Phillip dreamed of a man whom he admired in actual life. This man was someone who spoke his mind, suffered rejection when his views were not "politically correct," yet kept working and never retreated from acting according to his beliefs. In the dream, this man appeared as much younger than he was, but had long, beautiful white hair, as though he was also an old man.

This dream illustrates the formation of a positive self-structure that could be a new psychic container. Psychic life transforms well only if old and new, imaged in myth by the wise old man and the child, are in harmony. Then one has a sense of one's history, knowledge, and experience, along with new, creative ideas. The two exist together in a stable way, without the new totally annihilating anything that had previously been thought or believed, or the old crushing anything new. This harmony has a powerful containing influence, for it also leads to a harmony of opposites such as mind and body—exactly what is absent in the Fusional Complex of the mind. Creative ideas can then manifest in space and time. The deeper levels of incompatible opposites still have their effect, working against this harmony, but no longer totally denying it.

Phillip began to experience a sense of joy. He had known it in brief moments before, but now it was more present, and quite

beautiful to see. Though painting was still extremely difficult—
and commissions were postponed for years, as he could not man-
age to paint for the hours on end that were required—his capacity
to paint for longer periods of time began to return, beginning with
a visit from his sister. When she was present he could paint better;
furthermore, she initiated an important ritual. Phillip was to set a
timer and paint for forty-five minutes. Then another timer would
be set for fifteen minutes, during which he was to relax and not
paint. With this ritual, and his sister's presence, he could paint for
much of the entire day.

His sister began to appear in his dreams as a positive feminine
figure, leading him up a mountain or encouraging him to take a
difficult path rather than a seductive, easy one. In such dreams his
sister was often opposed by his mother, who wanted him to choose
the lesser struggle and to "return to the garden."

With this development Phillip's creativity took a leap forward. He
began to see a mandala in his mind's eye and in his dreams. He had
never before had this experience, and with it a flood of creative energy
opened, in which Phillip was moved to sculpt the mandala image and
experienced a deepening of the subject matter of his painting.

This burst of energy, perhaps a sign of what could come, then
diminished. Though painting was easier than it had been before
his sister's visit, he could still only manage at best three hours a
day. Such progression and regression are always part of a progres-
sion through and from the control of the Fusional Complex.

* * *

The Fusional Complex can exert so powerful a control that
often no amount of inner imagery or numinosity alone can break
its deathlike grip. One also needs an outer relationship, an "object
relation" through which one feels seen and desired. It seemed that
all of Phillip's suffering had been part of a path of his individua-

tion, and certainly his creative abilities had deepened. However, the capacity to incarnate or embody them, so to speak, only became more stable and enduring when he was invited to join one of the world's most prestigious galleries. This new "object relation" allowed his energies to flow.[2] Phillip could finally experience, in actual space and time, a rebirth of his creative life, and on a level far beyond what he had ever previously achieved.

However, one must never look for cures or great successes in analytic work. This quest can work against the mystery of a life—even though Phillip had had more than his share of mystery and would gladly have settled for a relationship that brought comfort, touch, and an end to his infernal loneliness.

Phillip's joy never left him, but his loneliness was terribly painful. At times he still found "medication" in marijuana and safety in fantasy, as his Fusional Complex was often far too much to bear.

After its strangle hold upon painting diminished, the Complex showed its mercurial nature and shifted to relationships, manifesting as a characteristic pull toward someone and an equally strong terror of rejection, both of which left Phillip passive and paralyzed. More paintings were finished and sold, and more sculptures were commissioned. But his torment did not end. He could surely hear but not take refuge in the ancient adage that loneliness is the principle of individuation. He could, however, keep his faith that he was in an individuation process, and that he had a fate that he had to pursue.

* * *

One can rarely predict change. Perhaps the best one can do is to set the table, so to speak, with the necessary ingredients, and wait for the self to appear in its own, timeless way. Over the years we had uncovered and explored key aspects of Phillip's Fusional

Complex—the torment of the fusion-distance opposites; extreme narcissism, rage, and fear; extensive and hidden passive fantasy; madness and subtle body damage from incorporated maternal madness; formation of substitute skins; abject states of self-loathing, shame, and radical loss of energy.

One essential ingredient was lacking: the chthonic dimension. The chthonic is that which is "of or relating to the underworld," as in the chthonic deities like the Greek Hades or Dionysos. Psychologically, it refers to especially strong aspects of the human shadow, without which a capacity for desire, the "I want" as a state not necessarily sanctioned by spiritual or collective values, rarely appears in the life of an individual. And when it does appear, it manifests in compulsive, mad forms that usually are destructive, rather than creative, in their boundary-breaking. Yet, without the chthonic dimension as a felt "companion,"[3] the ego rarely has the strength to release the trapped soul in the unconscious—often taking the image of a young child dominated by terror and deep inertia—and thus end the spell the soul both suffers and exerts upon the entire personality. (The essential role of the chthonic dimension in resolving the Fusional Complex will also be seen in the following chapter, especially in *Hamlet*, where Hamlet lacks the chthonic dimension seen in the figure of his "opposite," his uncle, Claudius.)

I have noted how the analyst must often embrace the chthonic dimension—by intentionally "leaning into" the field and encountering the oscillations of madness (Chapter Two). Intentionally penetrating the field, the analyst breaks the incest barrier of entering into the unconscious. As such, his or her action can feel restrained not only by the analysand's resistance to leaving a "safe territory" of known behaviors and ideas, but also by the power of a taboo.[4]

Phillip had been going through yet another cycle of marijuana use now for an unusually long stretch of time. However, something was brewing within him that felt new to both of us. It is dif-

ficult to describe such changes, for as Phillip's drug use continued, albeit sporadically, one could well wonder just how deep any transformation had been. However, a difference was palpable, something like a spiritual change that both accepted his condition and could be less identified with it. Phillip also had a growing resolve to further deepen his meditation practice. His faith that his energies for painting would return more fully also took on a clarity and resolve, showing a remarkable freedom from worry about the loss of the most valued thing in his life.

At the end of a five-month period in which he recalled no dreams, Phillip had the following dream:

> I'm entering your house. It is white, one story, with gardens around it. "Can I stay here?" I ask you, and you say, "Of course, but I have to leave for several weeks." As you go to your car, you give me a bottle of red wine. Then three men arrive. They sort of know me. They're young hoodlums. I don't want them there, but they want to stay. They say we can drink wine together.

Entering my house in the dream, and living there, without me, apparently meant that Phillip could begin to own his sovereignty. Beyond that, he could "take in" the chthonic energies represented by the "hoodlums"—his disowned shadow side that was so different from his decent and highly cultured nature.

This dream was a culmination of the process through which Phillip's individuation crystallized and his desire and capacity to paint returned. For ten years he had not been able to manage the sustained effort that the nature of his painting required. During this time he would welcome any visitors or telephone calls—anything to avoid the terror of the canvas! Not now. Phillip avoided all intrusions into his concentration. He could now paint for twelve to fourteen hours a day, and with great intensity. Furthermore, the

changes in his creativity that had been brewing all along, and could only be accessed at infrequent intervals, were now available to Phillip. A previously unknown strength apparently arrived with these dream figures that also desired wine, the intoxicating passion of creativity. Phillip painted better than ever before.

<p style="text-align:center">* * *</p>

There is a beautiful Egyptian Pyramid text, from about 2500 B.C.E., that describes the soul's emergence from chaos and non-being:

> I am that living soul with outstretched face
> Who pushed out its head, which freed itself, who brought
> itself away
> When the doing of that which was to be done was [still] in
> confusion,
> When the doing and commanding of that which was
> To be done was [still] asleep.
> I create and I command for him who commands the good.
> My lips are the Twin Companies,
> I am the great Word,
> I am a redeemer—so shall I be redeemed, and I shall be
> Redeemed from all evil.[5]

This is a magic spell from over forty-five hundred years ago, a kind of self-hypnosis to encourage the right attitude to identify with the Creator-spirit when facing the powers of chaos. Modern psychology would describe this void, abyss, or chaos as psychosis—but Egyptian and other ancient cultures knew it to be a great mystery, and commonly denoted it as the negative side of the Great Goddess. Furthermore, modern approaches, especially as they focus upon early infancy, tend to see the source of ordering of

disorder to originate in the mother's capacity for imagination, or, as it is often called, maternal reverie. Ancient, pre-scientific traditions experienced the source of order as also, if not primarily, coming from the subject's own innate resources.

Thus the Fusional Complex was a rite of passage through the psychotic anxieties of Phillip's past—and perhaps the collective past as well, for we never know how "personal" or "archetypal" such a journey actually is—and into a new sense of self. The renewal of Philip's creative life was an archetypal, acausal process, combined with the formation of object relations. His deep immersion in a "dark night of the soul" finally showed a stable change, a "whitening" and renewal. Given his suffering, this seemed like nothing less than a miracle—one that Phillip knew would never have existed without the process he had endured, and through which he had so deepened his faith, consciousness, and spiritual practice.

12

BEYOND THE SELF

A S WE TURN OUR ATTENTION TO LARGER CULTURAL ISSUES, we must recall that the Fusional Complex emerges out of an underlying field. Like a particle in physical theory, the Fusional Complex is an activated point of the Fusional Field, which contains both a fusional pull toward an undifferentiated state of Oneness, and a simultaneous drive toward the separating and differentiating quality of Twoness.

The Fusional Field activates when a culture no longer adapts well to collective needs and hence must alter its ruling values and consciousness. The required change will usually be opposed by existing powers—symbolically this opposition often takes the form of the "old king"—with the result that the Fusional Complex begins to manifest widely within individuals in the culture. Each time individuation makes new demands for consciousness and for a new relationship to the self, the Fusional Complex again raises its head out of the activated Fusional Field.

To further approach the question of the self and its transition through the Fusional Complex, let us first go back in history to a time before the existence of a self.[1] For not only did such a time exist, but also, historically speaking, it is remarkably recent.

The self's initial stirrings were recorded first in Renaissance alchemy, which endeavored to create the *lapis*, the "Stone of the Wise," a stable connection to transcendent, numinous reality. The

lapis was created out of a "prime matter," and the nature of this substance was a great secret, simply because it is so difficult to describe. Jung's discovery that the Attis-Cybele myth was the *prima materia* is one of his greatest insights into the alchemical mind.[2]

The alchemists said that it takes gold to produce gold, and with the spiritual gold of illumination creating a "true imagination" (in distinction to wishful fantasies, or "false imagination"), they interacted with their "substances"—or, internally, with the perplexing nature of the Attis-Cybele dynamic, including its madness—so that something new, the *lapis*, might be created. Believing that the imagination was part of the transformative process, they studied the substances in their retort, or vessel, and experienced spontaneous visions of the process, at times experiencing very chaotic states known as the *nigredo*. So strange to the modern-scientific approach, this sought-after goal of a stable connection with numinous reality was deeply and willfully subjective, a product of the alchemical imagination as a spiritual fire joining the opus of the transformation of substances, both physical and psychic.

Shakespeare wrote at the height of Renaissance alchemy, and his work reflects the same unconscious strivings of the time.[3] The manifestation of the "self-aware individual," an aspect of the *lapis*, and the turmoil and suffering that accompanies it, can be observed in his masterpiece, *Hamlet*. The literary critic Harold Bloom suggests that Hamlet was "the prime origin of Romantic self-consciousness."[4] The Shakespeare scholar Marjorie Garber calls Hamlet "the mirror that subsequent writers, philosophers, and critics have held up to human nature"[5] and describes his story as "a confrontation with consciousness."[6] Hamlet's struggle is always with us, though we may avoid it as we behave automatically, in accordance with collective standards, rather than recognize, as did Coleridge in his famous remark, "I have a smack of Hamlet myself, if I may say so."[7]

The enduring interest in Shakespeare's masterpiece, spanning centuries and nationalities, surely points to the existence of an eternal, archetypal pattern in the play. Perhaps it is thanks to Shakespeare's consummate portrayal of this archetypal struggle that only the Bible, of all works in English, has been commented upon more than *Hamlet*. Throughout its history, *Hamlet* has engendered the most bafflingly different readings.[8] I am choosing to add one more: I suggest that the archetypal pattern in *Hamlet* is the story of a new self-structure emerging through the ordeal created by the Fusional Complex.

* * *

As a new form of awareness is trying to surface in our own collective psyche, it is opposed by a tyranny no less ruthless than that of the collective world of *Hamlet*. Shakespeare expert Michael Neill, in his essay "*Hamlet*: A Modern Perspective," explains:

> The monarchy of Queen Elizabeth I was sustained by a vigorous network of spies and informers. Indeed, one portrait of Elizabeth shows her dressed in a costume allegorically embroidered with eyes and ears. . . . Behind the public charade of warmth, magnanimity, and open government that King Claudius [Hamlet's uncle, who has killed Hamlet's father] so carefully constructs, the lives of the King's subjects are exposed to merciless inquisition. . . . Everyone is eavesdropped upon.[9]

Hamlet's task lies in seeing past his uncle's mask of benevolence and care, and living his heroic journey while the negative archetypal image of the Dark Goddess (the Eye was the earliest form of the Mother Goddess who, as in ancient Egyptian myth, destroyed everything she saw[10]) is dominant. There is little of the

positive feminine to help him; Hamlet's own ruthless narcissism and desire for disconnection contribute to the demise of Ophelia, while his deeply incestuous entanglement with his mother, Gertrude, dominates his relation to the feminine.

The problem of integrating feminine qualities—positive values of relatedness, nonrational or lunar sight, and Eros; and negative or shadow qualities such as destructive vision and threats of abandonment—is central to the difficulty of an emergent self in the fullness of the alchemical goal of the *lapis* during the Renaissance. It has also often been seen as central to *Hamlet*. "Female sexual desire is, in Hamlet's mind, and therefore in the minds of many influential critics of the play, something out of control. It leads to marriage or to madness—to Ophelia's mad songs, so disturbingly erotic. . . ."[11] But the focus of the difficulty with the feminine is not to be found in the Freudian understanding of Hamlet and his incapacity to act as, following Ernest Jones, a conflict based upon a latent desire for his mother.[12] In Freudian terms, the conflict is "pre-Oedipal"; it lies within the archetypal drama of Attis and Cybele. Hamlet's dilemma is far deeper and more universal than his Oedipal complex.

Hamlet is the hero who tries to bring forth a new consciousness, and his journey bears not a small likeness to Attis and his merger with Cybele, while the death of Ophelia falls into the structure of the death of the nymph Sagaritis. While the Attis-Cybele myth shows a structure of a "missing fourth"[13] with its three characters, Shakespeare has added the fourth in the evil Claudius, who has killed the good king, Hamlet's father. Shakespeare understood that the dark, chthonic Claudius was "an opposite to Hamlet,"[14] and it is precisely the father, in his embodied, chthonic role, who is required if the passage through the Fusional Complex is to be successful. To draw a further parallel, Hamlet's madness, so variously understood by commentators throughout centuries as either contrived or genuine,[15] may well be seen as a parallel to the madness of Attis.

Did Shakespeare know the Attis-Cybele myth, recorded in Ovid's *Fasti*? He at least knew Ovid's *Metamorphoses*, where he could read the myth of Venus and Adonis, a son-lover story, with the son's gruesome slaying by a wild boar, sacred to the goddess. Apparently Shakespeare took special care with his narrative poem *Venus and Adonis*,[16] a tale that has much in common with the Attis-Cybele story. He also knew Virgil's *Aeneid*,[17] where we find Cybele as the supporter of Aeneas, a *galli*—one of those in Cybele's cult who were castrated and thus gained her protection.

It is asserted that *Hamlet* derives from a lost revenge drama, *The Spanish Tragedy*, by Thomas Kyd,[18] but this possible attribution should not displace the equally vital "source" of Shakespeare's own imagination and unconscious psyche. Whatever the origins of *Hamlet* were, Shakespeare thoroughly recast any previous forms. In especially emphasizing the "perplexed, interior life of the hero,"[19] the playwright demonstrated the theme of interiority and self-awareness that would more fully develop in the seventeenth century. Neill writes:

> Hamlet grounds his very claim to integrity upon a notion that true feeling can never be expressed: it is only "that . . . which *passes show*" that can escape the taint of hypocrisy, of "acting." It is as if, in this world of remorseless observation, the self can survive only as a ferociously defended secret, something treasured for the very fact of its hiddenness and impenetrability.[20]

Hamlet's inner world stays private; it never reaches into space-time reality, but lives only in his soliloquies. Neill continues:

> Soliloquy is a realm of noncommunication—a prison as well as a fortress in which the speaker beats his head unavailingly against the walls of his own cell. Thus the

soliloquy that ends Act Two reproaches itself for a kind of speechlessness—the mute ineffectuality of a "John of Dreams," who, unlike the Player, "can *say* nothing"—and at the same time mocks itself as a torrent of empty language . . . (II, ii, 545–546).[21]

This fantasy-like preoccupation, as a compensation for the impossibility of incarnating one's vision or awareness in the real world, is, as we have amply demonstrated, rampant in those dominated by the Fusional Complex. Hamlet's consciousness exists most acutely in this "in-between world"; typical of the Fusional Complex, he can neither act nor not act. In the famous "To be or not to be" soliloquy, every movement, toward being or toward doing, is met by its opposite, leaving Hamlet "giving pause" to any awareness or reflection he may have.

To be or not to be; that is the question:
Whether 'tis nobler in the mind to suffer
The slings and arrows of outrageous fortune,
Or to take arms against a sea of troubles
And, by opposing, end them. To die, to sleep—
. . . Ay, there's the rub,
For in that sleep of death what dreams may come
When we have shuffled off this mortal coil
Must give us pause. . . .
(III, i, 58–70)

Hamlet has the awareness of a man "noble in reason . . . in apprehension how like a god" (II, ii, 293–296), but he cannot bring this into action. He cannot stay with his awareness and trust it—for example, confronted with his father's ghost, who tells him the true story of his father's murder, he continually questions what he knows is true: "The spirit that I have seen may be the devil, and . . . perhaps

... abuses me to damn me. I'll have grounds more relative than this" (II, ii, 575–581).

One can grant him some wisdom in this questioning. However, after the play within the play, which certainly proves his uncle's guilt—at least, it would to someone with a *chthonic awareness*, one whose body would know the truth—Hamlet again questions himself. He is fused with inner fantasies that always bring doubt, and he is neither able to stay with them—in which case he would have to suffer and experience his deep incestuous desires for his mother, Gertrude—nor can he separate from them and act—in which case he would have to confront Claudius. Just as we find in the Fusional Complex, Hamlet cannot focus upon his unconscious and explore it, nor can he separate from it.

What does Hamlet lack? What would allow his magnificent potential to become actualized? As we have noted, Shakespeare tells us himself, when he says that Claudius is the opposite of Hamlet (V, ii, 60–62). Claudius acts. He kills what is in his way and then acts to get rid of Hamlet. Without the chthonic force, Hamlet languishes in the Fusional Complex, his incredible new consciousness unable to live in actual time. Thus *Hamlet* is very much the tale of the masculine that fails to act because he lacks the "darkness" for the deed. Like the ancient and enduring Attis-Cybele myth, Shakespeare's masterpiece demonstrates the necessity of this darkness in the process of actualization.[22]

Hamlet stays as isolated as anyone submerged in the Fusional Complex. "He is set apart from those around him by his access to ... private utterance: in it he can, as it were, 'be bounded in a nutshell and count [himself] a king of infinite space' (II, ii, 248–49)."[23] Hamlet's inner space is the isolated space of the Fusional Complex, and his metaphor of a "nutshell" is the "substitute skin" that we have abundantly seen to dominate the necessity for containment of the Fusional Complex.[24]

And his inner world is further hidden within the container of

his madness. The world in which *Hamlet* existed—the court of Claudius and Gertrude, representing the collective consciousness at the time—was so treacherous and dangerous that the new awareness symbolized by Hamlet could only remain a potential reality.

Typical of the Fusional Complex,

> Hamlet shows himself capable of both instinctive violence and of cold-blooded calculation, but his behavior is purely reactive. Otherwise, he seems oddly paralyzed by his success—a condition displayed in the prayer scene [III, iii, 73–96] where he stands behind the kneeling Claudius with drawn sword, "neutral to his will and matter," like a frozen revenger.[25]

In the end, catastrophe rules: Hamlet, the symbol of the potentially self-aware man, dies, and so do all the major figures of the play. The passage of the new self through the Fusional Complex fails, derailed by madness, rage, fantasy, and the incapacity to act upon what one knows to be true. The dark, chthonic forces that would have had to be assimilated for this act only turn negative. It will be nearly two hundred years before the self-awareness represented by Hamlet will incarnate into space-time existence.

* * *

The "self-aware" person, as a general, culturally accepted fact, was stirring in the seventeenth century. The historian of ideas Lancelot Law Whyte tells us: "In English 'conscious' as meaning 'inwardly sensible or aware' appears first in 1678, and 'self-consciousness' or 'consciousness of one's own thoughts' in 1690."[26] As rational-perspectival awareness was born out of a magical and mythical form of consciousness in which the individual's aware-

ness was a group consciousness, the new, self-aware individual also began to emerge. The notion of an individual self as an ideal with collective resonance did not take root, however, until the late eighteenth century.[27]

What is fascinating in this development is not only the late arrival of an individual, self-aware person as a goal to be achieved and as a value that was then taken for granted, but the form the process took. For example, the historian Dror Wahrman, in *The Making of the Modern Self*, ingeniously reflects upon the fact that up until about 1780, the notion of the female and "female governance" was reflected through the popular image of the beehive and the queen bee. One finds metaphors of the "glorious queen," the "warlike queen," or the "Amazonian Dame" (found in Joseph Warder's 1713 tract on bees, which he dedicated to Queen Anne). Warder's manual was called *The True Amazon*, and the image of the bee that he constructed represented popular thought for most of the eighteenth century. Contrasting feeble drones and warlike Amazons as the society of the hive, Warder's image formed a symbol of accepted ideas of a queen as a "strong and vigorous ruler, commanding absolute and unswerving loyalty . . . the martial Dame heading the Female State."[28]

By the end of the eighteenth century, the imagery had changed, indicating changing images of the self in the unconscious. No longer was the queen bee written about as an Amazon, or as warlike; she became instead "the mother of her people,"[29] valued only for her eggs. The drones

> were [also] subjects of more creative re-imagining, [from] effeminate degenerates [who] thus deserve their unmanly fate, and have no sex . . . to self-sacrificing altruists who hide their true manliness for the common good of the community . . . and to the unappreciated epitome of caring fatherhood.[30]

The once fierce, ruling Amazonian queen was reduced to an extremely pacific existence, with no sting and no military pride[31]—and the full nature of the feminine was lost to the emerging conscious self. This radical change in imagery was a cogent metaphor for collective attitudes toward female power as they changed near the end of the eighteenth century. By the 1780s, the female was no longer acknowledged to have a "gender reversed" potential in which she was warlike and powerful; instead she was defined entirely by the maternal bond, for, as we will discuss below, the emerging consciousness of that time could not integrate the full spectrum of feminine energies.

Another remarkable example of the cultural changes at the end of the eighteenth century that gave birth to the self-aware individual is seen in the art of acting. Wahrman explains that up until that time, to act meant to become the character. It was in no way an issue of having a split consciousness of self and other; the actor was to fully *substitute* the character played for his own identity. In a 1743 essay we read that a good actor is "so much the *Person* he represents, that he puts the *Playhouse* out of our Heads, *and is* actually to *us* and to *himself* what another actor would only *seem to be.*"[32]

A good actor lost himself in his roles. One commentator likened the good actor to the "priestess of the Delphic god, who as soon as she ascended the sacred tripod, became possessed, and uttered with a voice and mien, not her own, the sacred oracles."[33] The "mysterious" process of the actor's metamorphosis became a focus of concern in the late 1700s, as questions arose as to whether the actor truly became the character played, via "identity substitution," or if "identity-splitting" was instead involved. As the century's last decades approached, instead of "substitution," the actor was said to take on the identity of the character he played only "to a certain degree."[34] The crucial change to objectivity was taking place, and the act of "substitution" radically diminished in value.

While throughout history there have been figures that had individuality, for example Alexander the Great or the Egyptian pharaoh Tutankhamen, there had never before been a time in history when such individuality was resonant with the collective consciousness and was a goal for everyone.[35] The emergent self-structure forming the base of that individuality strongly elevated the value of separation over fusion, and reduced the feminine to maternal functions. Why did the conscious self take this path of development?

For individual identity to finally emerge, as it did at the end of the eighteenth century, human consciousness had to pass through the trials of the Fusional Complex. The development toward a rational ego as a carrier of identity, and toward a capacity for subject-object differentiation, in distinction to fusion, had to occur before the mysterious alchemical process that joined opposites and reveled in new forms of order could possibly consolidate, rather than remaining a fantastic and fleeting goal. The heroic attitude, through which order is created from disorder and a subject-object consciousness exists, had to first gain stability before an ego that could suffer and relinquish the heroic power of mental creation might, as in our historical epoch, again return to the task of working on the *prima materia* of the Attis-Cybele myth.

That which survives the transit of the Fusional Complex is rarely or never the whole alchemical vision. The complexities and obscurities of the process through which the Renaissance alchemists sought qualitative changes in the "matter" (psychic and physical) undergoing transformation—especially through the intentional merging of the alchemist and his experiment, thus encouraging the transformative power of imagination—were incompatible with the rational-perspectival awareness that was just consolidating.[36] Thus, in service of the need to develop a rational-perspectival form of awareness, the deep processes connected with the Attis-Cybele myth and the formation through it of

a self-structure symbolized by the *lapis*—which included the feminine, chaos, and the ambiguities of the alchemical god Mercurius[37]—were largely excluded from conscious reflection and most radically replaced by Descartes' famous motto, "I think, therefore I am."

What did finally consolidate was a fragment of the self-structure foreshadowed by the *lapis*. Rather than including an embodied-chthonic form of both masculine and feminine existence, combined with causal and acausal approaches toward deciphering meaning, and with the capability of renewing itself through an interplay of order and disorder within a space beyond three dimensions, the self that *survived* the transit of the Fusional Complex was wholly rational, separate, disembodied, and spatially "inside" a person.

The *lapis* was never created, as far as we know, just as gold was not made from lead. The *lapis* was a creative fantasy, much like a creative impulse that, when it finally lives in space and time, is a small reflection of the larger image. In this transit of the Fusional Complex, the alchemical *prima materia* yielded the ego, with its rational-discursive consciousness, alienation from the feminine due to its fragility in the face of Fusional Fields, and denial of its own dark, disordering shadow. All that denial and repression was necessary for the ego to emerge as a stable entity.

But the *lapis* is far more than ego as a center of consciousness. What happened to the far deeper sense of self, of an inner reality that can be known as a guiding spirit? Has that arrived? Does it have any collective resonance?

In the alchemical fantasy, this self would have a body and an instinctual as well as a spiritual life. And the self, created as the *lapis*, would exist as a stable center amidst all the turbulence of somatic-emotional life.

I think we are at a point in history where some individuals either have an awareness of such a self, or know they are on a path

working toward it. Jung's idea of the individuation process, whereby the center of gravity of psychic life moves from the ego toward the self, is the prime example of how this tendency exists in the human psyche. Generally, the embodiment of this process is rare, because it runs into the Fusional Complex and the difficulties of maintaining an awareness of the inner self within fusional pulls toward the body and instinctual processes—one's own and others'. The mutual field as a container and medium of an interaction, while separate identities are still maintained, might be a way of thinking about a greater realization of aspects of the *lapis,* as it might exist in our historical time.

Just as the separate individual is a relatively recent possibility for humanity, but we saw precursors of it even thousands of years ago, so too the individual consciously centered in a self that is neither inner nor outer exists today, but not yet with collective resonance. If anything, there is an opposite movement toward fundamentalism and god-images of previous millennia. Just as the alchemists believed that the creation of the *lapis* first required a numinous experience of God, perhaps humanity is returning to the numinous in the ways of fundamentalism, before the creation of a self can become a greater possibility.

To become centered in the self is an experience of separation from others and from fusional needs. This movement always encounters abandonment anxieties or fears of envy. Perhaps we are at that stage today on the path of individuation. But when the movement is taken, the array of alchemical fantasies of mutual fields; dark, disordering processes; the body; and deep mysteries of relationship begin to be more than abstractions. Rather, they become like visions that we strive to realize.

* * *

The rational ego now exists as a collective fact, no longer the

domain of a few individuals, but a fact of our Western civiliza-
tion—and now Eastern civilization as well—a way of life that is
taught and modeled everywhere. Strong and weak egos exist in all
sorts of varieties, but the consciousness that can separate the
world into parts, neglect some for others, and, initially with
Descartes, create a science that is separate from any divine refer-
ence or purpose, is now entrenched. Its power, so forcefully seen
in the rapid expansion of technologies that breed more technol-
ogy, has long been a soul-destroying shadow side, and perhaps
that is why, in our time of the revaluation of all forms of con-
sciousness and knowledge, the possibility of objectivity; the rela-
tionship of science and culture, male and female; and the very
structure of consciousness, the ego, and the self are all in a process
of change. As the emergence of a rational-discursive consciousness
and associated sense of identity was Hamlet's story, we hope the
same ordeal is initiating a new self and attendant consciousness of
our own.

In this context, Jung's remark that "I have long held that our
psychic situation is now being influenced by an irruption of the
Oriental spirit . . . analogous to the psychic change that could be
observed in Rome during the first century of our era [as] the cult
of Attis and Cybele spread throughout the Roman Empire"[38] is
especially cogent. It has been two thousand years since Cybele was
invited into Rome through the guidance of an oracle, and four
hundred years since Hamlet and Renaissance alchemy, but
humankind may now be ready for the great challenges that these
earlier, historical epochs attempted to address. The stakes of suc-
cess or failure could not be greater.

Perhaps the end of the dominance of the power of "knowing"
and of problem solving through rational-discursive means was
foreshadowed by the events of September 11, 2001. The archetypal
level, while capable of traumatizing an individual, as in that catas-

trophe, is also capable of creating a common ground of human experience, a sense of kinship.

Back in the '60s the poet Allen Ginsberg took part in a picketing demonstration against Madame Nhu, the "Dragon Lady" of Viet Nam. The sign he carried read, "Madame Nhu and Ho Chi Minh are in the same boat of meat." After September 11, for a while, we were in the same "boat of meat" as the rest of the traumatized and suffering human race. George Bush and Osama bin Laden were in the same boat of meat. We are all in that boat, and to truly know and feel that mystery means to sacrifice identifying with the separating, aggressive impulse that would forever find outer enemies to attack. That sense of kinship was the gift of the dark side of God, of the feminine, dark numinosum as many felt it on September 11.

That gift was quickly squandered. Instead of taking time to reflect and to suffer, America sprang forward. The spirit of attack and retribution dominated, and manifested, later in images of a President declaring victory from the flight deck of an aircraft carrier, or posturing in the face of guerrilla attacks on our troops in Iraq, challenging the enemy with an adolescent slogan: "Bring 'em on!" The possibility to collectively feel in the same "boat of meat," the chance for communion with a suffering world, was lost. We attacked. We found an enemy. This spirit of regression to old heroic forms is precisely the opposite of the capacity to experience and suffer limitation.

Sometimes I wonder whether the greatest opportunity of George Bush's presidency may not be remembered as those seven minutes in which he did nothing, but sat, quiet, with book in hand, reading with a young girl, unresponsive to the aide who had just told him of the attacks. Was he trapped, for those moments, in a Fusional Complex, unable to act or not act? After that, the ways and power of the rational ego swung into high gear. The very

possibility of a higher, spiritual reflection and questions of human relationship departed as the spirit of the numinosum was co-opted by power-driven fantasies of a campaign of "Shock and Awe."

Before the tragic events on September 11, I had just started teaching a class on Samuel Beckett's work, beginning with his novel *Molloy*. This was fortuitous; Beckett has been a great source of comfort for me and for others. He is a master of the alchemical *nigredo*—despair, chaos or madness, depression, anxiety. We surely are now in an overwhelming state of *nigredo*. Beckett plays with the anti-worlds in chaotic, mad states of mind like a judo expert, flowing with them, weaving a story searching for a self.

Beckett said that he was transformed by seeing his mother with Parkinson's disease when he returned to Ireland after World War II. Her face, he said, was like a mask, unrecognizable. Out of this shock and transformation grew the great breakthrough in his work: "I realized that everything I'd written had been a lie . . . all about what I knew when the only thing I could write about truthfully was what I didn't know, didn't feel. . . ."[39]

Beckett finally wrote what felt true to him, after a dark vision in which he experienced, as he said, "how totally stupid I am." He wrote his greatest works from this dark and terrifying honesty. Dare we feel our stupidity now? As Beckett's character says at the end of *The Unnamable*, "I don't know, I'll never know, in the silence you don't know, you must go on, I can't go on, I'll go on." We try to know, understand, make sense of life, see patterns . . . and throughout it all know we are ignorant.

Beckett's attitude may be seen as the anti-hero facing the dark aspect of chaos. Not power, but submission to ignorance—a conscious submission, not a passive flight into fantasy—rules Beckett's suffering. The attitude acknowledges the fact that one must suffer consciously, rather than delude oneself through disso-

ciating or obliterating the assumed source of terror. Such aggressive heroic effort may also be necessary, but not at the expense of becoming mad, totally losing a sense of limitation, and inflating one's capacities to annihilate and also survive.

If we have the courage to consciously suffer the trauma of terrorism and September 11, seeing it as a mirror, a face that is our own, rather than dissociate from our fears and anxieties and only rush to crush them, and if we have the courage to embrace the opposites of the Fusional Complex and be limited by its madness, then we may gain a new orientation. We may gain a self that is different from anything we had known, and that may lead us through the terrifying times in which we live. Active, conscious defense and strength is also necessary. But it will primarily be from our chaos, ignorance, and fear, not from our strength, spiritual belief, and knowledge that a new consciousness and a new self-image will be born.

* * *

When the field associated with the Fusional Complex is enlivened, we often lose the very boundaries that define our sense of self. Is this pathology, to be averted? Or is it a mysterious and discontinuous shift that underscores the direction of human development in our present era?

Does the emerging self-structure in our epoch contain its own darkness—a shadow side not reducible to human action—that can verge upon evil? Does the new self include the feminine, and especially the negative numinosum of the Dark Goddess? And would this self also include what all previous self-structures have assiduously avoided: chaos, as in the Greek *Apeiron*? Perhaps the self includes all of these qualitative changes—Jung's researches into the phenomenology of the emerging self have uncovered them all[40]—but as well, perhaps the new self will be found in the paradox of going beyond the self.

When we encounter the Fusional Complex, its field tends to annihilate a subject-object distinction and reduces our subjectivity to a phantom that we cling to, only to further lose contact with the person we are supposed to be with. One might then wonder if intentionality and consciousness are the point of the interaction, or if there is a mystery to fusional states that escapes a reflective consciousness, centered upon its own subjectivity. In a psychoanalytically oriented world, anything but consciousness and its increase is anathema. Similarly, the scientific approach to life requires principles that create order, and strongly values the ordering potential of a subject-object relationship.

However, if a subject-object distinction and increasing self-awareness are somehow not readily available, are we to struggle for them, like the mythical hero overcoming the dragon of unconsciousness and relentless fusion states? Or are we to reconsider the possible meaning or purpose of encounters with the Fusional Complex?

When it comes to the telos of the Fusional Complex, along with Jung—though in a very different way—the writings of the Lithuanian philosopher, Talmudist and psychologist Emmanuel Levinas have been important to me. This is particularly so in his reflections upon the limitations of the human self, or, in his terms, upon the ethical problem of asserting and defining our sense of being, securing our own existence, as opposed to the primary importance of seeing the spiritual background of another person.

This emphasis upon the primacy of the other, rather than the individual self, indeed the ethical imperative of being for the other, characterizes Levinas's life work. He insists upon examining transcendent visions for power motives, primary concern for one's own being, and eventually catastrophic results. He reminds us: "Auschwitz was committed by the civilization of transcendental idealism."[41] Jung shocks our idealizations of a transcendent deity with his statement that "the overwhelming psychic factor is called

God, [and] as soon as a god ceases to be an overwhelming factor
he dwindles to a mere name. His essence is dead and his power
gone."[42] Levinas goes further:

> The situation in which God comes to mind would be nei-
> ther miracle nor the concern to understand the mystery of
> creation. Is the idea of creation primary? The shock of the
> divine, the rupture of the immanent order, of the order
> that I can embrace, of the order which I can hold in my
> thought, of the order which can become mine, that is the
> face of the other.[43]

In Levinasian ethics, relationship to the other, seeing God in
the face of the other (which surely requires the experience of
transparency as part of Gebser's aperspectival awareness) becomes
the primary concern.

The experiences of the Fusional Complex force us to recon-
sider ways we have historically thought about the other. I face my
analysand and feel my essence annihilated by what I experience as
a madness of impossible demands to totally be *for her*, and to com-
pletely forget my feelings, consciousness and knowledge, to com-
pletely set aside my self. But doesn't healing come from the
interactions of the analyst's self with his analysand's absent or dis-
ordered self?[44] Levinas would emphatically say no. And experi-
ences of the Fusional Complex make me wonder if his wisdom
isn't the greater measure.

The fields associated with the Fusional Complex create such
distressing conditions, challenging the analyst's sense of existing,
that one often wonders if it is possible to maintain any semblance
of relatedness, or if a destructive quality is so insidiously present—
at times the notion of evil comes to mind—that it is best to end
the treatment. Do I have a right to do this? Do I have a right to say
that I am unable to proceed further because I cannot continue to

function as an analyst? That is, if I lose my sense of sufficiently having a self, so that I fail to exist enough to be marginally reflective and not act out my feelings, do I have the ethical right to end the treatment?[45]

These issues, met with throughout this book—for example in Naomi's insistence that I only repeat everything she said, and my intolerance for this demand; and in the abject states I repeatedly knew with her; or in the many examples I have given of couples, or analysand-analyst interactions, where terrible pain and non-communication ruled, with one or the other person wanting nothing but to get away from the stickiness of the encounter—all reflect failures or near failures in relatedness to the other, while a frantic search for a self took over.

Martin Buber said that evil is created each time the possibility for an I-Thou connection is missed. Revulsion in the face of the abject fields of the Fusional Complex tends to deny the possibility of the I-Thou connection, while submitting to the field, and seeing the Fusional Complex as neither the "other's" creation nor one's own, but as a field quality both people are buffeted by and that creates their interaction, can turn the abject into a state of union, into *our* abjection. Even what at first appears as a complete absence of the I-Thou, an absence of what the Renaissance alchemists called the *coniunctio*, can turn into the holiness of a state of union between people. So in our withdrawals and aversions to the other, in our failures to go deeper than the *slime* of abjection and madness, do we escape from evil, or do we actually create it?

No one challenges us more in regard to what limits we allow ourselves in facing the field of the Fusional Complex than Levinas. In fact, his examples of what must be faced often reflect the torment of the Fusional Complex and its fields so deeply that I wonder if he was formulating his ideas, especially in his most

important work, *Otherwise Than Being*, from these very experiences, and the madness encountered. He writes: "The soul is the other in me. The psyche, the-one-for-the-other, can be a possession and a psychosis; the soul is already a seed of folly."[46] The phrase "seed of folly," which Levinas uses throughout the book when talking about the psyche, is perhaps a code word for madness/psychosis.[47]

The demands Levinas places upon himself, and others, seem crazy. In an interview, Levinas says: "The other passes before I do; I am for the other, that which the other has as duties with respect to me, that's his business, not mine!" The interviewer exclaims: "But it is a crazy demand." To which Levinas replies: "It is crazy, yes. . . ."[48]

I have withdrawn from fields of the Fusional Complex because I could not do otherwise. I felt a total loss of self, and a fusional pull into the analysand, to be dangerous. I did not trust the other. Levinas would insist that my lack of trust was an ethical failure, and it may well have been. His challenge haunts me as I look over many decades of analytical work, including "difficult" cases that, although few in number, took me to the brink of what I could tolerate. He demands an act of courage, based on a belief that "Peace with the other precedes knowledge, and the interpersonal relation is primordial."[49] Ethics, he would say, is not a spectator sport. Rather, "it is [an] experience of a demand that I cannot fully meet and cannot avoid."[50]

Colin Davis, in his explication of Levinas's work, tells us that *Otherwise Than Being* is "a bizarre and difficult text."[51] Levinas's prose is so complex and filled with new terms and the hyphenation of old ones that he himself calls his work strange. Indeed, Simon Critchley, a major figure in Levinasian studies, states, "No attempt has yet been made to appreciate [*Otherwise Than Being's*] strangeness."[52] Such terms—bizarre, strange—are familiar to us

from descriptions of the meaninglessness of psychotic states. Jung once insisted that Hegel's prose was so abstruse as to be pathological. What would he say about Levinas?

Yet I see an author embedding himself in what may appear psychotic because he is trying to describe a level of relationship that, from any rational-discursive point of view—with any concern for a subject-object difference, or dependency upon an inner, orienting state of being, what we call the self—annihilates a sense of self and identity, and yet does have a possible meaning. I read Levinas as situating himself in the depths of the experiences one has when the Fusional Complex organizes, or disorganizes, the four-dimensional field that two people may embrace and become embraced by.

For Levinas,

> (The) subject is subject, as it were, and the form that this subjection assumes is that of sensibility or sentience. Sensibility is what Levinas calls "the way" of my subjection. This is a sentient vulnerability or passivity towards the other that takes place "on the surface of the skin, at the edge of the nerves."[53]

The entire phenomenological thrust of *Otherwise Than Being* is to be found in what Levinas calls substitution:

> For me, the notion of substitution is tied to the notion of responsibility. To substitute oneself does not amount to putting oneself in the place of the other man in order to feel what he feels; it does not involve becoming the other nor, if he be destitute and desperate, the courage of such a trial. Rather, substitution entails bringing comfort by associating ourselves with the essential weakness and finitude of the other. It is to bear his weight by sacrificing

one's interestedness and complacency-in-being, which then turn into responsibility for the other.[54]

What a long way we have come from "substitution" in the mid-eighteenth century, in which becoming the other was a high virtue. Between then and now, the dynamics of the Fusional Complex have required us to reject such fusion with an object as a possible state, so that a rational ego could develop. With Levinas, a completely new notion of substitution—which requires the precondition of a self that can be sacrificed—has evolved. This seems to me to be a crucial way of thinking and feeling about the intense fusional demands one can experience in the domain of the Fusional Complex.

In that domain, we also greatly benefit from Levinas's understanding of "the crucial distinction between 'Saying and the Said' [that] informs all textual and thematic aspects of *Otherwise Than Being*."[55] Giving priority to the Said entails a failure to recognize another distinctive dimension of language, which Levinas calls Saying: "underlying, though not fully represented by, every utterance is a situation, structure or event in which I am exposed to the other as a speaker or receiver of discourse."[56]

> The Said presupposes Saying [which] does not chronologically precede the Said, but it has priority over it. . . . The Said is easiest to analyze because it comprises the themes, ideas or observations, which we intentionally communicate to one another. . . . Saying is more elusive, because its meaning cannot be encapsulated in the Said. . . .[57]

"The Saying and the Said" figures prominently in communications through the field associated with the Fusional Complex. One analyst reported that nine out of ten times a particular analysand began their sessions by asking, "Am I late or on time?" He was

silently amused at this and didn't know what to make of it, so would let the question pass, and the session would go on to discussions about the analysand's marital troubles. Likewise, in his presentation of this case, the analyst moved on to a "real issue," but when I brought him back to the moments in question, he could register that they felt strange and uncomfortable.

When I asked him to continue to remember these moments, which turned out to be etched sharply in his memory, he could perceive his analysand as having two sides. It was as if a young child and an adult were present in a peculiarly fused image, a "child-adult"—not an adult with childlike qualities, nor a child that is adult-like, but an amalgam that was not seamless.

The child part carries the fusional dimension, the adult its denial. The child betrays the adult in "outing him" from his power position. The analyst betrays his analysand's child and adult parts in his collusion to ignore the experience of a fleeting madness, as he fears the "stickiness" of the bizarre object of the "child-adult" that breaks through for an instant and withdraws. And I am at the edge of betraying the analyst's own child-adult part, for it is present, not as a complementary joining of young and old, but, like the state he tries to dismiss in his analysand, like two objects welded together while the seam shows. This bizarre quality is present to me as he talks about his analysand, encouraging me to collude with his need to dismiss the odd way his analysand asks him, nine out of ten times, "Am I late or on time?" The betrayal would be to only hear the Said.

There is even more to the Saying. The message communicated to the analyst in the bizarre moment of beginning is, "Are you and I totally one, so you always know where I am?" And, simultaneously, "There is no depth to the question I'm asking." The "impossible" opposites of the Fusional Complex are present, complete merger and complete disconnection. All of this is part of the

"Saying"—its essence always expanding, and essentially unknowable—that accompanies the "Said," the simple question, "Am I late or on time?"

The Saying can never be "asked about"; it must be perceived. It would not appear on a transcript of the analysand's session. In the three-dimensional world of rational discourse, all that exists is the Said. Yet, unless one experiences the created field and its abjection, and allows one's own interiority to cease being one's reference point, one is like a traveler in a forest, fixated upon a map so as not to get lost, and hardly seeing the beauty, danger, and surprises of the environment.

The fields associated with the Fusional Complex are *there*, and they may be unbearable in their indifference to meaning, to our comfort, or to our survival.[58] To shift to something "that is" is like finding an interpretation of the analysand's state of mind. Levinas's remarkable injunction is to subordinate oneself to the other and to the field. Naturally, he has been accused of masochism.

I read Levinas not primarily as a way of being with my analysand, and not as an ethical code to follow. Rather, I think of his work in a more symbolic way, infusing whatever I do or feel or think with a demand for "being for the other," in the other's most abject condition. Levinas's teaching often also allows me to push myself away from knee-jerk reactions to the psychotic fields of the Fusional Complex, and to instead dare to be subject to them, which may be a re-visioning in our own era of the ancient wisdom of the cleansing of madness through the cult of Roman Cybele.[59]

The message of "being for the other" can reverberate in us amidst the fields of the Fusional Complex, countering a mad, narcissistic need for power, knowing, and a totally secure self unchanged by relations with the other. And yet the formation of an individual self, as in the alchemical *lapis*, cannot ever be sub-

sumed under an ethical necessity of "being for the other." The process of incarnation of the self is an archetypal power that cannot be denied.

The self that is on the horizon of individual and cultural awareness encompasses its own chaos, the body, and feminine forms of the numinosum.[60] While having an individual nature, the self will also live in the field of relationship, and become known through an ethical demand to be for the other.[61] In either case—as an individual self or as a shared quality of the field of relationship—the Fusional Complex will be the passage through which that self will move from merely potential into actual reality.

Appendix A

DEVELOPMENTAL AND IMAGINAL-FIELD
APPROACHES

I AM BEHOLDEN TO NUMEROUS AUTHORS WHO HAVE ADDRESSED facets of the material I present in this book; they all do so with their particular attitudes toward the psyche, which often differ from my own. For instance, notions some readers will be familiar with—such as a developmental process, or object relations, or the self, or individuation, or complexes, or the concept of a field transmitting energy and information between people—are so laden with the metapsychology of different "schools of thought" that I believe any analyst drawing on them as if an ecumenical approach were possible, runs the risk of distorting his or her own text and the sources quoted as well. With this in mind, I will try to draw some comparisons and distinctions between my own approach and developmental theories, and indicate the usefulness of employing both together in analytic work.

Much like a scientist ordering nature with principles and theories, the developmental model posits a series of stages that an emerging ego tends to enter and must pass through if it is to attain maturity. This is usually seen as a capacity to love and work in an adapted way, not distorted by overly narcissistic needs, omnipotent and omniscient ego-inflation, or a compulsion to see others as either (or alternately) all "good" or all "bad." Also, maturity can mean an adaptation to the inner world and its demands, say of

creativity or change. Various stages of development, which differ according to their particular school of thought, are posited, and normalcy is a feature of having successively transited the various levels, while pathological features are understood as failures in development, and fixation in early stages.

Such developmental approaches offer a map of psychic life that can be very effective in diagnosis and treatment planning. It can help the analyst to organize his or her own disordered states of mind, and even use these experiences for information about the analysand's process.

However, there are limitations to the developmental approach, especially its emphasis upon causality—e.g., the failure to advance into and through a developmental stage would be seen as a *result* of a lack of maternal relatedness, or of a constitutional excess of envy, or as a failure of the maternal object to sufficiently process her infant's aggression, perhaps in becoming reactive rather than empathic. But can one really know that one person *causes* some reaction in another? All we can know is that two people, as in the mother-infant dyad, share a field, out of which contents such as emotions or fantasies, or meaningless shards of psychosomatic life, emerge. One may infer that such contents do exist in one or the other's psyche, but experiencing them as manifestations of the field through an *a*causal, synchronistic form of order, changes the tone of the interaction—from the endeavor of ordering disorder, to being affected by the field and *its* order (see Appendix B). Mystery, wonder, takes the place of (an often self-protective kind of) knowing. Thus a theory is not imposed upon one's experiences, as in a causal-developmental understanding, as much as meditation upon the field reveals its essences.

The developmental model is also skewed toward believing that increasing consciousness through interpretation (by the analyst) is the goal of the analytic endeavor. However, pre-scientific, alchem-

ical attitudes would instead focus upon *experiencing* the field or the in-between world and being changed by that experience. Rather than believing that the human self is a core structure that evolves through the proper relationship, like an acorn that could evolve into a tree, a pre-scientific approach would insist that experiencing the field, being affected by it, would facilitate an *incarnation* of spiritual reality, a movement from a numinous Other into an embodied life.

The clinical issues regarding autistic-like states addressed by the psychoanalyst Thomas Ogden and the neo-Kleinian analyst Judith Mitrani may address the same material I organize through the lens of the Fusional Complex. For example, an important metaphor that appears in the literature on autistic-like structures is that, in normal development, a containing *fabric* of the emergent self forms.[1] When the mother-infant dyad is unable to function in a way that provides a healing, sensory experience, holes are created in the fabric of the emergent self. Therefore, bodily separateness becomes a source of unbearable anxiety and panic, resulting in an agony of consciousness.[2] An autistic shell—encompassing certain but not all aspects of the personality—forms as a "substitute fabric" to protect the person from the overwhelming anxieties of psychotic process.

In *Autistic Barriers in Neurotic Patients,* the Kleinian analyst Frances Tustin, who pioneered the investigation of autism, notes that "the loss of their intrinsic sense of existence [is the] autistic child's greatest dread. Massive tactile sensations prevent threatening things from being experienced" (1986, p. 142). She also quotes a case report by Madame Coquil about a patient named Steve: "Since his mother left, the space between Steve and me, and his mother and him, seemed to be clogged up. I feel him to be inaccessible to me, wrapped in a wet universe, which he himself secretes" (in Tustin, 1986, p. 143). Such idiosyncratic

metaphors are essential for describing the in-between world of the subtle body, something Jung also noted (see Chapter Three, note 3).

My approach differs from developmental theories, however, in that I don't primarily focus upon a historical-causal model of the analysand's life. Instead, I find the notion of a complex, which can emerge at any stage of life—surely the Fusional Complex is central in infancy, and at later developmental stages—to be more effective in understanding the analysand's suffering and the purpose of that suffering, and in encouraging change. That is to say, the *perception* that emerges out of the mutual field experience is, I believe, a more useful way to encounter and contain the extremely difficult experiences of the nearly autistic states that one meets in clinical practice, and to allow for the analysand's self to emerge as the individuation process flows, less hindered by past traumatic experience.

The central difference in our approaches lies in ways I attempt to perceive the simultaneity of a fusional state *and* a total absence of empathy. It is the capacity to simultaneously glimpse these "true contradictories," rather than recognize autistic-like encapsulation, or fusional states with (often inanimate) objects, that most strongly differentiates my approach from what we are led to perceive through developmental models.

As many of the cases in this book suggest, I believe the theory of the Fusional Complex can inform the developmental approach when both are used together. For example, Ogden's notion of an "autistic-contiguous position" is one in which the experience of surfaces touching one another is a principal medium through which connections are made and organization achieved.[3] But how are "touching surfaces" replicated in the adults in analytic process? If one thinks in terms of the subtle body or the somatic unconscious (see Chapter Three), and realizes that this "in between" domain merges into the physical body, then dealing with the field of the subtle body by *seeing it* opens to a kind of healing touch

rarely achieved through interpretation. I think the power of the subtle body approach was especially effective for Naomi and Gerald, but played a role in all the cases in this book.

Also, the notion of an "autistic-contiguous position" seems to me to force the autistic-like imagery into a body-focused state of "adhesive identification" with objects. I find the main dynamic to be both mental and somatic, and to manifest in the impossible logic of $A = -A$, representing the condition in which one can see the mental state between people and its fundamental disconnection, or the somatic state and various qualities of attachment, but not both together—at least in a normal, rational mode of perception. While I have examined it most explicitly in Kyle's case (Chapter Three), discovering this logic as a quality of the field was the fundamental leverage of healing in all the clinical material I have presented.

There is no doubt that "object relations," at first between infant and mother, are essential for neutralizing the psychotic energies that threaten existence.[4] However, the developmental approach too strongly emphasizes the "be all and end all" of object relations, and fails to recognize the remarkable reparative and containing qualities of archetypal processes. Its advocates will at times refer to endogenous healing processes, but these remain something like an unspecified hidden parameter. In Phillip's and Naomi's cases—the two that best exemplify the importance of object relations—archetypal healing processes were strongly evident as well.

But if we believe, with Jung, that the numinous heals, it makes sense to consider developmental theories with pre-scientific attitudes and archetypes in mind. Let us examine Tustin's idea that autism is a two-stage process. First the child (perhaps as an intrauterine experience) bonds in an "adhesive identification" with the mother in an attempt to find safety from overwhelming anxieties; but this bond is intolerable because the infant only meets more anxieties, in the form of persecutory shards of emo-

tional and sensate life that are devoid of meaning. Then, to counter this, a second stage of isolation occurs. I think this two-stage process, which to one degree or another probably exists in everyone as a function of his or her early maternal experience, manifests in extreme versions in later life as a mind-body splitting, in which a fusional pull toward the body of the other exists, simultaneously with a state of noncommunication, akin to autistic isolation, both operating through the "duck-rabbit" (see Chapter One) interaction of opposites.

How we think about the initial and pathological "adhesive identification" revolves around how we envision the child's first object. Is that first object the mother? In that case, there would have to be posited a toxic quality in the mother, for example a severe depression during pregnancy, or a toxic quality of the mother-infant dyad, or a neurological factor creating extreme forms of distress, with the infant clinging powerfully to the mother in a search for safety that fails.

However, there is another way to think about the extreme levels of anxiety that seem to attend separation issues in people with strong autistic-like qualities. What if the first object were an archetypal energy—call it Love, Light, Sound—or any other name for an ineffable first presence? Then we must recognize that separation from that object, and the entrance into space-time life, creates extreme disorder. This order-disorder paradox is extremely dominant at birth, and it is so central to human experience that it is found in the mythology of every culture.

Many myths record a common sequence of the consecutive events of order and disorder: either the creator or hero creates a form of high-grade energy, often through meditating and creating order, as in the Indian myth of the god Prajapati creating the Endless Light; or, as in a Polynesian myth, the hero steals such energy in the form of grain from the gods, or as fire in the story of Prometheus. Then an attack of disorder follows that attempts to

destroy the hero or god, or at least to steal back his prize. Creating order, or bringing a higher order of energy to a lower one, such as a system in space and time, always results in a created disorder in that system.

In a less archetypal form, the very act of a person becoming conscious in a new way, for example connecting with feelings as never before, and then having to live life in the context of old patterns and routines, structurally is the same as bringing a new form of order (the new awareness) into another system with preexisting forms of order and energy, with the result that disorder is also created. This is one reason why initiating a creative work can go hand in hand with extreme anxiety and even nightmares.

The myths tell us of ways that the god or hero deals with created disorder. For example, he may sacrifice himself and create the world from his parts so that he will not be devoured by death. Alternatively, he may lose some of the valuable substance he tries to bring to humankind, i.e., to incarnate in a time-space framework—but also keeps and transmits some of it. One sees this pattern in creativity problems, when a person cannot tolerate his or her creation being only a fragment of the larger vision that inspired it.

Science offers another derivation of the order-disorder paradox. The Law of Entropy Increase, the Second Law of Thermodynamics, has been science's cardinal principle since the nineteenth century. Numerous scientists have asserted its special place among all the laws of science. The law states that in a closed system, i.e., one with which there is no energy exchange, the order or energy-value of the system always decreases, or at best remains constant. The measure of disorder, or of the decrease in value of energy to do work, is called entropy. The entropy cannot decrease.

Hence, if one adds order to a system—the term for this, from the science of information theory, is "negentropy"—disorder, entropy, must also increase such that there is no net decrease of

entropy. However one chooses to define the system in question—as isolated, say in the case of a split-off psychic quality such as a strong complex, or as several linked systems, like two people—the entropy of the overall system cannot decrease. Therefore, increasing order in that system must also result in a disorderly creation.

Is the early life of the infant somehow in connection to sources of negentropy, of a very high-grade energy? The child may know and experience a transpersonal dimension of life through the spirit or through the body before encountering the mother as a first object. It is possible, for example, that the infant's intrauterine experience may include energies and frequencies on a quantum level whose perceptions become blunted or structured in space and time. On the quantum level, just as an electron is not localized until measured, so too it is possible that consciousness has an infinite expanse that is suddenly limited as it enters the restrictions of space and time. A transpersonal dimension, which is characterized by high-grade, numinous energies, may be involved in the infant's experience of life in space and time, an experience dominated by the order-disorder paradox.

Such beliefs cannot be justified through scientific observation. People who have known the numinosum and have been changed by that spiritual experience can focus upon their illumination, even years after it has occurred, and focus upon the field experienced with a crying infant. A transmission can occur that results in the infant beginning to smile. Is this truth or sheer nonsense? One can never convince a rational scientist of such experiences. And anything felt as numinous will generally be reduced to some transient, temporal-lobe event, at best.

For me, the developmental approach is necessary. It acts like an initial or boundary condition that an equation must satisfy in mathematics, else "solutions" are only general. In psychology, our reflections upon developmental stages of growth focus upon the particularity of the individual, and help expose the history of early

trauma—which numinous experiences often do not significantly affect. Yet the numinosum, even in the domain of trauma, can then offer a sense of meaning and purpose, which developmental models often fail to do. The combination of a common field between analyst and analysand *and* a reflection upon development conjoins an *a*temporal field of experience with a temporal one; and out of this combination, an image, or perception of historical events, may emerge.[5]

Appendix B

THE FUSIONAL COMPLEX AND THE FIELD:
A "GUIDE FOR THE PERPLEXED"

FIELDS FUNCTION IN THE SPACE OF THE HUMAN BODY, E.G., linking conscious and unconscious processes; and also extend outside of the body, affecting other people and even material objects. When two people interact, their fields interact, yielding an "interactive field." Because two people will create their own particular field, we need to think of the field as *their* field, endowing it with a personal quality. Yet the field concept is far more than an amalgam of each person's subjective states of mind. Instead, as in physics, the field has its own laws: the specific field between two people has dynamics that are general. Archetypal dynamics, rather than personal-subjective dynamics, rule its properties. For example, an important pattern widely found in alchemical thought (which is a mine of information on the qualitative forms the field takes) is that states of the union of opposites are followed by disorder, known as the *nigredo*, and that this sequence is goal-oriented. In alchemical thinking, the pattern is not causal, but rather a synchronistic occurrence that *happens* and is registered as important because of the meaning that the coincidence creates. Likewise, the Fusional Complex can be understood as one pattern among many that the field manifests. An alternative way of thinking would be to focus primarily upon the Complex as gener-

ating a field, much the way an electrical charge creates a magnetic field. Both approaches can be useful.

Such field properties come to light when *we attend to them*, that is to say, when we observe them through the eye of the imagination. What one "sees" in the field evokes latent field qualities (analogous to Jung saying that what you see in a person you bring out of him). For example, an analyst who has a range of experiences that include the numinous dimension of the psyche may perceive this during a therapy session, perhaps as a sense of "*light*" in the field and in the analysand. An analyst such as Freud, who said he did not know the "oceanic experience," will not see in this way. He or she may perceive other dynamics in the analysand, for example an array of defenses. Each of these different analysts will tend to evoke a different field quality. In this way one's consciousness and behavior affect the field, at times resulting in changes in the archetypal processes, and hence of the nature of the field.

To continue with this example, the perception of the numinosum, the term Rudolph Otto coined for varied experiences of the sacred, will often result in the field becoming more enlivened and its presence felt. The perception of defenses such as repression and denial will tend to obscure the numinosity of the field and its inherent, archetypal dynamics, for such perceptions operate in a three-dimensional framework of insides and outsides, while the numinosum is beyond such space-time considerations. But the analyst's "sight" can bring the awareness of the numinous to the analysand, and also enliven the field between them. This is only one of many ways that the field gains existence and quality.

When we approach an interaction between two people in terms of the field as a "third area," we understand relationship not primarily from inwardly reflecting upon sensations, feelings, and cognition of various kinds, but from observing the ways such data take their organization and meaning from an underlying field. Our perceptions, as in Gebser's aperspectival awareness, or in

Levinas's critique of our relations with the other, can see what is *there* as objects become transparent; thus the outer gains a spiritual reality that is not reducible to the subject's unconscious projection. Furthermore, and this is essential, the field can then become the subject and we become *its* object. Our experience of the field and its effects thus goes beyond containment in an "inner" or "outer," three-dimensional sense, and, like the alchemical *vas hermeticum*, bears a topological similarity to the four-dimensional Klein bottle.[1]

How does this approach aid us in our effort to help people to become more conscious of psychic life and thus gain in self-knowledge? While self-knowledge does manifest out of the field, much as electrical charges are manifestations of the electromagnetic field, this question demands serious attention.

To this end, consider an imaginary dialogue about the field concept. The imaginary therapist, like many actual therapists I know, is perfectly capable of recognizing the existence of the field, but has important questions about its efficacy. These questions arise especially when the issue of the field's own dynamics is engaged. I shall denote the therapist as B, and myself as N.

> B: When I think of your notion of a field, it doesn't seem to go well with my experience. I know what you mean, but I often have the experience of feeling something with an analysand, for example anger or anxiety or fear, and I can usually sort out whose feeling it is, mine or the analysand's. It is very important for the analysand to know that he or she has these feelings, or for me to know this when they are primarily mine. If I see the anxiety or anger as a field quality, as belonging to both of us, I think I lose a vital therapeutic advantage of consciousness.

> N: Like anything, the field idea can be used creatively or

defensively. The kind of discernment you speak about is essential, but, if you will, try to think about it as follows. For this purpose I'd like to consider a most famous axiom from alchemy, because alchemy is a mine of information on the field's own processes. I'm referring to the so-called "Axiom of Maria," which goes as follows: Out of the One comes the Two, out of the Two comes the Three, and out of the Three comes the Fourth as the One.[2]

You can take the initial One as a chaotic state of unknowing, what we should experience at the beginning of each session. Much like a creation story, from this chaotic state the Two may arise. (In the case of the Fusional Complex, we deal with states between One and Two, but for purposes of discussing the field, I will focus upon times when Twoness has been established.) That means you begin to experience opposites such as subject/object, or conscious/unconscious. Chaotic fusion is diminished—between analyst and analysand, and between the conscious and the unconscious—and a tension between opposites emerges. Now from this state of Twoness the Three emerges. This means that some state, such as anger or anxiety, is capable of emerging into space-time existence. At this point you have a choice.

On the one hand, you can begin to infer "whose emotion" is primary, either yours or the analysand's. This is the structure of an interpretation. Your reflections that determine "whose affect is present" implicitly (if not consciously) follow the dynamics of the "Axiom of Maria."

However, suppose you do this. You may have stopped at the Three. You could have chosen to go further. Suppose you now allow that whatever emotion you apprehended to exist in your analysand is, instead, a field quality. This requires a sacrifice of the power that Threeness grants,

namely the power to know *whose* affect it is. You could imaginally project the quality in question into the field. This is an act of conscious projection that feels like throwing the affect into the space. As a consequence, the field itself is enlivened. This action of genuine unknowing is essential in dealing with the Fusional Complex, in which any extracted sense of Threeness as an interpretation can endanger the analysand's stability.

By enlivening the field through sacrifice, both people gain the opportunity of experiencing a shared quality, the field and its particular nature. This can take many forms, but the main issue is that experiencing the field as an object is similar to a shared vision, each person with his or her own imagery. The field experience also tends to oscillate back to Threeness so that both people can take back, so to speak, their own contents, such as anger, fear, etc.

Thus through the field any encounter can have a quality similar to the complementarity principle in physics whereby light can have a wavelike or particle nature. The psychological parallel is that any interaction can be seen in terms of projected and introjected contents, or as a field of shared contents and energy. The one creates difference and the other creates a sense of union.

B: I understand this, and I have experienced these things. However, I worry that you are imposing a theory upon experience that I don't believe I always have. I'm still concerned that this field idea can be used to create distance between the analyst and analysand, and I don't yet see its necessity. Certainly the union states you describe are special, even healing. Yet the entire apparatus of fields and field dynamics doesn't necessarily fit my experiences.

For example, several weeks ago I had an amazing experience with an analysand. Working with a dream he had of a young child, I felt a sense of an inner child stirring in me and I mentioned this to him. Then it seemed that both children were meeting one another, and we both noticed a change in the atmosphere, I guess you would say the field, between us. It was as though the energy had increased, and we were both pleased and surprised.

I remember telling this to my supervision group as an example of how I had been successful in getting him to relate to his body and to its wisdom, by virtue of carefully listening to my own body and allowing it to guide me. This was a new and important experience for him.

You might say that we had experienced a union or *coniunctio*, and that the nature of field dynamics was that a disordered state, the alchemical *nigredo*, would probably follow. When I saw him he was happy, remembered the last session, and I felt a very strong feeling connection with him throughout the session. There wasn't a *nigredo*.

N: That is interesting. I know you work by circulating your feelings as you breathe into them. You may have found a way to circumvent the *nigredo*. However, tell me, did he dream the night of the day you had what I also would have thought was a *coniunctio* experience?

B: Yes, he dreamed of his superior at work whom he is very angry with. He said he hates the way the woman monopolizes their time together, easily for an hour and a half together on some days. I have worked with him on holding his own with this woman, and he has had success.

N: How long do you see him for?

B: An hour and a half.

N: I think the *nigredo* is very much alive in him, but the feelings have been split off into the image of the woman at work. You could bring it into the room and help him see how there are, in a sense, two of you. I wonder if he experienced his mother in this way.

B: He is just getting to see himself as positive. It's premature to bring in his negative feelings. I can't see how that would be possible now.

N: You may be right. Perhaps you would have to just know about them and about the hidden negative transference. However, the field concept is exceptionally good for dealing with this problem. I can understand how speaking about *his* negative feelings towards you would be undermining. But you could recall with him the nature of the energized field between you and its beauty, and explain that alchemical imagery showed that a dark disordered state, even one in which no relatedness at all was possible, usually followed. In other words, you describe the nature of the field, and do not ascribe the dark feelings in his dream to his feelings about you in the transference.

Knowing this, you could then further reflect upon the situation between you. The art here is to not lose sight of the fundamental mutuality and unknowability of the essence of the field. Whatever comes into our awareness is always partial.

The field is a remarkable container for such material, while neither your analysand's inner space nor yours is alone capable of such containment. As long as one allows the field dynamics to exist, i.e., brings them into existence

through sensing and pointing out their presence, there is shared container.

I'd emphasize that the *nigredo* is not the analysand's any more than it is yours. This is useful if you believe and experience it. The *nigredo* may be reflective of his early experience, and perhaps of yours as well. These "contents" will emerge out of the field as its Threeness and Fourness oscillate. In a sense one must have faith in the analysand, and in oneself, that *not interpreting* in a developmental style will allow the analysand to discover much of his or her early historical material as a by-product of field experience.

This act of *not interpreting* will be felt as a sacrifice of power. The field experience between you and your analysand can help join opposites, such as the beautiful maternal image and the witch, that were split from the earliest months and years of life. This joining leads to the *nigredo*, which must be suffered together in order to embody the numinous and create an inner self.

With the field approach, both people learn that they share unconscious material. If they are true to the awareness of a field, they will also acknowledge that if one person appears more conscious at one time, a shift to unconsciousness of the same content is bound to occur at another time.

Psychoanalysis today is at the same threshold as science in the nineteenth century when the great experimentalist Michael Faraday introduced the field concept, elaborated upon by the outstanding theoretician James Clerk Maxwell. Faraday conceived of fields from the force lines created by magnets. Something was obviously creating these patterns, and this something was clearly related to the electrical charge of the object within the field. However, did the charged object create the field, or was the field

itself a kind of subtle matter that had its own laws? Faraday chose the first option, Maxwell the second. His approach was to be the fateful one for the future development of science. It culminated in the idea of the quantum field and Einstein's declaration that everything is the field, by which he meant that all manifestations in the world, what was called matter, was a result of emanations of the quantum field.

When Maxwell created his concept of the electromagnetic field, he attempted, in the spirit of the times, to relate the field to then-known mechanistic laws such as conservation of charge, momentum, energy, etc. He struggled for seven years in this endeavor, employing incredibly ingenious mechanical models, until he finally had to submit to the realization that the field could not be reduced to anything known in science. The field was an entity by itself, irreducible, while electrical charges and magnetic forces—in fact all force (and with quantum fields, all matter)—was an effect of the field.

As in Maxwell's struggle, it is not easy to learn to think differently. But this is exactly the demand that I think is placed before psychotherapy today, a demand that takes the profession out of a pretense of being scientific. For the field experience is always a mystery of subjectivity encountering, and discovering, objective field-dynamics.

NOTES

1. It is not unusual that such chaotic experiences appear very early in an analysis; but they are so odd and difficult to reflect upon that the analyst tends, usually unconsciously, to dismiss them and focus instead on "getting to know the person." Or they may be attributed to the so-called borderline personality, well known for intensely emotional and chaotic interactions at an unusually early stage in an analysis. However, perceiving, experiencing, and communicating the existence of the Fusional Complex, even in a first session, can be appropriate and significant for the course of the analysis.

2. The idea of a "complex" was introduced by C. G. Jung over one hundred years ago, and has proved one of his most insightful discoveries. Jung became aware of the complex while doing word association experiments. Previous to his work, these experiments were concerned with classifying the linguistic nature of the subject's responses. However, unlike other investigators at the time, he did not dismiss the subject's responses that seemed disturbed, such as taking a much longer time than average to give a response to a word, or responding in an unreflective way, with a meaningless rhyming, known as a "clang association." Jung analyzed these and other responses, and found that they fell into different groups that he named "complexes," distinguished by their capacity to disturb the subject's ability to focus and spontaneously offer an association. The disturbed associations offered in the experiment could further be differentiated into complexes of sex, money, work, creativity, the mother, father, religion, etc. Changes in galvanic skin response, heart rate, respiration, and other factors could also be seen to accompany the activation of a complex.

 Jung's work on word association and the discovery of complexes earned him international acclaim and Freud's special interest. Over the years after his initial discovery, Jung began to refine the nature of the complex. A major advance was to recognize that the associations that clustered about the complex had not only a particular "feeling tone" but also an impersonal, archetypal core. Yet the associations could be seen as

"personal" in the sense of being acquired during one's life, the result of painful experiences that were either repressed or dissociated. The number of associations clustered in a complex was taken to be an indication of the strength or energetic charge of that complex.

Thus, if one did an association experiment, and one complex had more associations than any other, it proved to be the "strongest complex" with the highest energy charge and capacity to disturb the ego's functioning. Jung also realized that complexes were the architects of our dreams, and that they tripped us up in "slips of the tongue." He saw that every person has complexes, but also that those complexes can have control of the person. When a strong complex constellates, it can overwhelm ego functioning and even behave like a mythical monster, devouring other complexes and psychic energy. When especially strong, as in the complex in a schizophrenic, a complex can dominate the entire psyche.

3. See Appendix B for a discussion of the field.

4. See Appendix A.

5. Partridge tells us that "space" (from the Latin, *spatium*) is related to *patere*, "to lie open . . . wide-open, large" (in Rosen, 2006, p. 3). Rosen further notes early forms of space in Plato's *Timaeus*, where the Creator fashions a receptacle for "that in which [an object] becomes," describing the receptacle as "invisible and formless, all-embracing . . ." (Ibid., p. 10). Thus "space," in its earliest formulation, is an invisible receptacle in which a process may evolve and be embraced.

6. The duck-rabbit was first published in 1899, by the American psychologist Joseph Jastrow. Jastrow used the image to underscore the fact that perception is not just a reaction to a stimulus, but is also a mental activity. We perceive with the eye, but also with the mind's eye.

7. Jung first employed the term *archetype* in 1919, taking it from Gnostic and mystical sources by writers who "knew" in ways that the science and psychology of Jung's day would only have scoffed at. Jung took the word primarily from the *Corpus Hermeticum*, a series of Gnostic writings from the early centuries of the Common Era where God is spoken of as "the archetypal light"—and also from one of his favorite sources, Dionysius the Areopagite: "That the seal is not entire and the same in all its impressions . . . is not due to the seal itself, . . . but the difference of the substances which share it makes the impression of the one, entire, identical archetype to be different."

Writings such as these proved essential for Jung, for here he was not operating as a rational scientist but as one penetrating deeper into the essence of the seen, which lies in the realm of the unseen. Thus, if a person had a dream, Jung insisted that it was only a fragment of a larger reality that could be known through the technique of active imagination. A

deeper "light" could shine through from the unconscious psyche. Images could appear that would vary according to the personal life and associations of the complex, the door to the unconscious psyche. Yet one could sense a sufficient unity to these images to perceive the workings of a background "seal," the archetype, manifesting through its numinous energies.

Jung's assertion that the complex had an archetypal core emerged from experiences with imagination. In a frightful descent into the unconscious during the years after his break with Freud, 1912–1916, Jung's imagination worked upon the dream and fantasy images that emerged from his psyche, sensing—amidst a very "dark night"—that some larger and true core of his being was unfolding. He focused upon images woven from the associations clustered about the complex, and lowered his attention so that he entered into the world of "in between" consciousness and the unconscious. In this intentional lowering of a sharply focused, rational form of awareness, he discovered that deeper imagery spontaneously emerged. He called this technique "active imagination."

In distinction to illusion, such imagination could carry a deep truth. Jung was further bolstered by the writings of alchemists, for whom the imagination was the fire of their art on its psychic level, and especially by the alchemical distinction between true and false imagination. Working with the imagination thus became the hallmark of Jung's approach to the psyche.

8. Being embodied is an experience of feeling finite in the form of the human body. To be identified with one's thoughts, and hence "out of the body," and then manage to enter into an embodied state, moves a person back to his or her true essence (Jung commented that if one is out of the body one could be anything, like a gas). Animals in dreams often represent an embodied point of view, and as the animal always follows its true nature and rarely becomes neurotic by taking a path that denies its nature, being embodied links a person to his or her true self, especially as it is experienced in the here and now.

9. Rosen, 2004, p. xiv.

10. Perhaps the mythical notion of a Golden Age is one in which all changes through the Fusional Complex were facilitated by enlightened Beings, while that of an Iron Age, or the Kali Yuga of Indian tradition, would manifest severe resistance and the emergence of the Fusional Complex in a widespread manner. Our present era has been frequently likened to the Kali Yuga.

11. Stein, pp. xii–xiii.

12. Jacobsen, p. 3.

13. Grotstein, p. 257.

14. See Chapter Two, Chapter Three, and Appendix B.

15. Many have read about gaining non-ordinary perception in the books of

Carlos Castaneda, namely the teachings about *seeing* by his mentor, don Juan. In the mythology of the Kwakiutl Indians of the Pacific Northwest, the non-ordinary perceptive capacity is the treasure gained through the ordeal of facing the two-headed sea monster, Sisiutl. We also know aspects of this form of perception from mystical literature, as found in William Blake's notion of "seeing through one's eyes, rather than with them," or in Dennis Klochek's work on discovering "Spirit Vision." Malcolm Bull has elucidated this form of vision in the writings of Nicholas of Cusa and others, and has keenly explicated the notion of the "true contradictories" that may be involved in such perception. Henry Corbin's notion of the imaginal is in the same field of experience, and C. G. Jung's vast corpus of work continually points to the "consciousness of the unconscious" and to its myriad forms, notably in the imagery of "eyes" or "soul sparks" common in Renaissance alchemy. J. Marvin Spiegelman's work on "mutual process" addresses, in an intimate clinical way, the field phenomena and emergent imagination I am describing. The work of Maurice Merleau-Ponty on perception, and Jean Gebser's notion of an *a*perspectival form of awareness, are key and will appear again later in this book.

16. See Appendix A.

17. The new consciousness through which these perceptions emerge is radically different from the rational-discursive form that fuels both developmental models and approaches that frame psychic contents as occupying either "insides" or "outsides" of people. Instead, the awareness involved focuses upon *time* in a way that is totally different from the time of past, present and future. Jean Gebser has called this four-dimensional consciousness, in which time has a presence and intensity, *a*perspectival. In his magisterial work *The Ever Present Origin,* Gebser spares no effort in showing how the new form of consciousness has been emerging, especially since the end of the nineteenth century. He speaks of a consciousness *mutation,* beyond the rational-discursive form that took shape in the Renaissance with the discovery of perspective and led to classical science.

18. I have known situations in which a person is suspended within opposites of a fusional attachment and complete disconnection in a relationship. His or her partner may end the relationship, yet the person lingers, longing for the relationship and often appearing delusional to others who insist he or she "get on with life." Friends can become alienated, as they feel unable to influence the person (the "subject") to do what seems so obviously the right course, i.e., to forget a once loving connection. They tend to emphasize what was wrong with the relationship. The subject agrees but insists, "There is something more to understand." All the while, life seems to pass the subject by, and suicide beckons as a way out of intolerable pain. Friends become exasperated and fall away, for they cannot

manage the field created by the "impossible" opposites of fusional drives and noncommunication with the subject. The madness in the interaction, the subject's failure to "make sense," becomes intolerable.

CHAPTER 2

1. Schwartz-Salant, 1989.
2. See Appendix A.
3. Rundle Clark, pp. 76, 80.
4. Apprehending opposites allows for the existence of space. However, the space in question is by no means the empty space of science, nor the space of separation that allows for subject-object differentiation. The space is alive, teeming with energy and potential information. This space was once known as the subtle body; it is beyond causality, normal space-time experience, and reason as we usually know it. Learning to allow this space and its processes to function as not only an object of our life with an analysand, but also as a subject that affects us as its objects, is the necessary therapeutic action. Within this framework, we learn to name what we *see*, not to interpret, and to be changed by the space and its processes.
5. See Appendix A.
6. The aperspectival awareness that can perceive imagery in the analysand, or in the field, and believe this act to be more than a projection, indeed to have objective truth to it, has been developed in great depth by thinkers such as Jean Gebser and Maurice Merleau-Ponty. The rational-discursive form is also necessary, and beyond that, one must often include a magical and mythical form of consciousness.

 As an example, the magical form arises when the analysand is helped to re-perceive incorporated, negative, and often psychotic aspects of a parental figure. This perception can act like an exorcism, relieving the person of damaging, internal states that do not belong to his or her own nature. The mythical, soul-centered dimension operates when we recognize how the Fusional Complex generates a *field experience*, which has its own archetypal dynamics beyond individual subjectivities projected into the field, and, like a myth in a "primitive" culture, organizes the psychic experiences of both people.

 The mythic dimension can also enter the analytic process through reflecting upon the ancient son-lover myth of Attis and the Great Mother Cybele, which as we shall see (Chapter Ten) represents the archetypal core of the Fusional Complex, and metaphorically portrays the imagination and behavior of someone ruled by the Complex. The resultant "integral" consciousness (Gebser), combining magical, mythical, rational-

perspectival, and aperspectival forms, is like a symphony featuring one and then another instrument of awareness.

7. "Eye and Mind," in Merleau-Ponty, p. 167.
8. See my *The Mystery of Human Relationship* for an in-depth study of "axes of splitting," whether mind-body, front-back, or side-to-side, e.g., p. 87.
9. Melville, Chapter 74.
10. Rilke, p. 193.
11. C. G. Jung explores this "light" in-depth in various works on alchemical symbolism, but especially in his *Mysterium Coniunctionis*.
12. Gebser, p. 26.
13. Ibid., p. 24.
14. The environmentalist Ed Ayres recalls an historical event that beautifully portrays the fact that when we are confronted with something that is utterly alien to our normal way of perceiving life, we may totally fail to recognize its existence:

> For millennia, the Aborigines of eastern Australia used small bark canoes to fish off the coast of their isolated continent. They had no contact with whites. But on April 29, 1792, the British sailing ship *Endeavor*, under Captain James Cook, sailed into a bay and encountered a group of natives—the first known contact between Australians and Europeans. . . .
>
> [The natives] showed no evidence of seeing anything at all. The ship floated past the canoes . . . the Aborigines took no notice. They displayed neither fear nor interest and went on fishing. . . .
>
> The Europeans on the ship, having seen that no hostile responses had been provoked, lowered their landing boats and began rowing to shore. Then the sight of the men in a small boat was comprehensible to them; it meant invasion. Most of the Aborigines fled into the trees, but two naked warriors stood their ground and shouted. . . . (pp. 5–6)

15. "Eye and Mind," in Merleau-Ponty, p. 167.
16. Ibid., p. 180.
17. In Busch, p. 88.
18. Ibid., p. 183.
19. Ibid., p. 122.
20. J. Marvin Spiegelman is one such therapist. Another is D. W. Winnicott, whose paper "The Split-Off Male-Female Elements to Be Found in Men and Women," in *Psychoanalytic Explorations*, pp. 170ff, tells of a male analysand who he felt was talking about penis envy, and of how he said to

the man: "I am listening to a girl. I know perfectly well that you are a man but I am listening to a girl, and I am talking to a girl. I am telling this girl: 'You are talking about penis envy.' " He goes on to say that "there was an immediate effect in the form of intellectual acceptance," and that the analysand then said: "If I were to tell someone about this girl I would be called mad." Winnicott then records his next response, which, as he said, "really surprised me: 'It is not that you told this to anyone; it is *I* who see the girl and see the girl talking, when actually there is a man on my couch. The mad person is *myself*.' "

Winnicott asks: "Is it obvious what was happening here?" He tells us:

> I have needed to live through a deep personal experience in order to arrive at the understanding I feel I have now reached. And, it was the mother's "madness" that saw a girl where there was a boy, and this was brought into the present by my having said, "It is I who am mad." On this Friday he went away profoundly moved and feeling that this was the first significant shift in the analysis for a long time. . . .

One can easily criticize Winnicott's making such statements to an analysand, and it is pointless to argue with those who would be critical, for they would rely upon a fundamentally different mode of awareness than Winnicott has adopted. I believe he was seeing in a way that can be taught, and that can be shown to significantly differ from rational-scientific modes of awareness. I also believe that many analysts see in this way, but falter in courage in publishing what they see, and instead craft their perceptions within more collectively accepted, rational forms.

Clearly, Winnicott's approach was extremely important, creating a shift as never before in the twenty-five years of this man's analysis (also with other analysts). My guess is that the perception of what was *there*, not primarily the reconstruction of historical life, was of the essence.

21. The full rendition of the myth is: When you see Sisiutl you must stand and face him. Face the horror. Face the fear. If you break faith with what you know, if you try to flee, Sisiutl will blow with both mouths at once and you will begin to spin. Not rooted in the earth, as are the trees and rocks, not eternal, as are the tides and currents, your corkscrew spinning will cause you to leave the earth, to wander forever, a lost soul. Your voice will be heard in the screaming winds of the first autumn, sobbing, pleading, and begging for release. When you see Sisiutl the terrifying, though you will be frightened, stand firm. There is no shame in being frightened; only a fool would not be afraid of Sisiutl the horror. Stand firm, and if you

know protective words, say them. First one head, then the other will rise from the water. Closer. Closer. Coming for your face, the ugly heads, closer, and the stench from the devouring mouths, and the cold, and the terror. Stand firm. Before the twin mouths of Sisiutl can fasten on your face and steal your soul, each head must turn toward you. When this happens, Sisiutl will see his own face.

Who sees the other half of Self sees Truth.

Sisiutl spends eternity in search of Truth. In search of those who know Truth. When he sees his own face, his own other face, when he has looked into his own eyes, he has found Truth.

He will bless you with magic, he will go, and your Truth will be yours forever. Though at times it may be tested, even weakened, the magic of Sisiutl, his blessing, is that your truth will endure. And the sweet Stalacum will visit you often, reminding you that your Truth will be found behind your own eyes. And you will not be alone again. (Cameron, pp. 45–46.)

The contagion from Sisiutl that can contaminate represents ways that madness undermines ego functioning and a sense of reality. Madness is contagious. This contagion also spreads through the field that madness creates. Hence, when Dionysus, the god who brings madness, came into a province in Greece, he was said to bring an epidemic of madness (Detienne, pp. 3–4). The blowing from both mouths at once represents the simultaneous opposites in madness that can easily cause one to lose a sense of identity and feeling embodied. Being turned to stone corresponds to the common experience of feeling dead or inert when faced with a psychotic part, like the madness in the Fusional Complex. Facing opposites as represented by the opposing heads of Sisiutl, one often feels overcome by a mindless, empty, despairing and dissociated state. Identifying this condition may lead to "biting the tongue" that would lie by speaking quickly and thereby making the condition vanish before it is known. If instead one suffers the state of impotence that one feels, a new-found capacity to feel empowered against the confusion engendered by the psychotic area can grow. Only through the strength of recognized limitation and the impotence of one's rage can a new strength appear, one that can see the Sisiutl force without spinning out of control in a frantic effort to find some kind of order.

The myth suggests that we must keep faith amidst confusion, until we glimpse both opposites together. This releases Truth, the Truth of the moment, and with it the gift of the "sweet Stalacum," representing the vision with which one can see into the other, and feel the truth "found behind your own eyes."

This notion of suffering dismembering and terrifying states through

conscious submission, rather than trying to defeat them with logic, is at the core of many mystery religions where mania is a major experience. Thus those submitting to the mania in the cult of Cybele (see Chapter Ten) were cured of both the mania they experienced and the madness they brought with them to her rites.

22. In the aperspectival form of consciousness one has the capacity to focus and differentiate parts, and also maintain an individual sense of identity as one is penetrated by the field, while the magical level of consciousness orients through the archetypal and non-individual level, so that identity is a group quality of immersion in the cultural field (see Gebser for an depth analysis of the different modes of consciousness). In the magical level there are no meaningful idiosyncratic images, and nothing is permitted that goes beyond what is already known; anything new is to be avoided, as all experience is blended back into pre-existing mythical structures. Thus, in the magical mode, two people might order an experience by reflecting upon an astrological similarity or difference between them, and not upon a consciousness unique to their interaction at the moment.

23. Bull, pp. 26ff.

24. Rosen, 2006, pp. 33–34.

25. See Chapter Twelve and Levinas's idea of "the Saying and the Said."

26. This act recalls the phrase "the suspension of disbelief," initially coined by Samuel Coleridge during his investigations of the imagination.

27. The evening following his sexual experience, Kevin dreamed that he was with his first love. As they walked along, feeling very loving and holding hands, he said, "I hope you're no longer with that other man." Hearing this, she became enraged and walked away.

Here we have the essence of his inner condition played out in the previous evening's experience. The woman in his dream has "another lover." The dreamer wants her to get rid of him, and this enrages her. The dream thus shows the inner constellation in the dreamer's psyche as it was triggered by the evening's events. *He was the one who had to penetrate* with a chthonic energy, as we later did in our session, and reveal the odd nature of her communication. However, he backed off, and implicitly wanted her to take care of the potentially dangerous forces he felt in her, which could criticize and limit his expression.

The dream is remarkable for the way the woman stalks away. For she is also an Anima figure that desires that the dreamer grow out of his passivity, indicating the inner, autonomous urge in the psyche to deal with the Fusional Complex and grow through it.

In any person, myth and actual history are interwoven. Dreams become a link to a larger, archetypal background that can engender mean-

ing in a person's struggle as well as illuminate personal life and portray actual, historical events in metaphorical form.

CHAPTER 3

1. In *Autistic Barriers in Neurotic Patients* (at the beginning of Part Two, "Psychogenic Autism in Neurotic Patients," which deals with material akin to the Fusional Complex), Frances Tustin quotes Sydney Klein's 1980 paper in which he says, "The sooner the analyst realizes the existence of this hidden part of the patient the less the danger of the analysis becoming an endless and meaningless intellectual dialogue. . . . Although the analyst has to live through a great deal of anxiety with the patient, I feel ultimately the results make it worthwhile" (in Tustin, 1986, p. 181). This has certainly been my experience.
2. From his description, one would think that his friend's unrelated, self-centered behavior would be obvious. However, this was not the case; the field of the Fusional Complex hides such "obvious" perceptions.
3. C. G. Jung described what he called the *somatic unconscious*, the *physiological unconscious*, or the *subtle body*, as experiences of the unconscious that differ from the *psychic unconscious*. The relationship to the psychic unconscious results in the capacity to formulate experience conceptually and causally, unlike the relationship to the somatic unconscious, which instead yields imagery within a sense of acausality. The subtle body, Jung said,

> is beyond space and time, beyond our grasp, per definition; the subtle body is a transcendental concept, which cannot be expressed in terms of our language or our philosophical views, because they are all inside the categories of time and space.
> So we can talk primitive language as soon as we come to the question of the subtle body, and that is everything but scientific. It means speaking in images. Of course, we can talk such a language but whether it is comprehensible is an entirely different question. (1988, pp. 443–444)

Throughout this book I use metaphors for the in-between world of the subtle body that raise the same question Jung asks here, namely, can they be understood? Do images, such as a "torn subtle body," a "damaged psychic skin," or a "sensate fabric between us," possess communicative value? Other analysts have used idiosyncratic images such as a "wet, clogged up space" (Coquil, quoted in Tustin, 1986, p. 143) between analyst

and analysand to describe experiences with autistic patients, the phenom-
enology of which is akin to field experiences with the Fusional Complex.
Such images, though highly idiosyncratic, are precisely the kinds of
metaphor required in dealing with experiences of the somatic uncon-
scious. As difficult as it may be, when we deal with the Fusional Complex
I believe we must express ourselves in an imagistic manner, because the
damage to containment occurs in that imagistic realm of the subtle body.
Images have a greater chance of communicating when they emerge out of
an embodied awareness of the somatic unconscious.

In particular, Jung's work on synchronicity and acausal processes
forms a structural basis for such perceptions, and also for ways that they
can be meaningful to both analyst and analysand. Synchronistic experi-
ences, which I believe are a form of aperspectival awareness, are a result of
an intersection of experiences of the somatic unconscious, and its acausal
quality with a time-bound state of existence (von Franz, 1974, p. 242).
The latter could consist of the of the moment of the analyst's intentional
"leaning into" the field, and perhaps, as well, of his or her reflecting upon
the analysand's early life and developmental factors in the formation of
the Fusional Complex, while the timeless, acausal state would be engaged
in the experience of being in the field These two forms of awareness, one
time-bound and the other outside of linear time, experienced as a mutual
field with the analysand, can combine to create a higher probability for
the manifestation of a meaningful coincidence, an image that has a truth-
value for both people.

4. Rosen, 1995, p. 127.
5. Rosen, 2006, p. 33.
6. Bull, pp. 31ff.
7. See Appendix A.
8. Over the next month of sessions, the role of internal envy in his life—an
incorporation of his mother's envy—emerged in one powerful example
after another. In each session he carefully described how anything good in
his life, such as a new job possibility or a beginning of a creative work, was
immediately destroyed by actual physical accidents, some of them severe.
Kyle could also experience his negative transference, through which what-
ever I said during any given session was destroyed by envy, leading to it
being totally "forgotten." The term "envy" made all the difference to Kyle,
for it became a container for a number of awful experiences that emerged
whenever he came forth into owning his own power.
9. When Kyle and I experienced the fusion-distance field through the
topology of the Klein bottle, we were feeling a very mild form of union,
i.e., amidst the total discontinuity of the opposites, there was, paradox-
ically, also a union experience carried by the sensate-like fabric of the

subtle body. The ancient alchemists called this field quality of union the *coniunctio*. Such union states are followed by a radical disorder, what the alchemists called the *nigredo*, which was "darker than dark," a "source of madness," a dreadful condition in which "many have perished"—and yet the essential condition for any transformation to become stable. When Kyle and I experienced the oscillating surfaces of the Klein bottle, he had been in analysis with me for four years. After that time there were several *nigredo* states, some very dark and chaotic, that challenged our analysis and Kyle's individuation process. Over the next two years a self-structure, an authentic center for Kyle's existence emerged, experienced as an inner, mysterious force that could orient his conscious attitude in ways he had never known to exist.

10. Ideally, a person should be able to continue to feel his or her adult status and age while imaginally experiencing an inner state that may be far younger. But this is a structure to be gained and is often the result of arduous work, for commonly the strength of the "younger" emotions pulls the adult personality into identification with them. (Lydia Salant, personal communication)

CHAPTER 4

1. The odd condition of Restless Leg Syndrome, while linked to dopamine and neurological deficits, can have the Fusional Complex as its psychological underpinning. As such, the physical behavior represents the "impossible" fusion-separation dilemma: unable to separate or stay related to an object, one runs in place, uncontrollably.

2. When an object relation is incorporated, it is swallowed whole rather than internalized along with a parallel, reflective process that is somewhat aware of similarities and differences with the object. Incorporation lacks this reflection and is best seen as an unconscious "swallowing," for example, of a parental figure's madness or depression in order to deny the existence of such destabilizing affects. Incorporation can play an important role in the genesis of the Fusional Complex.

As a consequence of such incorporations, a person can live with a largely unconscious orienting and determining influence upon his or her sense of identity of and being in the world. This influence may not only be totally hidden from the person's awareness, but, to employ Derrida's terminology, it may be *encrypted* within an inner *safe*. This unconscious influence exists within whatever self-formation was created.

Derrida's formulation stresses how this hidden influence does not evolve through a conflict of opposites. "The inner safe [is] enclosed within the self. What is needed, still mute, is the contradiction springing from the incorporation itself. It ceaselessly opposes two stiff, incompatible forces, erect against each other" (Derrida, p. xv). Or, one could say, the "contradiction" is thrust back into a time before creation, before the Biblical Second Day.

3. Rosen, 1995, p. 127.
4. Derrida further realizes the fate of this lack of a conflict between opposites (I suggest that the main opposites involved are the fusion/distance dyad), and adds the special insight that the contradiction is encapsulated within a field of desire. "Without this contradiction within desire, nothing would be comprehensible: neither the relative solidity of the crypt . . . nor the hermeticism and the indefatigable effort to maintain it, nor the failure of the effort, the permeation from within or without, seeping through the crypt's partitions. . . ." (Derrida, p. xv). In other words, until one begins to reach beyond the autistic-like encapsulation of the incorporated contents, and suffer the conflict of opposites, there is no consciousness.

Typical of the dynamics of trauma and dissociation, the contents of the crypt, or safe, which is "no place," are created through the unconscious fantasy that the events that created it never occurred. Furthermore, the chronic absence of desire, or a suffering of feeling the existence of desire that cannot be joined and felt in life, with another person, accompanies the encrypted state:

> The trauma and the "contradictory" incorporation should not have taken place. The topography of the crypt follows the lines of a fracture that goes from this no-place, or this beyond place, toward the other place; the place when "pleasure's death" still silently marks the singular pleasure: safe. (p. xxi)

Derrida's description of a "place" in the self where a trauma is hidden in a way that forecloses its existence—"it never took place"—and creates a sense of "safe," both in the sense of safety and of being encrypted, tracks the genesis and fate of mad parts of the Fusional Complex, just as "two stiff, incompatible forces, erect against each other" can represent the fusion-distance opposites.

5. As we shall see in Naomi's material, to which we return in the next chapter.
6. This refers to the so-called entrance into the depressive position. Cf. Gerald's case in Chapter Eight.

CHAPTER 5

1. Some psychoanalytic writers speak of a sensation-created "fabric" of the self (see Appendix A), and how that fabric can become torn or seem to have holes in it. How are we to understand the lack of formation of a cohesive surface comprised of organized sensations? How are we to understand the "holes" in the fabric of an emerging self? Does the self indeed have a "fabric"?

Throughout several thousand years, up to the reign of science and the discarding of kindred concepts such as the ether, we find the proposition that a *subtle body* exists as a cloak or garment of the soul, the inner life. In *The Doctrine of the Subtle Body in Western Tradition*, G.R.S. Mead explains that this subtle body is not a "thing" like the physical body, nor is it only an energy system. Rather it is a fabric of *relations* that structure an "in between" realm, a "medium between soul and body" (p. 38) that can be healthy or damaged (p. 45).

Thus the doctrine of a "subtle embodiment of the mind," a "body" not as dense as the actual body, and in fact capable of manifesting in various grades of density, is ancient. It was thought of as having "lower" and "higher" forms, the latter being close to Light and known in this pure state as an organon of Light, or as a celestial body. The "lower" or less pure variety entertained a close relationship with the physical body and the animal soul, and in this "inferior aspect" it was usually called the *pneuma*, the spiritual body, or the spirit-body (p. 34).

Mead explains:

> It must, however, be always clearly understood that, for our philosophers, spirit in this sense is subtle body, an embodiment of a finer order of matter than that known to physical sense, and not soul proper [which is immaterial]. By body, moreover, is not meant developed and organized form, but rather "essence" or "'plasm" that may be graded, or as it were woven into various textures; in itself unshaped, it is capable of receiving the impression or pattern of any organized form. (p. 36)

Higher and lower aspects of this subtle embodiment of the mind were posited and argued about in the early centuries C.E. For example, the so-called lower forms were sometimes considered to be a "counterfeit spirit" (p. 35), similar perhaps to the "substitute skins" discussed in this chapter.

There is a difficulty with using spatial metaphors for the subtle body. Mead notes that in the ancient writings, such as "Isis to her Son Horus" in

Thrice Greatest Hermes, "both spirit [i.e. subtle body] and body are *in* the soul, and not soul *in* the spirit." However, he then notes that in these writings we also read "the soul is spoken of as vehicled in, or on, the spirit. But as the soul is said to use the sprit not *as* its envelope but only 'as though it were' its envelope, there is no real contradiction" (p. 38).

There is a better way to avoid this "contradiction." If the subtle body is understood to have the typological structure of a Klein bottle, then the "soul" can be experienced as "inside" the subtle body, but it can then oscillate to the "outside" of it, like an observer objectively considering the nature of this plasm. Thus we are in the subtle body as subject, and we are the objects of its processes: the subtle body contains the soul and the soul contains the subtle body. The "contradiction" is obviously resolved once the dimensionality of the subtle body is no longer three-dimensional space of vessels with separate insides and outsides, but the four-dimensional space of the Klein bottle (Chapter Three). It is not surprising that the Klein bottle should also be the spatial nature of the subtle body, since it was that "body" that was the object of the transformations of alchemy. For more on the subtle body in clinical practice see my book *The Borderline Personality: Vision and Healing*.

2. 1991, p. 298.

3. A female patient became pregnant, but was so distressed about her life and marriage that she resented the pregnancy and seemed to ignore it—smoking, taking drugs, and exercising as she always had. She then dreamed that she was looking at a distant landscape and saw a gypsy caravan. An old gypsy woman was weaving a blanket that included an image of a baby. The dreamer did her best to ignore the gypsy, but the image was too striking not to be remembered the next day.

 The act of weaving likely represents an imaginative process that would attend to the formation of the subtle body of the fetus, and the archetypal nature of the dream points to this imaginative act as an innate drive. The dream attempts to compensate for the absence of this drive in the dreamer's ego consciousness. In post-uterine life, the mother's reverie with her infant continues to fulfill this function, and in later life, healthy object relations further help form and heal the fabric of the subtle body, which is continually bombarded by internal and environmental, emotional intrusions.

4. Naomi's "bubble," in which she was both subject and object, and I felt totally excluded, seemed like remnants of a "primary narcissism" in which the infant lives in a somewhat isolated world with no outer object, akin to an autistic state. The concept of primary narcissism has long been discarded by most psychoanalytic thinking. Yet Naomi's case, and many others, makes me think that we have not seen the last of this notion.

5. I have described this containing structure and how it was discovered in my book *The Mystery of Human Relationship*, though at that time I had not formulated the idea of the Fusional Complex. I was relating to this material as part of a field experience, and I was not aware of it is a "substitute skin" enclosing Naomi's Fusional Complex.

CHAPTER 7

1. In Sophocles' play *Trachiniae* (440–430 B.C.E.), Heracles' wife, Deianeira, applies what she believes is a love charm to a robe she has made for her husband. But she has been tricked by the centaur Nessus, who once attempted to abduct her and was shot with a poisoned arrow by Heracles. As he lay dying, Nessus instructed Deianeira to use his blood in a potion to ensure her husband's eternal devotion. Instead, when Heracles donned the poisoned garment, "the tunic clung to his sides, at every joint, close-glued, as if by a craftsman's hand; there came a biting pain that racked his bones."
2. In alchemy, the union of opposites, known as the *coniunctio*, is said to create the subtle body.
3. The psychoanalyst D. W. Winnicott (1972) showed how a young boy's mind became blank when his "mother's madness" was enlivened within him, a madness he had incorporated, i.e., swallowed whole with no reflection. Masud Kahn (1972) wrote a paper on exorcising what he called the madness of ego-alien factors.
4. These qualities are part of Michael Balint's notion of *The Basic Fault*, p. 21.

CHAPTER 8

1. Alice did not automatically shift from one alter to another, so I would not call this a dissociative disorder.
2. There is a great difference between passive and active fantasy. In passive fantasy one merges with an inner world of images, thoughts, and feelings, which forms a "substitute skin." In active fantasy, what Jung called "active imagination," the ego maintains a degree of objectivity and separation from the inner world. Yet it is separation of any kind that can be too anxiety-provoking and lead, instead, to passive fantasy.
3. See Chapter Two.
4. This experience has been elucidated by D. W. Winnicott in his *Playing and Reality* (p. 89f).
5. In the state he and I were in, now mildly aware of feeling attached and distant, yet feeling psychically contained within these opposites so that it was

possible to think, I had a partial answer for him. It seemed that his para-
noia was not only about being attacked by other people. It was also the
fear that his inner, sensitive soul had *of him*, e.g., of his attacks on himself
for "not being more authentic, or spontaneous, or successful, etc." The
inner life of his soul, I suggested, "spoke" through physical pains in his
chest, and through paranoid feelings and thoughts.

CHAPTER 9

1. We meet this in people who believe they smell bad, even when this is not
 actually true. For example, a person dreamed that he had bad breath. This
 was not true to his actual life situation, but did signify the abject nature
 of his Fusional Complex.
2. Malcolm Bull notes, "Sartre's definition of slime echoes Hegel's character-
 ization of motion as a contradiction. Here something is simultaneously
 being here and not here, have been distilled into an appalling new sub-
 stance in which that contradiction is not a temporary result of motion but
 the very essence of the substance itself" (p. 59).
3. Bull, p. 60.
4. The analyst's difficulty with recognizing or interpreting the "other mes-
 sage" to begin with originates in the nature of the abject state and the
 power of this state to affect the nature of the field between analyst and
 analysand. In *Powers of Horror* Julia Kristeva examines the kind of insidi-
 ous threat posed by the abject: "Not me. Not that. But not nothing either.
 A 'something' that I do not recognize as a thing. A weight of meaningless-
 ness, about which there is nothing insignificant." The abject is this non-
 object, which is "ejected beyond the scope of the possible, the tolerable,
 the thinkable."
 The abject is neither subject nor object. Rather, the abject condition
 results from regression into areas that preceded creation, before oppo-
 sites were differentiated on "the Second Day," as we have discussed in
 Chapter Two.
5. Cited in Kristeva, p. 56. Bataille also notes: "The act of exclusion has the
 same meaning as social or divine sovereignty, but it is not located on the
 same level; it is precisely located in the domain of things and not, like sov-
 ereignty, in the domain of persons. It differs from the latter in the same
 way that anal eroticism differs from sadism" (Kristeva, p. 56).
6. In *The Basic Fault*, Michael Balint dealt with an area that shares features
 with the Fusional Complex. The patient lives in a world of "fault." What
 may appear to be a creative conflict to the analyst is usually not fruitful at
 all for the patient, and only leads to despair. Balint evokes the danger of a

fault line in geology in addition to the sense that in any disagreement or conflict, someone is always at fault. Neither conflict nor conflict resolution seems possible, only blame.

He describes a countertransference reaction to the area of the basic fault that is extremely important (pp. 18–19). When the Fusional Complex is inwardly enlivened in some analysands, the analyst can suffer a very uncomfortable state of mind and body. He or she has the uncomfortable sense of knowing nothing; all of his or her knowledge and experience feels of little value, while the analysand in contrast seems very wise. The analyst fears the analysand's knowledge, particularly the special powers of observation and insight he or she seems to have into the analyst's deepest problems. There is little sense of this knowledge being used in a kind way; rather, suspecting controlling, power-seeking motives, the analyst feels inwardly frozen and just wants the state to end.

7. Schwartz-Salant, "Anima and Animus in Jung's Alchemical Mirror."
8. Bull, p. 61.
9. Yet how far can one go in facing the abject? Are there limits to how much responsibility we can assume for the other? The issue of ethics is unavoidable. See Chapter 12.

CHAPTER 10

1. Fasti, pp. 205–207.
2. Jung, 1967, p. 338, has shown how the tree is a major symbol of the individuation process. Cybele's destruction of the tree is indicative of how the madness in the Fusional Complex destroys or severely hinders the individuation process.
3. Roller, p. 66, tells us that, according to the Roman author Strabos, the goddess received her epithet "Dindymene" from the mountain Dindymon (which is rendered as Dindymus in the translation of Ovid's myth that I have used).
4. Note the kinship with Tustin's idea of the "two-stage" development of psychogenic autism (see Appendix A). Tustin wrote: "I have come to see that autism is a protective reaction that develops to deal with the stress associated with the disruption of an *abnormal* perpetuated state of adhesive unity with the other—*autism being a reaction that is specific to trauma*. It is a two-stage illness. First, there is a perpetuation of dual unity, and then the traumatic disruption of this and the stress it arouses" (quoted in Susan Maiello, "Going Beyond: Notes on the Beginning of Object Relations in the Light of 'The Perpetuation of an Error,' " in Mitrani, *Encounters with Autistic States*, p. 6). Maiello also notes that since "the time of onset of the

first stage [is] characterized by excessive adhesive-at-oneness . . . in the case of children show symptoms of the second stage from birth, the first stage would necessarily begin in prenatal life" (p. 8).

5. Roller, p. 248.

6. See Chapters Three and Five for discussion of the subtle body. The study *The Skin Ego*, by Didier Anzieu, addresses the myth of Marsyas in great detail (pp. 48 *passim*). His notion of a "Skin Ego" is surely consonant with the subtle body idea, but, being grounded in doctrines of psychoanalytically understood developmental processes and structural analysis, his approach leaves out the archetypal and its imaginal life, which has been my emphasis in this book. In a sense, the idea of a Skin Ego seems to me to be an analysis of the vicissitudes of the incarnation or embodiment of the pleromatic, archetypal life of the subtle body, without reference to that level of existence, for notions of *structure* alone fail to encompass it. The Skin Ego is a "mental image of which the Ego of the child makes use during the early phases of development to represent itself as an Ego containing psychical contents, on the basis of the experience of the surface of the body" (p. 40). "The maternal environment (surrounds) the baby with an external envelope made up of messages. This (leads to) the inner envelope, the surface of the baby's body, which is the site and instrument of the transmission of messages. . . . This appropriated envelope completes the individualization of the baby by providing a recognition that confirms its individuality" (p. 62). Anzieu then further explains the process the baby must successfully transit in order for his Skin Ego to become his own, rather than one totally fused with the mother, and that the baby here experiences fantasies of a flayed skin as in the Marsyas myth (pp. 63–64).

Anzieu's book is a treasure trove of insights about the fate of an individual whose subtle body has been damaged. If we refer to the case of Gerald (Chapter Eight), whose thoughts would fragment and disappear, we recognize the truth of the statement that "the Skin Ego underlies the very possibility of thought" (p. 41). Reflecting upon Naomi's material, Anzieu's notion that "the Skin Ego is one of the conditions for the [transition] from primary to secondary narcissism" (p. 41) is very much on target. Like the subtle body, the Skin Ego is a boundary between interior and exterior (p. 38) and is a psychical container that can become damaged, leading to severe states of depersonalization, such as in Bion's observation of people suffering from "a vital flowing away of vital substance through holes" (Ibid.).

7. Ibid.

8. The tree is made a tree of death through Apollo's vengeance, thus again, as in Ovid's story, showing how the Fusional Complex destroys individu-

ation. For more on the Marsyas myth, from a Freudian point of view, see Anzieu's analysis (pp. 48 *passim*).

9. Burkert, p. 148.

10. Gasparro, pp. 26ff. The motif of castration in the face of the Fusional Complex is, at times, symbolically depicted in dreams. For example, a man had an affair with a woman whom he found irresistibly attractive. He worried that she would confess their affair to his wife. In what might appear to be a heroic gesture he decided to help her visit her ailing mother in a foreign country. He had very little money, yet with great ingenuity, spending all the money he had and borrowing more, he managed to get her airline tickets and other accommodations.

 After the woman returned from the trip, the man reported to me that he felt let down, for she showed hardly any appreciation. The night before she returned he dreamed that he had taken a knife and cut his finger to the bone, but found to his amazement that it didn't hurt. This image represented his behavior and attitude. He mutilated himself to feel safe with this woman, and then, in hysterical fashion, didn't even feel the pain! In practical terms, his financial sacrifices landed him in debt and cost him several important business opportunities. All along his actions had little relationship to the woman's needs, for, as he finally learned, she felt him to be unrelated to her and only using her sexually. He eventually could realize that he was deeply fused with this woman, through his rather unbounded erotic life, and also totally disconnected from her.

11. In Roller, p. 304.

12. Gasparro, p. 87.

13. See Appendix A.

14. 1977, p. 215.

Chapter 11

1. Jung, 1916.

2. Judith Mitrani's declaration of the importance of object relations is very well stated:

 > Only through human relationship can a sense of internal space develop. Without this sense of internal space, the phantasy of getting inside of the object cannot develop and the unyielding sensation of being "at-one-with," equated and contiguous with the object prevails, perhaps as a remnant of the earliest intrauterine experience of existence. In such a hyperbolic and therefore *pathological* state of "at-one-ment," there can be no "psychological birth" and therefore no *meaningful* experience of

a physical life outside the womb, since the awareness of such physical separateness, when it impinges upon these as yet unformed individuals, can only be *felt* as catastrophic. . . . The subjective experience of "space," while one is in this state of existence is the "black hole." . . . As Grotstein put it, the experience of the black hole is an "experience of powerlessness, of defect, of nothingness, of 'zero-ness'—expressed, not just as a static emptiness but as an implosive, centripetal pull into the void." Thus "space" is not experienced as an area within which human relationship might be allowed to develop, but rather it is felt as the *presence of an inhumane and malevolent absence*, which must be blotted out of awareness at all costs. (1994, p. 82)

3. The ego must achieve a state in which it can feel this chthonic force as a partner at its side, something like a Mafia figure, who in legend does what is needed to achieve its goal, nothing more or less: "just business." Our modern culture's fascination with the underworld in television series and movies attests to the collective need for integrating this chthonic dimension into conscious awareness, rather than see it as an enemy to be denied through intellectual and spiritual escape. The ego can feel the chthonic energy as a partner that will enter into any interaction that requires it, and not otherwise, as though one had a protector who was deeply linked to body and instinct, with little reference to spiritual energies.

4. The incest taboo, seen as a barrier to entering into the unconscious and discovering the "treasure hard to obtain," was the major theoretical dissension of Jung from Freud, who insisted upon the incest taboo as a barrier against sexuality with family (or extended family) members. Jung recognized this "personal" aspect as well, but his insistence upon an archetypal dimension viz. the taboo as a barrier to experiencing the numinosum was characteristic of his awareness that far more than repressed or otherwise denied early maternal interaction was involved. In dealing with the Fusional Complex one always meets a mixture of these features. Sometimes one or the other point of view must be stressed.

5. Rundle Clark, pp. 59–60.

CHAPTER 12

1. This refers to the self as an immanent reality, and hence an "innerness" in distinction to the eternally existing transcendent Self. See Schwartz-Salant, 1982.

2. Jung explained that this myth compensated for the patriarchal dominance

of Western culture (1968, par. 26). However, Jung's Attis (in his rendering of him as the *prima materia*) is a chthonic figure, akin to the alchemical God Mercurius, who has, among other virtues, instinctual, embodied power. Jung's choice is somewhat strange. For the Attis we know of in all tales of his life with Cybele is anything but chthonic; Attis precisely lacks the chthonic dimension of embodied aggression. In a sense, Jung's Attis-Cybele myth is an updated version of the myth we know. I prefer to think of Jung as something of a trickster here, slipping in an individuated Attis rather than the weak and dependent shepherd of legend. I think the myth, in its original form(s), is indeed the *prima materia* that we must work with. For more on this, see Schwartz-Salant, 2006.

3. In his article "Shakespeare, Astrology and Alchemy: A Critical Historical Perspective" (*The Mountain Astrologer*, Feb.–Mar. 2004), Philip Brown illuminates Shakespeare's awareness of the Hermetic Tradition, a point Frances Yates has also made. Brown goes further to point out alchemical allusions in the plays. In *Romeo and Juliet* (quoting Martin Lings' book *The Sacred Art of Shakespeare*), we read ". . . the symbolism of Romeo and Juliet . . . is alchemical, the more so in that the two lovers are as it were transmuted into [golden statues] after their deaths." And, Brown notes, "One of the pivotal characters in *Romeo and Juliet* is . . . Mercutio," clearly related to the alchemical god Mercurius and embodying his hermaphroditic nature. Also, the alchemical *coniunctio-nigredo* symbolism is central to the play. See *The Sacred Art of Shakespeare* for more connections to alchemy.

4. Bloom, p. 145.

5. Garber, p. 466.

6. Ibid., p. 470.

7. Ibid.

8. Neill, p. 308.

9. Ibid., pp. 311–312.

10. Rundle Clark, pp. 218ff.

11. Garber, p. 494.

12. Ibid.

13. I am grateful to Lydia Salant for this insight.

14. *Hamlet*, V, ii, 60–62, and cf. Bloom's opposing sentiment, p. 61.

15. Neill, p. 309. We see traces of this madness in the "To be or not to be" soliloquy, where one reflection is always cast out by another. From this alone we may not be able to judge that a play of psychotic "anti-worlds" is active, but to do so is not far-fetched, and brings some coherence to the controversy over whether Hamlet merely feigned madness, as surely he did in part, or was truly mad. I suggest that Hamlet's madness was not

necessarily innate to his character, but was instead a symptom of being stuck in the Fusional Complex.

Shakespeare may have been suggesting Hamlet's madness in his use of an odd verbal trick called hendiadys. As James Shapiro tells us,

> Hendiadys literally means "one by means of two," a single idea conveyed through a pairing of nouns linked by "and." When conjoined in this way, the nouns begin to oscillate, seeming to qualify each other as much as the term each individually modifies. Whether he is exclaiming "Angels and ministers of grace defend us" (I, iv, 39) . . . speaking of the "book and volume of my brain" (I, v, 103) . . . Hamlet often speaks in this way. The more you think about hendiadys, the more they induce a kind of mental vertigo. . . . The destabilizing effect of how these words play off one another is slightly and temporarily unnerving. It's only on reflection, which is of course Hamlet's problem, that we trip. (p. 287)

Shapiro further tells us that

> it is very hard to write in hendiadys; almost no other English writer did so very often before or after Shakespeare and neither did he much before 1599. Something happened in that year . . . and continuing for five years or so past *Hamlet* . . . after which hendiadys pretty much disappear again. . . . But nowhere is [their] presence felt more than in *Hamlet*, where there are sixty-six of them, or one every sixty lines. . . . (Ibid.)

It seems reasonable to conjecture that Shakespeare used hendiadys to demonstrate the madness in Hamlet. For the effect of hendiadys is, as Shapiro has noted, "slightly and temporarily unnerving" and, just as we also experience in psychotic process, the full, mad force of the hendiadys comes forth when we try to reflect upon our slightly unnerved state, rather than dissociate from it.

16. Shakespeare scholar Stephen Greenblatt writes,

> Without once making an appearance in his own person—for, after all, this is a mythological fantasy—Shakespeare is constantly, inescapably present in Venus and Adonis, as if he wanted Southampton (and perhaps "the world," at which he glances in his dedication) fully to understand his extraordinary powers of playful identification. (pp. 240–241)

He also points out,

> Apparently indifferent to the printing house through most of his career, here for once he showed clear signs of caring. He chose for the printer someone he could trust, his fellow Stratford-upon-Avon native Richard Field. . . . Shakespeare was attempting, probably for the first and only time in his career, to find a patron, and with the theaters shut down and the plague continuing to rage, he may have thought a great deal was riding on whether he was successful. . . . Judging from the rush of imitations, admiring comments, and re-printings—ten times by 1602!—the poem pleased virtually everyone. (It was particularly popular, it seems, with young men.) (Ibid.)

17. Garber, p. 725.
18. Neill, pp. 311f.
19. Ibid., p. 310.
20. Ibid., p. 317.
21. Ibid., p. 318.
22. Nowadays, some of the best images of chthonic life are seen in stories about the Mafia, and our culture's fascination with such underworld life shows the necessity of integrating the chthonic dimension of existence. We need chthonic experience, not as a ruler in its own right, but as a companion that gives strength to the ego, that senses danger or safety and acts accordingly. The chthonic masculine part of one's being does not always stop to reflect and question oneself as to "what he should do." He does what has to be done.

 None of the men or women in the cases I have presented in this book had this chthonic quality. Without the strength of the chthonic, they are like Attis, like Hamlet, unable to leave the sphere of influence of the Fusional Complex.
23. Neill, p. 318.
24. The statement that Hamlet can be a "king of infinite space" in his nutshell resonates with the fact that the subtle body is beyond space and time.
25. Neill, p. 315.
26. *The Unconscious Before Freud* (New York: Basic Books, 1960), p. 43. Whyte continues: "In seventeenth-century Europe [the individual] had become so vividly aware of himself as a feeling, perceiving, and thinking person that in Germany and England, at least, he could no longer do without a term for it, a single word expressly referring to this experience." Further, "It is interesting that 'con-scious,' whose Latin source had meant 'to know

with' (to share knowledge with another), now came to mean 'to know in one's self, alone.' "

27. Wahrman, p. 168. Well past the middle of that century, people had, for example, much to say about feelings, but these were not thought about as interior, as "belonging to me"; they existed as part of an immersion in a group process (Hillman, p. 79).

28. Ibid., pp. 3ff.

29. Ibid., p. 4. Wahrman clarifies (p. 13): "It would be wrong to suggest that the emphasis on motherhood was a novelty of the last two decades of the eighteenth century. Quite the contrary . . . the mother was the normative figure. . . . [the] question is, when did the woman who chose *not* to mother become a fundamentally unacceptable and disturbing figure? It is here [that] we see clear marks of a late eighteenth-century turning point."

30. Ibid., p. 4.

31. Ibid.

32. Ibid., p. 171.

33. Ibid., p. 173.

34. Ibid., p. 175.

35. Long before an individual awareness emerged into collective consciousness, it existed only as a potential, stored in the unconscious, and the soul was a collective reality. In that state, as M. L. von Franz tells us: "The individual becomes aware of his or her individual inner Self, or 'eternal person,' only through the religious tradition, for only that tradition expresses the spiritual essence of his or her being. As shown by Helmuth Jacobsohn, the Egyptian of the Middle Kingdom period (up to 2200 B.C.E.) still believed that he met his non-collective, personal soul only after death, in the form of the so-called ba soul, a birdlike being that embodied his true inner Self. During his lifetime, however, the Egyptian felt himself to be real only as a member of the community, only insofar as he functioned according to the rules and laws of his religion." (1999, p. 255)

36. Schwartz-Salant, 1995, pp. 1–14.

37. Jung, 1967.

38. Jung, 1976, pp. 553–554.

39. Knowlson, p. 319.

40. See Jung's *Mysterium Coniunctionis*, pars. 654 passim.

41. Robbins, p. 40.

42. "Psychology and Religion," par. 137.

43. Robbins, p. 48.

44. See Jung's description of the analyst-analysand interaction in his *Psychology of the Transference*, pars. 363–64.

45. The psychoanalyst Joyce McDougal describes the loss of the capacity to

function as an analyst as sometimes occurring as part of treatment in very difficult cases:

> But in the case where the distinction between transference projection and reality observation is blurred, the way in which the analyst receives the patient's transference expression is likely to differ. Hidden in the shape of "pseudo communication" that seeks less to inform (literally: to give form to) the analyst of his thoughts and feelings than to get rid of painful intrapsychic conflict and arouse reaction in the analyst, we must wonder how the latter may best capture and interpret this "language." In the beginning he does not "hear" the message, nor does he immediately become aware of his emotional impact. It is difficult to detect what is missing, particularly since its ejection leaves no unconscious trace, and no neoreality has been invented to take its place as with psychotic patients. Gradually, affect is mobilized and indeed accumulates in the analyst; while the analysand flattens or distorts his affective experience, the analyst becomes literally "affected." The patient's associations have a penetrating or impregnating effect, which is missing in the usual neurotic transference and analytic monologue. What has been foreclosed from the world of psychic representation cannot be "heard" as a latent communication. It is the emotional infiltration that contains the seeds of future interpretations, but in order to be able to formulate these the analyst must first understand why his patient's discourse affects him in the way it does. . . . With the kind of patients I am describing the analyst is apt to feel in the first instance that he has somewhere along the line *ceased functioning adequately as an analyst* with this particular analysand. (McDougal, pp. 293–294.)

In the fields of the Fusional Complex, this condition can become chronic, while "functioning as an analyst" becomes the exception. This is what raises the issue of the ethics of continuing treatment.

46. 1981, p. 191.
47. I am grateful to Dr. Michael Gruber for this reference and his reflections on the text.
48. Interview conducted by Françoise Poirié in Robbins, p. 54.
49. Ibid, p. 57.
50. Simon Critchley, in Critchley and Bernasconi, p. 22.

51. Davis, p. 70.
52. Quoted in Davis, p. 70.
53. Critchley, in Critchley and Bernasconi, p. 21. The skin surface (as we have seen, for example, in Phillip's case) is the locus of a great deal of the distress of the Fusional Complex. See Appendix A.
54. Interview conducted by Augusto Ponzio in Robbins, p. 228.
55. Davis, p. 75.
56. Ibid.
57. Ibid., pp. 45–46.
58. See Levinas's notion of *il y a* (there is), Robbins, p. 45.
59. Gasparro, pp. 26ff.
60. See Vasseleu's work on light and the feminine, and feminist critiques of Levinas in Chanter.
61. In a letter to James Kirsch, Jung strikes a tone (not generally found in his attitude towards the transference) that harmonizes with this point of view: "With regard to your patient, it is quite correct that her dreams are occasioned by *you*. The feminine mind is the earth waiting for the seed. That is the meaning of the transference. Always the more unconscious person gets spiritually fecundated by the more conscious one. Hence the guru in India. This is an age-old truth. As soon as certain patients come to me for treatment, the type of dream changes. In the deepest sense we all dream not *out of ourselves* but out of what lies *between us and the other.*" (1934; in Jung, 1973, p. 172)

Appendix A

1. Ogden, 1986, p. 52.
2. Tustin, 1986, p. 43; Ogden, 1986, p. 52.
3. 1989, p. 50.
4. Mitrani, 1994, p. 82.
5. See *Number and Time*, by M.L. von Franz, for a discussion of the temporal and atemporal matrices underlying divination and the *I Ching*, pp. 241–242.

Appendix B

1. Rosen, 1995.
2. Jung, 1968, par. 26.

LITERATURE CITED

Anzieu, Didier. 1989. *The Skin Ego*. New Haven and London: Yale University Press.

Ayres, Ed. 1999. *God's Last Offer: Negotiating for a Sustainable Future*. New York and London: Four Walls Eight Windows.

Balint, Michael. 1968. *The Basic Fault*. Repr., New York: Brunner Mazel, 1979.

Bernasconi, Robert, and Simon Critchley, eds. 1991. *Re-Reading Levinas*. Bloomington, IN: Indiana University Press.

Bloechl, Jeffrey, ed. 2000. *The Face of the Other and the Trace of God: Essays on the Philosophy of Emmanuel Levinas*. New York: Fordham University Press.

Bloom, Harold. 2003. *Hamlet: Poem Unlimited*. New York: Riverhead Books.

Bull, Malcolm. 1999. *Seeing Things Hidden: Apocalypse, Vision and Totality*. London and New York: Verso Books.

Burkert, Walter. 1985. *Greek Religion*. Cambridge, MA: Harvard University Press.

Cameron, Anne. 1981. *Daughters of Copper Woman*. Vancouver: Press Gang Publications.

Castaneda, Carlos. 1968. *The Teachings of Don Juan: A Yaqui Way of Knowledge*. Berkeley: University of California Press.

Chanter, Tina. 2001. *Feminist Interpretations of Emmanuel Levinas*. University Park, PA: The Pennsylvania State University Press.

Clark, R.T. Rundle. 1959. *Myth and Symbol in Ancient Egypt*. London: Thames and Hudson.

Couliano, Ioan P. 1987. *Eros and Magic in the Renaissance*. Chicago and London: University of Chicago Press.

Critchley, Simon, and Robert Bernasconi, eds. 2002. *The Cambridge Companion to Levinas*. Cambridge: Cambridge University Press.

Davis, Colin. 1996. *Levinas: An Introduction*. Notre Dame, IN: University of Notre Dame Press.

Derrida, Jacques. 1986. Foreword to Abraham and Torok's *The Wolf Man's Magic Word: A Cryptonymy*. Minneapolis: University of Minnesota Press.

Detienne, Marcel. 1989. *Dionysos at Large*. Translated by Arthur Goldhammer. Cambridge, MA: Harvard University Press.

Douglas, Mary. 1966. *Purity and Danger: An Analysis of Concepts of Pollution and Taboo*. London and New York: Routledge.

Feuerstein, Georg. 1987. *Structures of Consciousness: The Genius of Jean Gebser*. Lower Lake, CA: Integral Publishing.

Garber, Marjorie. 2004. *Shakespeare After All*. New York: Pantheon Books.

Gebser, Jean. 1991. *The Ever-Present Origin*. Athens, OH: Ohio University Press.

Giovacchini, Peter L., ed. 1972. *Tactics and Techniques in Psychoanalytic Therapy*. London: Hogarth Press and the Institute of Psycho-Analysis.

Greenblatt, Stephen, et al. 1997. *The Norton Shakespeare*. New York: W.W. Norton & Company.

Grotstein, James. 1990. "Nothingness, Meaninglessness, Chaos and the 'Black Hole' I." *Contemporary Psychoanalysis* 26, no. 2.

Hand, Sean. 1989. *The Levinas Reader*. Oxford, UK, and Cambridge, MA: Basil Blackwell, Inc.

Hillman, James, and von Franz, Marie-Louise. 1971. *Lectures on Jungs's Typology, the Inferior Function and the Feeling Function*. Zurich: Spring Publications.

Jacobsen, Thorkild. 1976. *The Treasures of Darkness: A History of Mesopotamian Religion*. New Haven and London: Yale University Press.

Jung, C.G. 1916. "The Transcendent Function." In *The Structure and Dynamics of the Psyche*. 1960. Princeton, NJ: Princeton University Press.

———. 1958. *Psychology and Religion: West and East*. Princeton, NJ: Princeton University Press.

———. 1963. *Mysterium Coniunctionis*. Princeton, NJ: Princeton University Press.

———. 1967. *Alchemical Studies*. Princeton, NJ: Princeton University Press.

———. 1973. *Letters of C. G. Jung: Volume 1, 1906–1950*. Selected and edited in collaboration with G. Adler and A. Jaffé. Princeton, NJ: Princeton University Press.

———. "A Radio Talk in Munich." In *Collected Works* 18. Princeton, NJ: Princeton University Press.

Kahn, M. Masud R. 1972. "Exorcism of the Intrusive Ego-Alien Factors in the Analytic Situation and Process." In Giovacchini, ed., *Tactics and Techniques in Psychoanalytic Therapy*.

Klocek, Dennis. 1998. *Seeking Spirit Vision*. Fair Oaks, CA: Rudolf Steiner College Press.

Knowlson, James. 1996. *Damned to Fame: The Life of Samuel Beckett*. New York: Touchstone.

Kristeva, Julia. 1982. *Powers of Horror: An Essay on Abjection*. New York: Columbia University Press.

Lacan, J. 1977. *Écrits*. Translated by A. Sheridan. New York: W.W. Norton & Company.

Langer, Monika M. 1989. *Merleau-Ponty's Phenomenology of Perception: A Guide and Commentary*. Tallahassee, FL: Florida State University Press.

Levinas, Emmanuel. 1961. *Totality and Infinity: An Essay on Exteriority*. Translated by Alphonso Lingis. Pittsburgh, PA: Duquesne University Press.

———. 1981. *Otherwise Than Being, or Beyond Essence*. Translated by Alphonso Lingis. Pittsburgh, PA: Duquesne University Press.

———. 1999. *Alterity and Transcendence*. Translated by Michael B. Smith. New York: Columbia University Press.

Levi-Strauss, Claude. 1962. *The Savage Mind*. London: Wiedenfeld.

Lings, Martin. 1998. *The Sacred Art of Shakespeare: To Take Upon Us the Mystery of Things*. Rochester, VT: Inner Traditions.

Mandelbaum, Allen. 1971. *The Aeneid of Virgil*. Berkeley, Los Angeles, and London: University of California Press.

McDougal, Joyce. 1990. *Plea for a Measure of Abnormality*. London: Free Associations Books.

Mead, G.R.S., 1919. *The Doctrine of the Subtle Body in Western Tradition*. London: J. M. Watkins.

Melville, Herman. 1962. *Moby Dick*. New York: Hendricks House.

Merleau-Ponty, Maurice. 1964. *The Primacy of Perception*. Evanston, IL: Northwestern University Press.

Mitrani, Judith. 1996. *A Framework for the Imaginary: Clinical Explorations in Primitive States of Being*. Northvale, NJ: Jason Aronson, Inc.

———. 2001. *Ordinary People and Extra-Ordinary Protections: A Post-Kleinian Approach to the Treatment of Primitive Mental States*. Philadelphia: Taylor & Francis, Inc.

Mitrani, Theodore, and Judith L. Mitrani. 1997. *Encounters with Autistic States: A Memorial Tribute to Frances Tustin*. Northvale, NJ: Jason Aronson, Inc.

Neill, Michael. 1992. "*Hamlet*: A Modern Perspective." In William Shakespeare, *The Tragedy of Hamlet, Prince of Denmark*, ed. Barbara A. Mowat and Paul Werstine. New York: Washington Square Press.

Ogden, Thomas H. 1989. *The Primitive Edge of Experience*. Northvale, NJ: Jason Aronson, Inc.

Otto, Rudolph. 1958. *The Idea of the Holy*. London, Oxford, and New York: Oxford University Press.

Ovid. 1931. *Fasti*. Translated by Sir James G. Frazer. Cambridge, MA: Harvard University Press.

Rilke, Rainer Maria. 1982. *The Selected Poetry of Rainer Maria Rilke*. Edited and translated by Stephen Mitchell. New York: Random House.

Robbins, Jill. 2001. *Is It Righteous to Be? Interviews with Emmanuel Levinas*. Stanford, CA: Stanford University Press.

Roller, Lynn E. 1999. *In Search of God the Mother: The Cult of Anatolian Cybele*. Berkeley, Los Angeles, and London: University of California Press.

Rosen, Steven M. 1995. "Pouring Old Wine into a New Bottle." In *The Interactive Field in Analysis*, ed. Murray Stein, pp. 121–141. Wilmette, IL: Chiron Publications.

———. 2004. *Dimensions of Apeiron: A Topological Phenomenology of Space, Time and Individuation*. Amsterdam and New York: Editions Rodopi.

———. 2006. *Topologies of the Flesh: A Multidimensional Exploration of the Lifeworld*. Athens, OH: Ohio University Press.

Sass, Louis A. 1992. *Madness and Modernism: Insanity in the Light of Modern Art, Literature, and Thought.* New York: Basic Books.

Schwartz-Salant, Nathan. 1982. *Narcissism and Character Transformation: The Psychology of Narcissistic Character Disorders.* Toronto: Inner City Books.

———. 1989. *The Borderline Personality, Vision and Healing.* Wilmette, IL: Chiron Publications.

———. 1992. "Anima and Animus in Jung's Alchemical Mirror." In *Gender and Soul in Psychotherapy*, edited by Nathan Schwartz-Salant and Murray Stein, pp. 1–24. Wilmette, IL: Chiron Publications.

———. 1995. *C.G. Jung on Alchemy.* Edited with an introduction by Nathan Schwartz-Salant. London: Routledge.

———. 1998. *The Mystery of Human Relationship: Alchemy and the Transformation of Self.* London and New York: Routledge.

———. 2006. "The Alchemical Prima Materia in Relationship." *Alchemy: A Journal of Archetype and Culture* 74, pp. 137–150. New Orleans: Spring Journal.

Sfameni Gasparro, Giulia. 1985. *Soteriology and Mystic Aspects in the Cult of Cybele and Attis.* Leiden: E.J. Brill.

Shapiro, James. 2005. *1599: A Year in the Life of William Shakespeare.* New York: Harper Collins.

Spiegelman, J. Marvin. 1996. *Psychotherapy as Mutual Process.* Tempe, AZ: New Falcon Publications.

Stein, Murray, ed. 1995. *The Interactive Field in Analysis.* Wilmette, IL: Chiron Publications.

———. 2006. *The Principle of Individuation.* Wilmette, IL: Chiron Publications.

Tustin, Frances. 1986. *Autistic Barriers in Neurotic Patients.* London: Karnac Books.

Vasseleu, Cathryn. 1998. *Textures of Light.* London: Routledge.

Vermaseren, Maarten J. 1977. *Cybele and Attis: The Myth and the Cult.* London: Thames and Hudson, Ltd.

Wahrman, Dror. 2004. *The Making of the Modern Self: Identity and Culture in Eighteenth-Century England.* New Haven and London: Yale University Press.

Whyte, Lancelot Law. 1959. *The Unconscious Before Freud.* London: Tavistock Publications.

Winnicott, D.W. 1965. *The Maturational Process and the Facilitating Environment.* New York: International Universities Press, Inc.

———. 1971. *Playing and Reality.* New York: Tavistock Publications.

———. 1972. "Mother's Madness Appearing in the Clinical Material as an Ego-Alien Factor." In Giovacchini, ed., *Tactics and Techniques in Psychoanalytic Therapy.*

———. 1989. *Psycho-Analytic Explorations.* Cambridge: Harvard University Press.

Yates, A. Francis. 1964. *Giordano Bruno and the Hermetic Tradition.* Chicago: University of Chicago Press.

INDEX